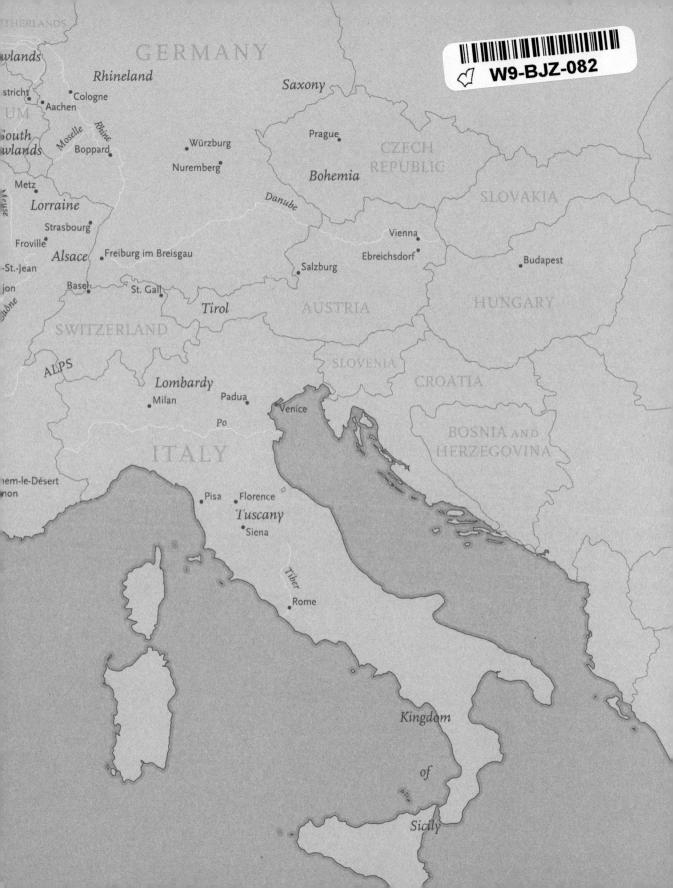

THE CLOISTERS

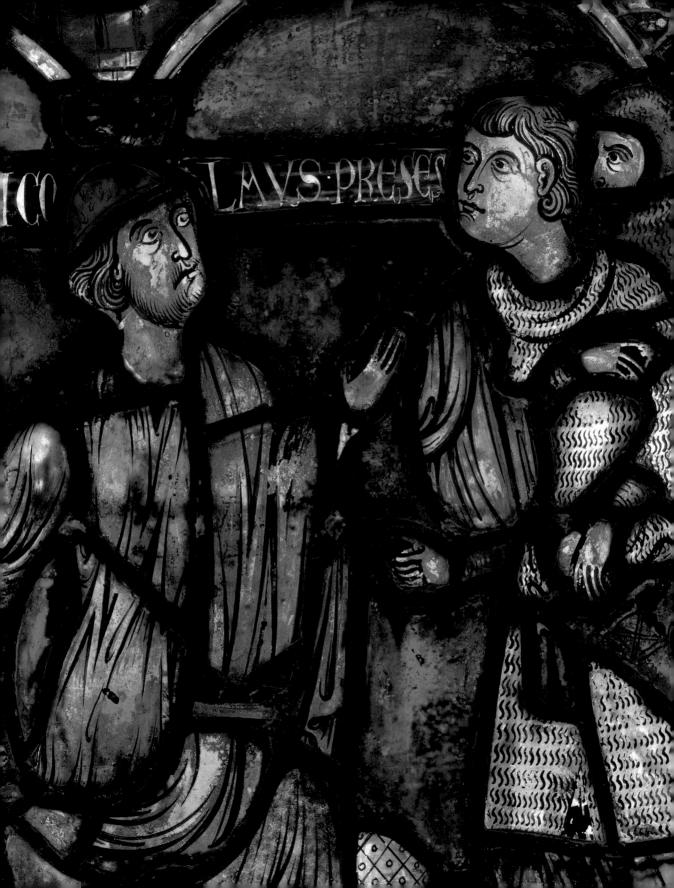

THE CLOISTERS

Medieval Art and Architecture

Peter Barnet and Nancy Wu

FINKELSTEIN MEMORIAL LIBRARY, 24 CHESTNUT ST. SPRING VALLEY, N.Y. 10977-5594

The Metropolitan Museum of Art, New York Yale University Press, New Haven and London This publication is made possible by The Peter Jay Sharp Foundation.

Published by The Metropolitan Museum of Art, New York John P. O'Neill, Editor in Chief and General Manager of Publications Dale Tucker, Editor Antony Drobinski, Designer Peter Antony and Christopher Zichello, Production Cathy Dorsey, Indexer

New color photography of The Cloisters and of works in the Metropolitan Museum collection by Oi-Cheong Lee, The Photograph Studio, The Metropolitan Museum of Art. Isometric plan of The Cloisters by John Papasian.

Color separations by Conti Tipocolor, s.p.a., Florence Printed and bound by Conti Tipocolor, s.p.a., Florence

Jacket/cover illustrations: front, detail of chapter house from Pontaut (no. 21); back, detail of *The Unicorn Is Killed and Brought to the Castle* (no. 122)
Frontispiece: detail of stained glass with scenes from the life of Saint Nicholas (no. 39); p. 174, detail of mirror case (no. 59)

Copyright © 2005 by The Metropolitan Museum of Art All rights reserved

No part of this publication may be reproduced or transmitted in any form or by any means, electronic or mechanical, including photocopying, recording, or any information storage or retrieval system, without permission in writing from the publishers.

Library of Congress Cataloging-in-Publication Data Metropolitan Museum of Art (New York, N.Y.) The Cloisters : medieval art and architecture / Peter Barnet and Nancy Wu.

p. cm.
Includes bibliographical references and index.
ISBN 1-58839-176-0 (hardcover)
ISBN 0-300-11142-8 (Yale University Press)
I. Cloisters (Museum)—Guidebooks. 2. Art, Medieval—Guidebooks. 3. Art—New York (State)—New York—Guidebooks.
I. Barnet, Peter. II. Wu, Nancy Y. III. Cloisters (Museum) IV. Title.
N611.C6A85 2005

709'.02074747I—dc22

2005029684

CONTENTS

- 6 | Director's Foreword Philippe de Montebello
- 8 | Introduction Peter Barnet and Nancy Wu
- 20 | Map of The Cloisters
- 22 Note to the Reader
- 23 | The Cloisters: Medieval Art and Architecture
- 176 Glossary
- 188 | Suggested Readings
- 193 | Selected References
- 201 | Acknowledgments
- 202 Index

DIRECTOR'S FOREWORD

 \blacksquare he first guide to The Cloisters was published in May 1938, the same month the newly constructed Museum opened to the public as a branch of the Metropolitan. That essential volume, subsequently reprinted and revised numerous times, was followed in 1951 and 1963 by enlarged versions that accommodated important new gifts and acquisitions, including the Hours of Jeanne d'Evreux and Robert Campin's Mérode Triptych. In his preface to the book's third edition, then Metropolitan director James J. Rorimer promised that "these additions have required yet another revised and enlarged...guide in order to give a comprehensive description of the collections." In the more than forty years since that book was prepared, The Cloisters has continued to grow, broadening and deepening its world-renowned holdings in the art and architecture of the Middle Ages. Once again we find that our many notable acquisitions and renovations have made necessary a new guide to its incomparable treasures.

The Cloisters: Medieval Art and Architecture builds on the legacy of those early guide books as it also incorporates important elements, such as historic photographs, published in other major books on the collection. These include Rorimer's excellent but long unavailable Medieval Monuments at The Cloisters (1941, rev. 1971), still an outstanding and eminently literate source on objects in the collection that "incorporate or support or enclose, as distinct from elements that can be readily moved." There is also Bonnie Young's A Walk Through the Cloisters (1979), a perennial favorite featuring a lively prose style and gorgeous photographs by Malcolm Varon that together lead the visitor on a visual tour of the building and the masterpieces of art within.

In a departure from those models, this guide is organized as a chronological survey of the collection. It begins, for example, with an important group of ivory carvings that visitors typically encounter in the Treasury, at the end of their visit, even though such ivories are among the earliest pieces at The Cloisters. By presenting those art works in roughly the same historical sequence in which they

were originally created, not only do we glimpse the evolving styles and traditions of the Middle Ages, we gain a better understanding of the historical and political contexts in which many of the objects appeared. An even more practical consideration behind this decision is that The Cloisters, never intended to be a static display of medieval art, continues to change. Except for a handful of immovable architectural pieces that are woven into the very fabric of the building, the works in the collection are subject to reinstallation and, occasionally, reconsideration as a result of ongoing scholarly research.

To date generations of scholars and curators have contributed to our knowledge of The Cloisters' collection, and this latest anthology benefits from their cumulative efforts. Each selected work is accompanied by the kind of detailed descriptive data now standard in art publishing, and most are illustrated with new digital color photography. The Cloisters: Medieval Art and Architecture is thus a thoroughly updated, contemporary guide befitting the Metropolitan's commitment to upholding the latest museological standards, yet it also reflects our respect as an institution for careful scholarship and the often painstaking pursuit of historical accuracy. On behalf of the Museum, I would like to thank the guide's co-authors—Peter Barnet, Michel David-Weill Curator in Charge, Medieval Art and The Cloisters, and Nancy Wu, Associate Museum Educator, The Cloisters-for their tenacity and vision in bringing this complex project to fruition. The Metropolitan acknowledges The Peter Jay Sharp Foundation, whose endowment for publications made possible this important guide. The Sharp Foundation's dedication to the Metropolitan's permanent collection speaks to the very heart of the Museum's mission, and we remain grateful for their enlightened support.

Philippe de Montebello Director The Metropolitan Museum of Art

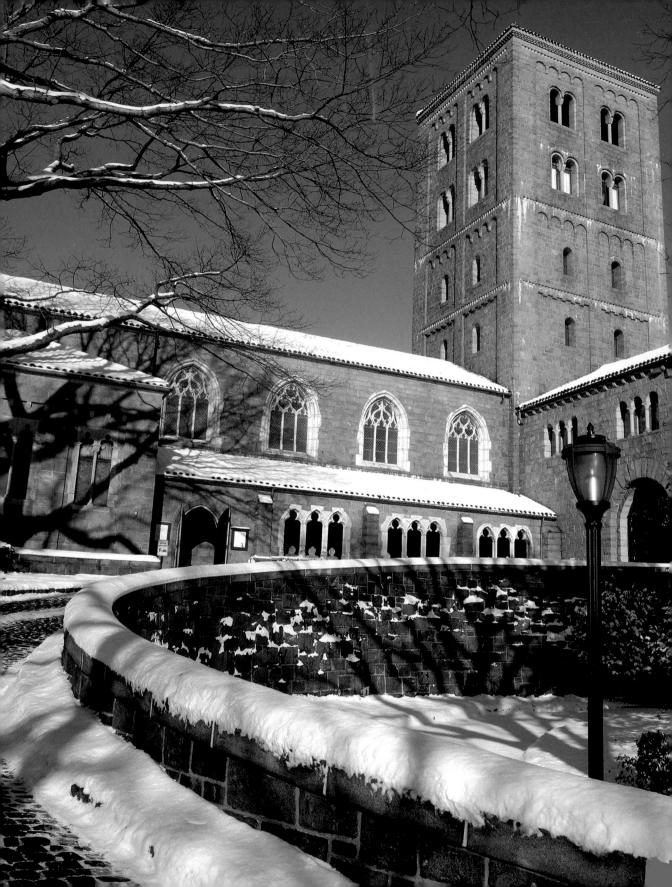

INTRODUCTION

The Cloisters, a branch of The Metropolitan Museum of Art, houses an extraordinary collection of art and architecture from medieval Europe, particularly from the Romanesque and Gothic periods. Students and enthusiasts of the Middle Ages have long made pilgrimages to The Cloisters to appreciate the collection's remarkable richness and broad scope. Many visitors also come to enjoy the Museum's magnificent setting, overlooking the Hudson River, and to experience its unique design concept, which incorporates subtle transitions between indoor and outdoor, past and present.

The history of The Cloisters begins with George Grey Barnard (1863–1938), an American sculptor trained at the Art Institute of Chicago and at the Académie des Beaux-Arts in Paris. From 1905 to 1913 Barnard was living with his family in a small village near Fontainebleau, where he was at work on a commission for the facade of the Pennsylvania state capitol building, in Harrisburg. To supplement his income, he became a casual art dealer and, later, an adroit collector, amassing in just a few years an impressive ensemble of medieval objects. Among his acquisitions were portions of four cloisters from southern France—Saint-Michel-de-Cuxa, Saint-Guilhem-le-Désert, Bonnefont-en-Comminges, and Trie-en-Bigorre—that would eventually form the architectural core of The Cloisters.

Barnard's interest in acquiring medieval sculpture stemmed from his frustrated attempts to introduce his students at New York's Art Students League, where he had taught in the late 1890s, to the beauty of medieval stone carving. He resolved to found a medieval museum "where the 'spirit of Gothic' could once more cast its spell." Barnard's timing was propitious, for at the turn of the twentieth century medieval architectural fragments were still available to the interested collector. Many such objects had become separated from their original settings as a result of pillage or vandalism, first during the sixteenth-century Wars of Religion and later in the French Revolution. Less violent causes, such as extensive renovations undertaken by owners—often a reflection of changing tastes—also contributed to the dispersal or destruction of art works.

Upper driveway entrance to The Cloisters in winter, with the Froville arcade and Sens windows visible at center

Interior views of George Grey Barnard's original Cloisters Museum, ca. 1925

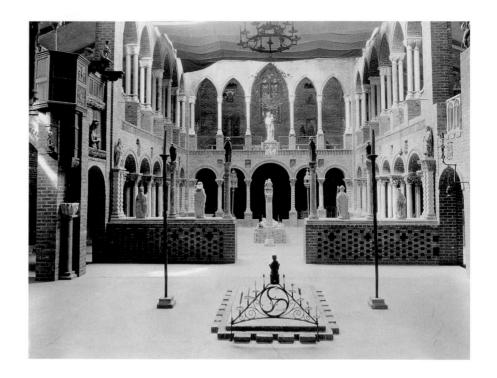

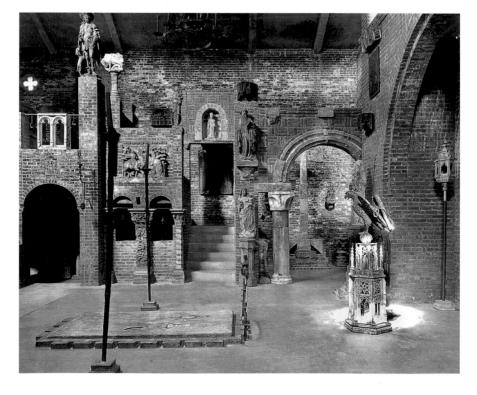

By the time Barnard began dealing in and collecting antiques, most of the fragments he was acquiring had already been displaced from their original sites. Some he found in private residences, but others had been hidden from view or even abandoned in fields.

In 1913 Barnard entered into negotiations with Mme Baladud de Saint-Jean for at least ten arches from Saint-Michel-de-Cuxa then decorating her bathhouse in Prades. The proposed sale alarmed local residents, however, as it did officials in Paris, who were already vexed by Barnard's earlier acquisitions. As a result, in late December of that year, shortly before the French senate passed a law designed to impede the export of historical monuments, Barnard shipped his entire collection to New York. He built a home for his antiquities at 698 Fort Washington Avenue and West 190th Street in Upper Manhattan. His new Cloisters Museum (opposite), essentially a barnlike brick structure with a pitched roof, opened in December 1914 "for the benefit of the widows and orphans of French sculptors." Four years later, at the end of World War I, Barnard's energies were diverted to yet another ambitious plan: to build a national peace memorial showcasing the achievements of world architecture. Although never realized, the project consumed so much of Barnard's capital he was forced to put his museum up for sale. In 1925 John D. Rockefeller Jr. (1874–1960) purchased the Barnard collection for The Metropolitan Museum of Art, and on May 3 of the following year Barnard's Cloisters reopened as a branch of the Metropolitan (below).

Over the next few years Rockefeller helped enlarge The Cloisters' holdings through gifts and initiated plans to better accommodate

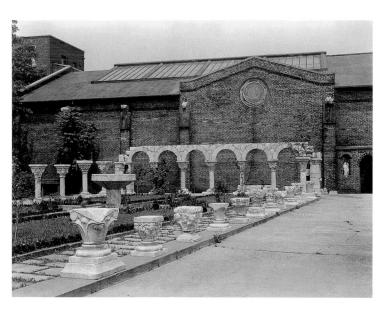

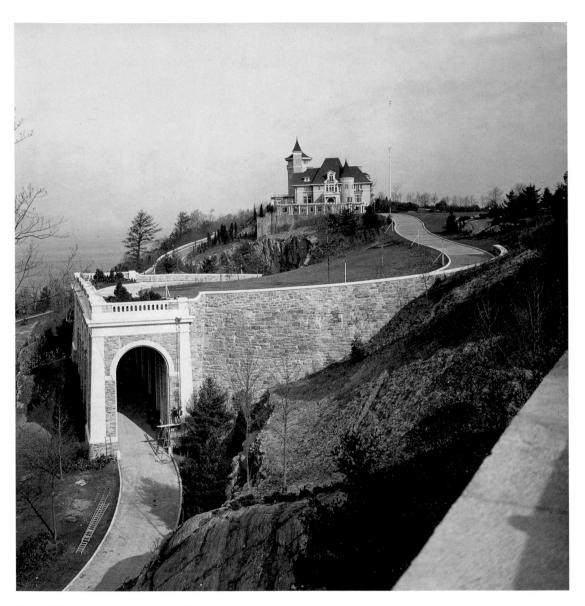

Estate of C. K. G. Billings, future site of Fort Tryon Park and The Cloisters, before 1926

Baron I. J. Taylor (1789–1879). Ruines de Saint-Michel-de-Cuxa, 1834. Lithograph, from Voyages pittoresques et romantiques dans l'ancienne France (Parls, 1820–78)

the ever-growing collection. He purchased a tract of land just north of Fort Washington Avenue, part of which had previously been occupied by the estate of C. K. G. Billings (opposite), and in 1927 he contracted Olmsted Brothers (the firm of Central Park architect Frederick Law Olmsted's sons) to landscape the area. They created what is now Fort Tryon Park (part of the New York City Parks and Recreation system), which Rockefeller donated to the city in 1930 with the condition that four acres be set aside for the future Cloisters Museum. Rockefeller also presented some seven hundred acres of the Palisades, the imposing bluffs on the west side of the Hudson River opposite the Museum, to the State of New Jersey, thereby preserving the remarkably pristine vista still treasured by visitors to The Cloisters. On a clear day the spectacular view stretches south to the George Washington Bridge and as far north as the Tappan Zee Bridge.

In 1931 the design for a new building was entrusted to architect Charles Collens (1873–1956), who had recently completed the Riverside Church on the Upper West Side of Manhattan. By a fortu-

nate coincidence, at the same time the new Cloisters was under construction (1935–38), New York City was extending its subway system to 190th Street, allowing excavated Manhattan schist to be used for the Museum's rampart walls. Similarly, the Belgian cobblestones paving the exterior grounds and driveways had been retired from the Wall Street area. Granite quarried near New London, Connecticut, was selected for the exterior facing, and Doria limestone from Genoa, Italy, was used on the interior.

Rockefeller had initially envisioned the new Cloisters as a castle-like structure modeled loosely on Kenilworth, in England, but he quickly realized that the predominantly religious content of the collection called for a style more evocative of medieval ecclesiastical architecture. To that end, Collens, working with Metropolitan curators Joseph Breck (1885–1933) and James J. Rorimer (1905–1966), surveyed numerous monuments in southern France for inspiration. The five-story tower, for example, is reminiscent of those in the region around Cuxa (above), while the entirely modern Gothic Chapel bears a resemblance to thirteenth-century chapels at Carcassonne and Monsempron. The dimensions of some individual stone blocks and the designs for roof and floor tiles were likewise patterned after ones from Europe. In fact, many European medieval monuments influenced aspects of The Cloisters' design, but none

The Cloisters viewed from the south, ca. 1938

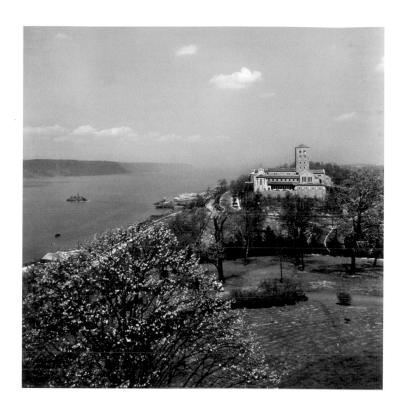

served as an exact model for any part of the Museum. In the final plan, Collens incorporated all four of Barnard's original cloisters as well as several other major architectural elements from medieval France, including an arcade from Froville (in Lorraine), a chapter house from the Cistercian abbey in Pontaut, and a Romanesque chapel from Langon.

Within the galleries of the new Cloisters the atmosphere was intended to be intimate, with minimal ornamentation, limited artificial lighting, and even an occasional burning candle. Some of the galleries reflected the original functions of the architectural fragments they incorporated, whereas others provided a neutral and sympathetic setting for the works on display. When the Museum opened in May 1938, Lewis Mumford, writing in the *New Yorker*, praised The Cloisters as "one of the most thoughtfully studied and ably executed monuments we have seen in a long time." Louvre curator Germain Bazin hailed it as "the crowning achievement of American museology."

Three of the newly reconstructed cloisters (Cuxa, Bonnefont, and Trie) incorporated gardens, an idea explored first by Joseph Breck in 1926 when he fashioned a garden court at Barnard's old museum with fragments from Cuxa. Curators James Rorimer and,

Columns and capitals from Saint-Guilhemle-Déserl uwuiting reinstallation in the new Cloisters, 1936 View of Cuxa Cloister garden from the tower

Opposite: Bonnefont Cloister garden

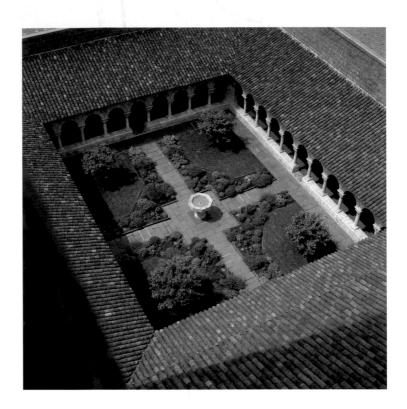

later, Margaret Freeman (1899–1980) pursued Breck's vision of recreating historical gardens. Rorimer personally surveyed catalogues of terracotta pots, and Freeman collected plant specimens from Cuxa in France. Their efforts to make The Cloisters' gardens aesthetically pleasing as well as educational were immediately seized upon by horticultural enthusiasts, and in 1939 the gardens were included on a list published by the Herb Society of America of "Botanic Gardens and Herbaria devoted especially to medicinal plants and other herbs for flavor, fragrance or household use." Today the gardens at The Cloisters are overseen by staff horticulturists who, like curators, are continually researching the species that grow there and adding new ones to the mix.

The Cuxa Cloister garden (above), with its central fountain, was conceived as a typical monastic enclosed garden. Footpaths intersecting in a cross shape divide it into equal quadrants, each planted with a fruit tree in the center and flowering plants along the border. The Bonnefont Cloister garden (opposite), overlooking an expansive view of the Hudson River and Fort Tryon Park, was designed with herbs and other useful plants in mind. The space is organized symmetrically, with four quince trees situated around a fifteenth-century Venetian wellhead, and plantings that are divided into small,

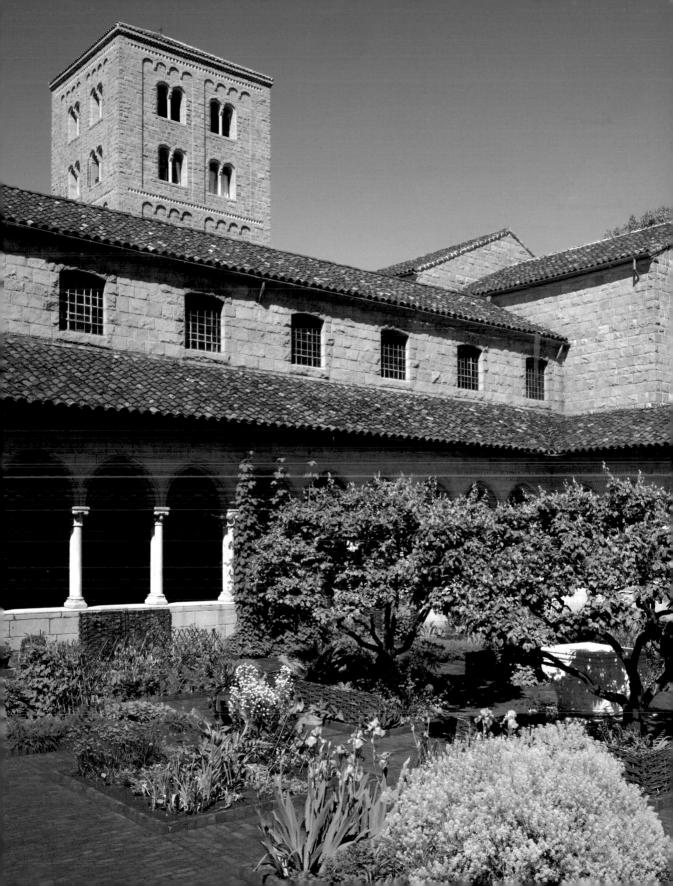

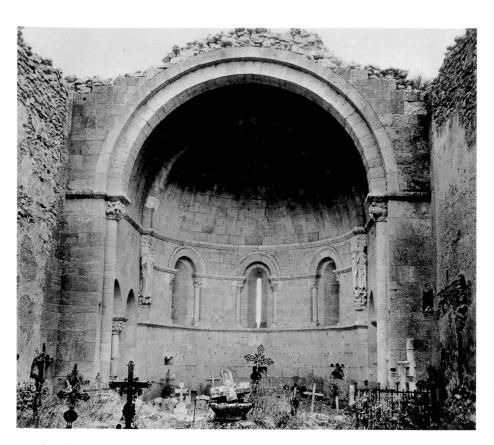

Apse from the church of San Martín at Fuentidueña before relocation to The Cloisters, ca. 1950s

geometrically shaped beds. The Trie Cloister garden offers yet another, less formal design approach. A tall fountain stands at the center of a rectangular plot amid some eighty species of plants, a profusion evocative of the millefleurs (literally "a thousand flowers") backgrounds of late medieval tapestries.

John D. Rockefeller Jr. remained intimately involved with the new Cloisters, proposing ideas to the curators and the architect and donating more objects from his personal collection, including, in 1937, six of the seven famed Unicorn Tapestries. His generosity culminated in 1952 with a significant endowment that assured the continued growth of the collection for years to come. In 1948 the original Hall of the Unicorn Tapestries was reconfigured into two smaller galleries to accommodate the newly acquired Nine Heroes Tapestries, a rare surviving set from the Late Gothic period. The 1950s saw the acquisition of the Mérode Triptych and the arrival of the apse from the church of San Martín at Fuentidueña, on permanent loan from the Spanish government (above). The installation of the apse required that the original Special Exhibition Room be reconfigured as a churchlike gallery space, which opened to the public in

1961. The superb acoustics of the Fuentidueña Chapel, as it is known today, quickly became apparent, and for more than forty years it has proved a popular venue for concerts of early music. The renovation and expansion of the Treasury, which contains such splendid liturgical and devotional objects as the twelfth-century ivory "Cloisters Cross" and the fourteenth-century Hours of Jeanne d'Evreux, was completed in 1988 to mark the Museum's fiftieth anniversary.

Today The Cloisters continues to enhance its holdings and improve its facilities. The gallery housing the Unicorn Tapestries was refurbished in the late 1990s, including new lighting installed above the long-shut (now reopened) wood louvered ceiling panels. The flat glass-tile roof and opaque plexiglass that had covered Saint-Guilhem Cloister since 1938 were similarly replaced in 2002 with a pyramidal skylight and a ceiling of transparent panels that allow natural light to filter softly into the interior. While these and other renovations help the Museum meet the latest in museological standards, they also occasionally reveal lost original design details, such as a small window hidden for decades behind a tapestry in the Boppard Room and now open once again onto a view of Cuxa Cloister.

As we adapt twenty-first-century technology to The Cloisters' unique setting, we do so in part to better accommodate the visiting public. At the same time, mindful of the contemplative atmosphere originally envisioned for the Museum, we seek a balance between accessibility and tranquillity. The number of didactic panels and wall texts, for example, has historically been kept to a minimum. Now, though, visitors can rely on random-access digital audioguides for information on highlights and major themes of the collection without intruding on the serene ambience in the galleries. Maintaining a respectful setting, especially given the spiritual resonance of much of the collection, remains a paramount concern at The Cloisters as we pursue our core missions; to preserve and protect the monuments of medieval art in our care; to elucidate those works through creative educational programming; to provide vigilant stewardship of The Cloisters' landmark physical facilities; and to continue collecting masterworks of medieval art at the highest levels of quality.

THE CLOISTERS

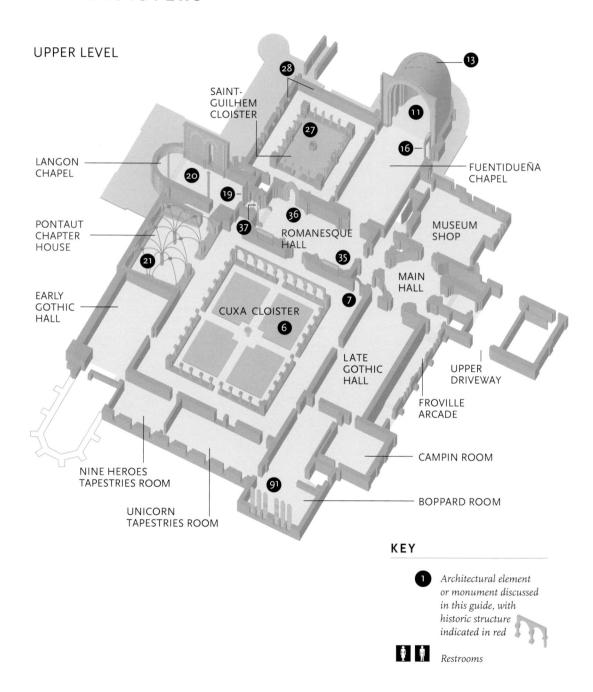

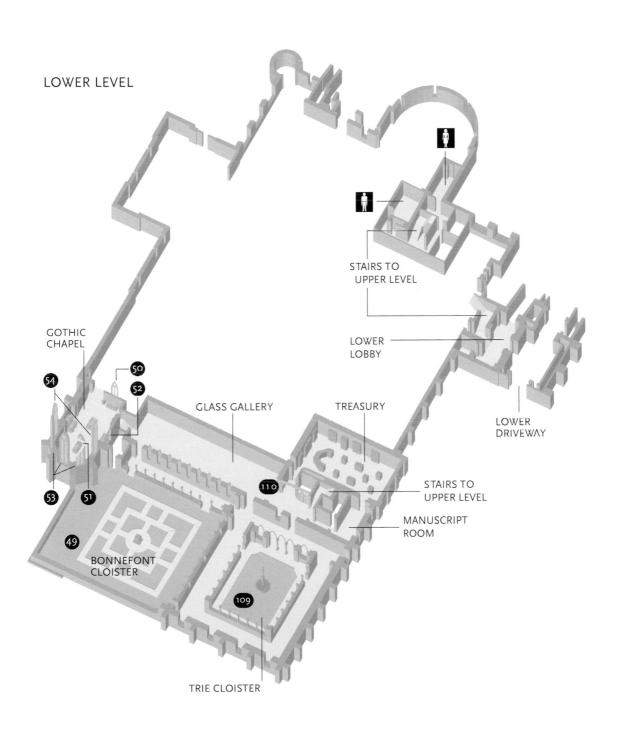

NOTE TO THE READER

All works of art are in the permanent collection of The Metropolitan Museum of Art, New York.

In object headings, information on country or culture of origin is generally listed in the following order: Country, Region (Province or Département), Town or City. Placenames within Catalunya (Catalonia) are given in Catalan; Castilian spellings are used for all other locations in Spain. Dimensions are in inches followed by centimeters. Unless otherwise noted, height precedes width precedes depth.

Biblical citations are from the Douay-Rheims Version. Because most of the events and persons from the Hebrew Bible that appear in the works of art are used in a Christian typological context, the traditional term *Old Testament* has been retained.

THE CLOISTERS

Medieval Art and Architecture

1 | Plaque with Saint John the Evangelist

Germany, North Rhine-Westphalia, Aachen, early 9th century Elephant ivory $7^{1/4} \times 3^{3/4}$ in. (18.4 × 9.5 cm) The Cloisters Collection, 1977 (1977.421)

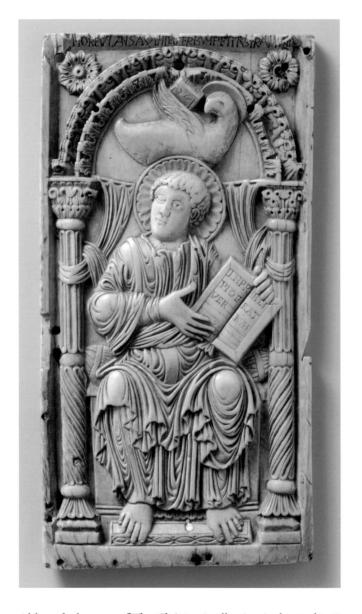

Although the core of The Cloisters' collection is devoted to Romanesque and Gothic art, the Museum houses several important early medieval treasury objects, such as this exquisite ivory plaque from the time of Charlemagne (r. as emperor 800–814), the so-called Carolingian period. On the plaque, which was probably carved in Aachen, Charlemagne's capital, we see a youthful Saint John the Evangelist sitting in richly carved classical garb. He is flanked by elaborate columns that support an arch framing his symbol, the eagle, and holds an open book bearing the words from the beginning

of his Gospel: In Princi/Pio Erat/Verbym (In the beginning was the Word). A second inscription, taken from a poem by the fifth-century Roman poet Sedulius, is found on the upper border: More volans aqvile verbym petit astra [iohan]ni[s] (Flying like an eagle the word of John aspires to Heaven). Although the original function of the plaque is not known, most surviving ivories from the Carolingian period once decorated covers of ecclesiastical volumes. The imagery and inscriptions on this example suggest that the plaque likely adorned the cover of a Gospel book.

2 | Plaque with Scenes at Emmaus

France, Lorraine (Moselle), Metz, ca. 850-900 Elephant ivory $4\frac{1}{2} \times 9\frac{1}{4}$ in. (11.5 \times 23.5 cm) The Cloisters Collection, 1970 (1970.324.1)

Carved during or soon after the reign of Charlemagne's grandson Charles the Bald (r. 840-77), this plaque reflects a later phase of Carolingian art. The figures, represented in lively poses, gesture broadly to convey the narrative. At left is Christ, identified by the halo, appearing after the Resurrection to two of his disciples on the road to Emmaus (Luke 24:13–32). At right we see the Supper at Emmaus, when Christ reveals his identity to the two disciples, set within a detailed representation of the town, including an elaborate gate and city walls. The horizontal format of the plaque suggests that it originally formed the front or back of a box whose other panels were decorated with additional scenes from the life of Christ (probably following the Resurrection). The elegant outer border was no doubt inlaid with a contrasting material. The plaque belongs to a stylistically related group of ivories from the second half of the ninth century traditionally associated with the city of Metz, where Charles the Bald had his court.

3 | Bursa Reliquary

North Italy, 10th century From the treasury of the Benedictine abbey of Saint Peter at Salzburg, Austria Bone, paint, copper gilt, and sycamore $7^{3/4} \times 7^{3/8} \times 3^{1/4}$ in. (19.7 × 18.6 × 8.3 cm) The Cloisters Collection, 1953 (53.19.2)

The crisply carved, flat decoration of this reliquary recalls the style and ornamental vocabulary seen frequently in large-scale stone carving throughout northern Italy. Its shape is also reminiscent of a bursa, a purse made of precious textiles in which saints' relics were carried. The openwork patterns of the bone plaques were originally silhouetted against gilded copper foil, creating a delicate interplay of light and shadow. In his twelfth-century treatise *On Divers Arts*, the German monk Theophilus recommended a similar decorative approach to the ivory carver: "Delicately draw little flowers or animals, or birds, or dragons linked by their necks and tails, pierce the grounds with fine tools and carve with the best and finest workmanship that you can. After doing this, fill the hole inside with a piece of oak covered with gilded copper sheet so that the gold can be seen through all the [pierced] grounds."

4 | Three Holy Women at the Holy Sepulcher

North Italy (Milan?), early 10th century Elephant ivory $7\frac{1}{2} \times 4\frac{1}{4}$ in. (19.1 × 10.8 cm) Purchase, The Cloisters Collection and Lila Acheson Wallace Gift, 1993 (1993.19)

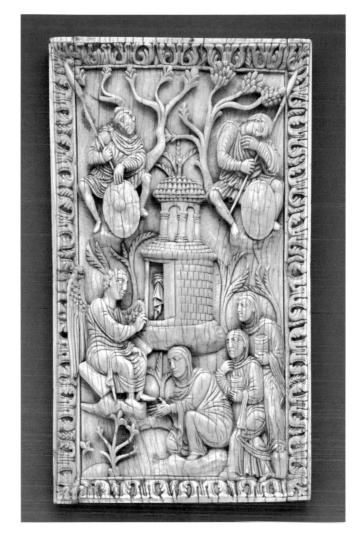

Like the ivory plaque with Saint John the Evangelist carved about one hundred years earlier (no. 1), this plaque was probably made to decorate a book cover. At the center of the dramatic scene is the Holy Sepulcher, with the burial shroud of Jesus visible through the open door of the circular building. The soldiers—who the Bible says were "struck with terror, and became as dead men" (Matthew 28:4)—are seen behind the tomb, as the Holy Women approach with their ointment jars. The latter are greeted by the winged angel, sitting atop the lid of the sarcophagus, who informs them that Christ has risen from his grave. The figures, particularly in the upper portion of the ivory, are boldly carved and deeply undercut. The strong, symmetrical composition and the masterful carving make this ivory a powerful piece of relief sculpture.

5 | Plaque with Saint Aemilian

Master Engelram and his son Redolfo Spain, Castilla-León, 1060–80 From the monastery church of San Millán de la Cogolla, near Logroño Elephant ivory, with glass inlay $6\frac{5}{8} \times 3$ in. (16.8 \times 7.6 cm) The Cloisters Collection, 1987 (1987.89)

The relics of the sixth-century Spanish saint Aemilian were housed in an ornate shrine crafted of ivory, gold, and gems. We are remarkably well informed about the reliquary, which was made on the occasion of the translation (or transport) of the saint's relics from the monastery of Suso to the church of San Millán de la Cogolla, dedicated in 1067. Although the reliquary was damaged during the Napoleonic invasion of Spain in 1809, we know from a 1601 description that The Cloisters' plaque decorated the roof of the shrine. On it we see the saint tending his sheep in the bottom

register, while above he receives a blessing from the hand of God at the top of a mountain.

In addition to this plaque, several other ivories from the shrine survive in European and American collections. One, in the State Hermitage Museum, Saint Petersburg, depicts the ivory carver and his assistant in the workshop and bears an inscription that identifies them as Master Engelram and his son Redolfo. Such images of artists were rare in this period, as was the practice of identifying artists by name.

6 | Cloister from Saint-Michel-de-Cuxa

France, Roussillon (Pyrénées-Orientales), ca. 1130–40
From the Benedictine monastery of Saint-Michel-de-Cuxa (San Miguel de Cuixà), near Perpignan Marble 90 × 78 ft. (27.4 x 23.8 m)
The Cloisters Collection, 1925 (25.120.398, .399, .452, .547–.589, .591–.607, .609–.638, .640–.666, .835–.837, .872c, d, .948, .953, .954)

The cloister is the nucleus of monastic daily life. Often square or rectangular in shape, it is essentially an open-air courtyard bordered by covered walkways connecting it to the other important spaces of the monastery, such as the church, chapter house, dormitory, and refectory. Most of the fragments with which this cloister is reconstructed come from the Benedictine abbey of Saint-Michel-de-Cuxa, in the eastern Pyrenees (the central fountain is believed to be from the abbey of Saint-Genis-des-Fontaines). Saint-Michel-de-Cuxa was founded in the ninth century by monks from the nearby abbey of Saint-André-d'Exalada. The original cloister, probably constructed during the abbacy of Gregory (1130–46), was almost twice the size of the present reconstruction. Many of the capitals bear wild or fanciful creatures, from crouching apes supported by naked men to

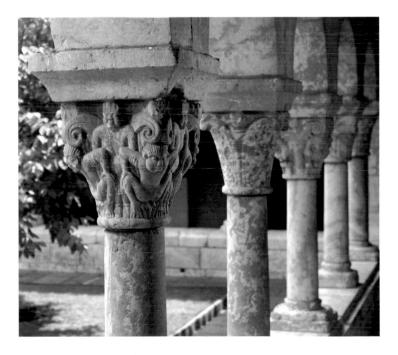

Detail of capitals

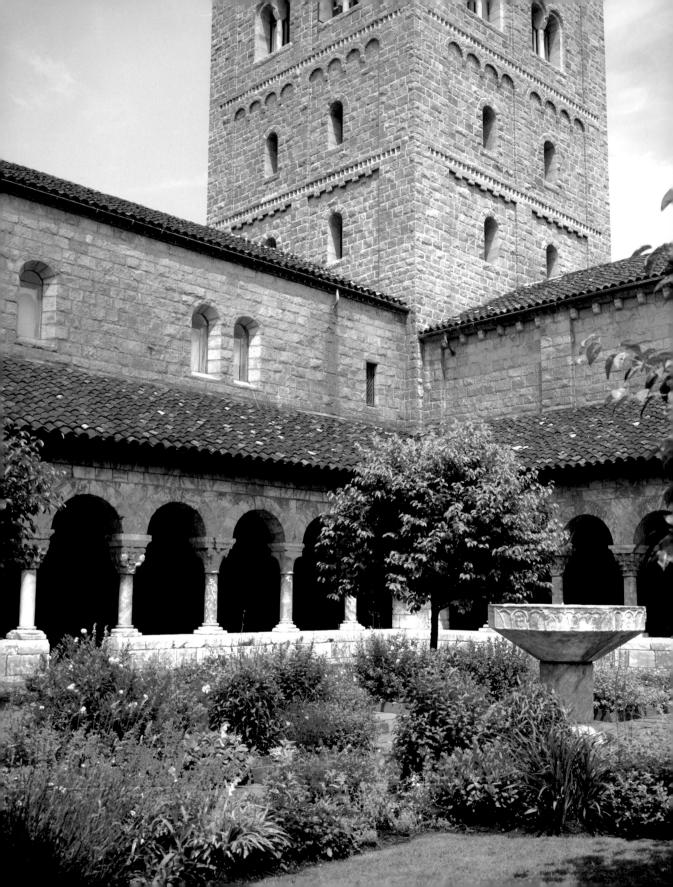

monstrous heads devouring claw-footed arms. In his *Apologia to Abbot William* (1125), the prominent theologian and reformer Bernard of Clairvaux noted the popularity of such hybrid and outlandish beings and criticized them as distractions from monastic contemplation.

Saint-Michel-de-Cuxa was confiscated in 1789 by the French state and sold in 1791; its sculpture began to be dispersed soon afterward (below). For the reconstruction at The Cloisters, Languedoc marble was quarried from the same mountainous region between Ria and Villefranche where the twelfth-century masons at Cuxa would have obtained their material. The layout of the garden approximates a typical monastic garth, like that depicted on the ninth-century plan for the Benedictine monastery in Saint-Gall, Switzerland. A crab apple tree stands in the center of each quadrant of grass, bordered by flowers and herbs. This ornamental garden mixes plants known in the Middle Ages, such as lady's-mantle and columbine—which can also be found on the Unicorn Tapestries (nos. 117–123)—with modern varieties to assure a continuous and bountiful display of blooms from April through October.

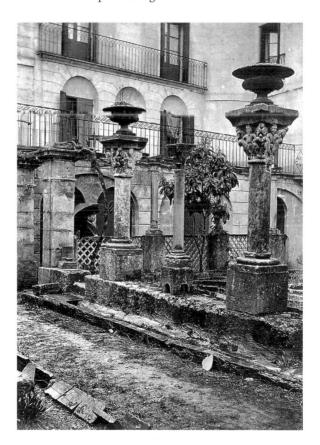

Columns and capitals from Saint-Michel-de-Cuxa installed in a garden in Aniane, France, before 1906

7 Narbonne Arch

France, Languedoc-Roussillon (Aude), mid- or third quarter of 12th century Said to come from a building in Narbonne Marble $38 \times 74 \times 11^{1/4}$ in. (96.5 × 188 × 28.6 cm) John Stewart Kennedy Fund, 1922 (22.58.1a)

This semicircular arch comprises seven stone blocks (known as voussoirs) decorated with eight real and fantastic animals: left to right, a manticore ("man-eater" in Persian, with the face of a man, the body of a lion, and the tail of a scorpion); a pelican (symbol of Christ); a basilisk (dragon with a serpent's tail, signifying the power to kill); a harpy (half-woman, half-bird creature whose sweet song lures men to their deaths); a griffin (with the body of a lion and the head and wings of an eagle); an amphisbaena (serpent with a head at either end); a centaur (with the head and torso of a man and lower body of a horse); and a crowned lion. These are all animals familiar from medieval bestiaries: texts compiled in the twelfth century describing such creatures and explaining their moral and religious associations.

The closest parallel to the carving style of the arch can be found in the nave capitals of the mid-twelfth-century church of Saint-Paul-Serge in Narbonne, but the original location of the arch remains unknown.

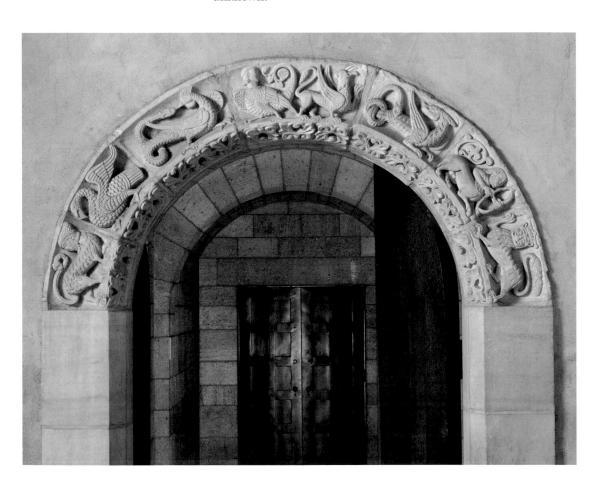

8 | Angel from Saint-Lazare at Autun

France, Burgundy (Saône-et-Loire), ca. 1130 From the former north transept portal of the cathedral of Saint-Lazare at Autun Limestone $23 \times 16^{1/2}$ in. $(58.4 \times 41.9 \text{ cm})$ The Cloisters Collection, 1947 (47.101.16)

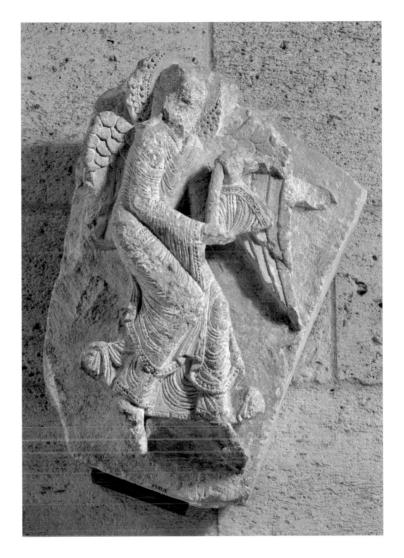

Seemingly afloat in midair, this angel was once a voussoir on the north transept portal of the cathedral of Saint-Lazare in Autun, Burgundy. His elongated body is accentuated with fine drapery folds, the sleeves and hem of his garment are decorated with beaded borders, and the feathers of his wings are articulated with deep lines. The fragmentary state of the voussoir no longer allows for a sure identification of the object held by the angel, in all probability a liturgical or musical instrument. The angel is one of a handful of physical remains of the twelfth-century portal, which was replaced with a Baroque doorway in 1776. The fine, calligraphic carving style bears a strong resemblance to the celebrated Eve figure from the lintel of the same portal, now at the Musée Rolin in Autun.

9 | Enthroned Virgin and Child

France, Burgundy (Saône-et-Loire), vicinity of Autun, 1130–40 Birch, paint, and glass H. 40½ in. (102.9 cm) The Cloisters Collection, 1947 (47.101.15) Despite the loss of the Christ Child's head, three legs of the Virgin's throne, and most of the original painted decoration, this sensitive carving manifests enormous sculptural power. The conception of the Virgin's elongated face and the treatment of the drapery folds compare closely to the well-known architectural sculptures of the cathedral of Saint-Lazare in Autun, including the relief of an angel in The Cloisters' collection (no. 8). Indeed, one of the sculpture's owners, Abbot Victor Terret of Autun, believed it came from a local church, perhaps Saint-Lazare. Surviving traces of paint reveal that the Virgin's tunic was forest green with vermilion cuffs, and her veil

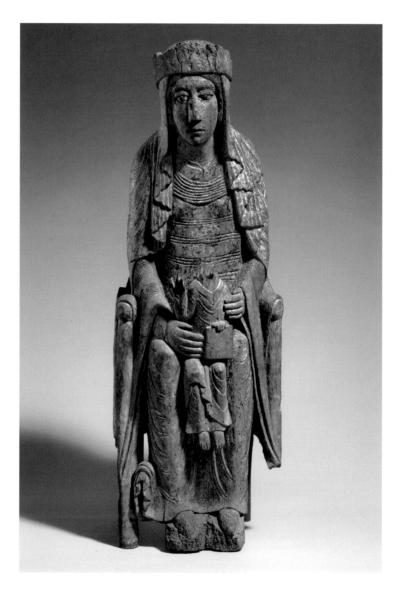

was a dark lapis lazuli blue. The Child's tunic retains traces of yellow, and his undergarment was red; the book he holds shows evidence of blue on the front cover and white and black on the sides. The Virgin's hair was black, and both eyes were originally inlaid with pupils of blue glass (only the proper right eye is original).

10 | Enthroned Virgin and Child

France, Auvergne (Puy-de-Dôme), 1150–1200
Said to come from the chapel of Saint-Victor at Montvianeix, near Vichy
Walnut with gesso, paint, tin leaf, and traces of linen
H. 27 in. (68.6 cm)
The Cloisters Collection, 1967 (67.153)

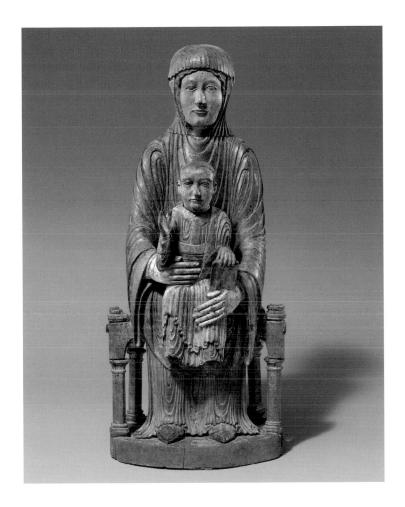

The Christ Child seated in a frontal pose on the Virgin's lap is a sculptural type known as the Throne of Wisdom, or Sedes Sapientiae (see also The Cloisters' Burgundian version, opposite). This seemingly straightforward arrangement actually conveys complex theological ideas, specifically the medieval tenet that Christ, like his ancestors King David and King Solomon, embodied wisdom and justice. Mary thus serves as his "throne," and Christ holds an open book emblematic of his divine wisdom. Sculptures like this one

frequently functioned as reliquaries; in fact, X-radiography has revealed the presence of a small sealed cavity under Mary's left shoulder that appears to contain a relic.

Recent treatment and study in the Museum's conservation laboratory have enabled us to reconstruct the original painted decoration of the sculpture. The Virgin's mantle was once dark blue (lapis lazuli darkened by a gray underlayer) and was further embellished with small lozenge-shaped elements of tin leaf that were intended to appear as gold. Beneath her blue mantle the Virgin wore a red robe. That same red, also decorated with tin leaf, is found on the Child's himation (the overgarment that falls over his shoulder), while his tunic (now light green) was originally a darker green with red lining. Both throne and base were painted in imitation of colored marbles and precious stones.

11 | Apse from San Martín at Fuentidueña

Spain, Castilla-León (Segovia), ca. 1175–1200 From the church of San Martín at Fuentidueña, near Segovia Sandstone and limestone H. to top of barrel vault: 29 ft. 8½ in. (905.5 cm); max. interior W.: 22 ft.½ in. (672 cm) Exchange Loan from the Government of Spain, 1958 (L.58.86)

> Church of San Martín at Fuentidueña, 1955

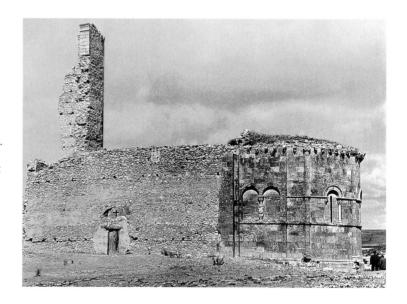

The church of San Martín stood in the village of Fuentidueña in north-central Spain, a region largely uninhabited, though claimed intermittently by Christian and Muslim forces, from the eighth through the eleventh century. Little is known about the building's history. By the nineteenth century, the apse—a term that most often describes a semicircular space terminating at the east end of a church, where the altar is situated—was the only part of the church surviving in fair condition (above). In 1957 the Spanish government agreed to lend it permanently to The Cloisters. The apse is covered by a barrel vault and a half-dome, with three small windows piercing the exterior wall. Flanking the window zone are two columns fronted with figures: on the left, Saint Martin, bishop of Tours (ca. 316–39/),

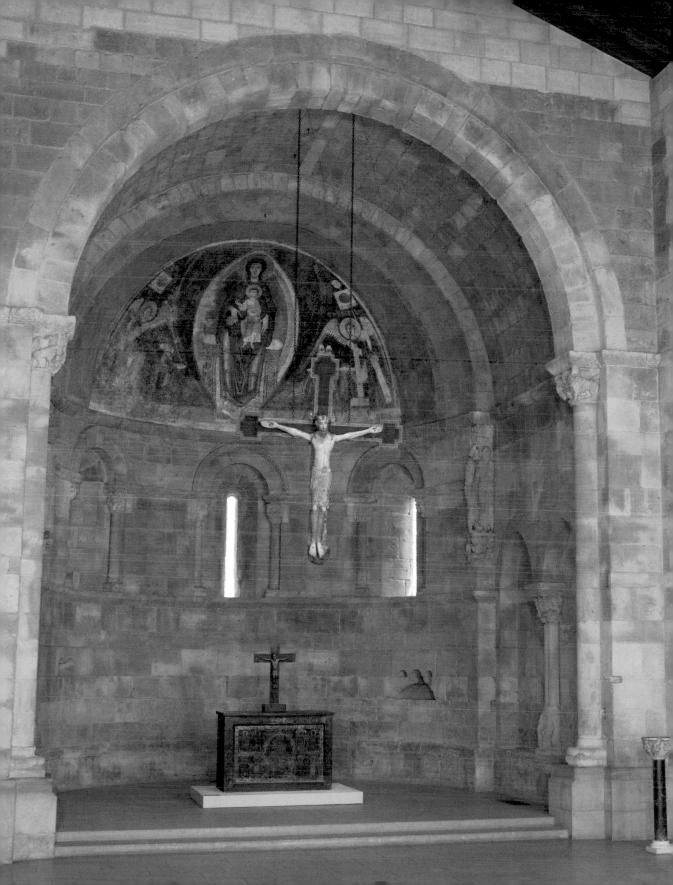

Fuentidueña apse being prepared for shipment to New York, 1958

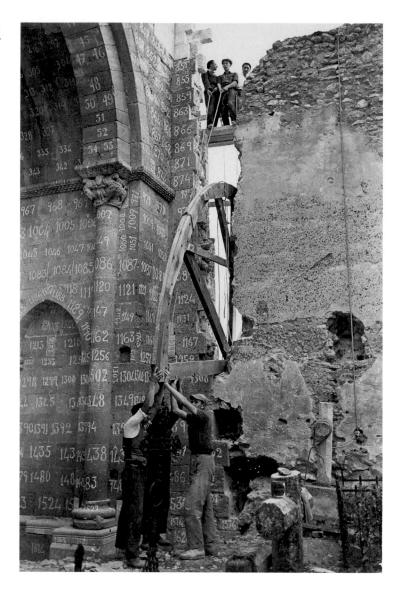

and on the right, the Annunciate Angel and Mary. Below a triumphal arch are two attached columns whose capitals depict the Adoration of the Magi (left) and Daniel in the Lions' Den (right). To accommodate the reconstructed apse, which comprises 3,300 stone blocks (above), the former Special Exhibition Room was partially demolished. The new gallery, which opened to the public in 1961, was designed to simulate a single-aisle nave with no projecting transepts, a plan characteristic of twelfth-century Segovian architecture.

12 | Crucifix

Spain, Castilla-León (Palencia), ca. II50–I200 From the convent of Santa Clara at Astudillo, near Palencia White oak, paint, gilding, and applied stones (corpus); red pine and paint (cross) I02 $\frac{1}{2}$ \times 81 $\frac{3}{4}$ \times 15 $\frac{3}{4}$ in. (260.4 \times 207.6 \times 40 cm) Samuel D. Lee Fund, 1935 (35.36a, b) This monumental crucifix represents Christ in a characteristically twelfth-century manner: triumphant over death, with his eyes open, and crowned. The patterns of his beard and rib cage are boldly carved, as is the drapery of the loincloth, and much of the painted and gilded decoration is original. The reverse is embellished with a painted image of the Lamb of God (Agnus Dei) at the center and symbols of the Four Evangelists at the terminals, suggesting that the cross was intended to hang away from the wall and be seen from both sides. The high quality of the carving and the generally fine state of preservation make this crucifix one of the most important Romanesque examples of its type.

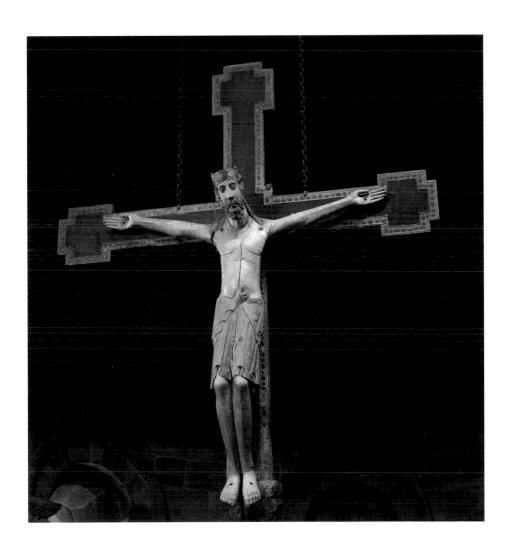

13 | The Virgin and Child in Majesty and the Adoration of the Magi

Attributed to the Master of Pedret Catalunya, Lleida, ca. 1100
From the church of Sant Joan at Tredós
Fresco transferred to canvas
10 ft. 7 in. × 19 ft. 5½ in. (323 x 593 cm)
The Cloisters Collection, 1950
(50.180a-c)

This fresco, attributed on stylistic grounds to the so-called Master of Pedret, comes from the apse of the church of Sant Joan at Tredós, in the Catalonian Pyrenees. At its center are the Enthroned Virgin and Child framed by a mandorla (an almond-shaped aureole). Flanking this central group, but on a smaller scale, are Archangels Michael (left) and Gabriel (right) in rigidly frontal poses. Only the Three Magi at the bottom—Melchior, Balthasar, and Gaspar—display any considerable agility or movement. The composition clearly intends to delineate the hierarchy of the figures. An Italo-Byzantine influence is evident in the representation of the bejeweled throne and the flaming wings of the archangels; the latter, in fact, are dressed in imperial Byzantine costumes.

The fresco was hidden from view until shelling during the Spanish Civil War (1936–39) destroyed a Baroque altar in front of it. The central group of the Virgin and Child was purchased by the Museum in 1950, followed soon after by the other two fragments (Michael and Melchior on one; Gabriel, Balthasar, and Gaspar on the other). When the Fuentidueña apse (no. 11) came to The Cloisters, the fresco fragments were mounted on its half-dome to evoke their original setting.

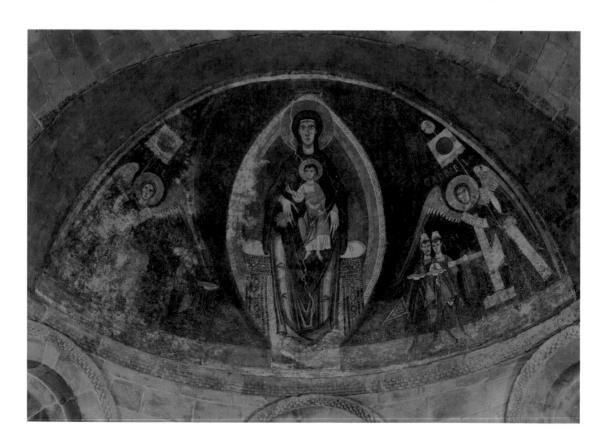

14 | The Adoration of the Magi

Spain, Castilla-León (Burgos), ca. 1175–1200 From the church of Nuestra Señora de la Llana at Cerezo de Riotirón, near Burgos Limestone H. left to right: 48¾ in. (123.8 cm); 52¾ in. (134 cm); 53¾ in. (136.5 cm); 51 in. (129.5 cm) The Cloisters Collection, 1930 (30.77.6–.9)

Adoration group as installed on the south facade of Nuestra Señora de la Llana, ca. 1920s Despite some visible damage, the masterful carving in this Adoration scene is still apparent in the swirling drapery folds and majestic postures of the figures. We see two of the Magi approaching the Virgin and Child (whose head is missing) from the left, while Joseph sits on the right with his head resting on his hand. The church of Nuestra Señora de la Llana at Cerezo de Riotirón, in ruins since 1924, no longer provides evidence either for the group's twelfth-century disposition or for the original placement or presence of the third wise man, but it is possible the group was intended for a tympanum. However, the earliest photograph of it, taken in the 1920s (left), already

shows the ensemble inserted in a recessed space not likely to have been its original setting. Comparisons with surviving regional sculptures have identified the hand of the sculptor, who, although anonymous, created this Adoration group in his mature style.

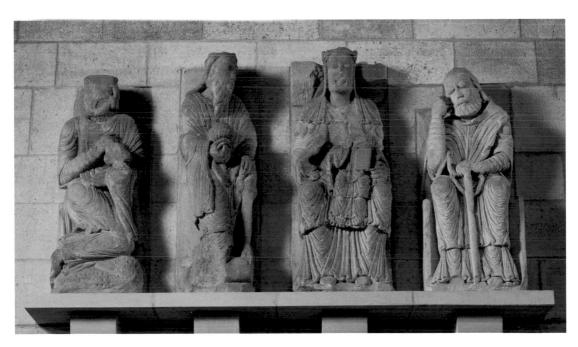

15 | Commentary on the Apocalypse of Saint John

Spain, Castilla-León (Burgos), ca. 1180 Probably from the Benedictine monastery at San Pedro de Cardeña Tempera, gold, and ink on parchment 17½ × 11¾ in. (44.4 x 30 cm) Purchase, The Cloisters Collection, Rogers and Harris Brisbane Dick Funds, and Joseph Pulitzer Bequest, 1991 (1991.232.1–.14)

In about 776 the Spanish monk Beatus of Liébana compiled a commentary on the biblical Revelation of Saint John, commonly known as the Apocalypse. Boldly illuminated manuscripts of Beatus's text are among the masterworks of early medieval Spanish art. This miniature, one of fourteen leaves from such a manuscript in the Museum's collection, depicts the imagery in Revelation 6:9–11, or the opening of the fifth seal. The horizontal bands of intense color behind the images are characteristic of Beatus manuscripts. In the blue register at top we see an altar table with hanging votive offerings and doves, representing the souls of the dead, on either side; in the middle reg-

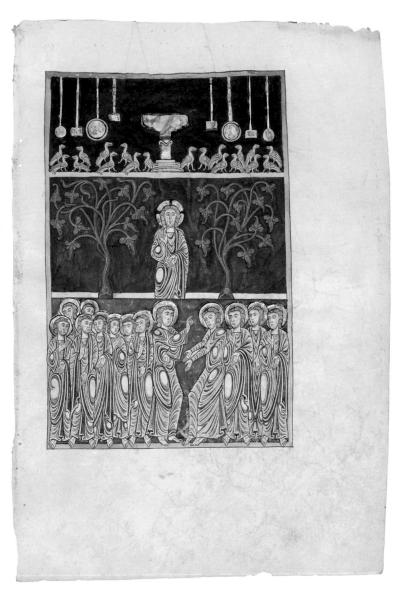

ister an image of the blessing Christ is flanked by trees; a crowd of martyrs fills the bottom register. The drapery of the figural decoration, which seems to cling to the bodies in the "damp-fold" style, is consistent with Spanish work of the period, as seen on the twelfth-century carved figures of the Adoration of the Magi group from Cerezo de Riotirón (no. 14), also in The Cloisters' collection.

16 | Doorway from San Leonardo al Frigido

Workshop of Master Biduino Italy, Tuscany, ca. 1170–80 From the church of San Leonardo al Frigido, near Massa-Carrara Carrara marble 13 ft. 2 in. × 76 in. (400 × 190 cm) The Cloisters Collection, 1962 (62.189)

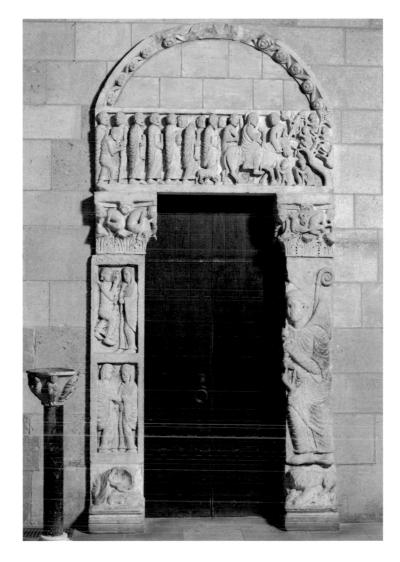

Elements of the San Leonardo doorway abandoned near Nice, ca. 1962

The church of San Leonardo al Frigido is situated near the juncture of roads leading to two great pilgrimage destinations of the Middle Ages: Rome, and Santiago de Compostela, in northwestern Spain. In 1879 this doorway was still standing at the entrance to the ruined church, but by 1893 it was in Countess Benkendorff-Schouvaloff's villa near Nice. In 1962 it was found in pieces in a field near that city (left) and was purchased by the Museum.

The stone carvings decorating the doorway are from different periods and by different sculptors. The two doorposts are recarved from an antique sarcophagus (excluding the capitals and bases), with scenes of the Annunciation and Visitation on the left, and, on the right, a depiction of Leonard, patron saint of prisoners, holding a

miniature figure with chained feet. The bases are postmedieval. On the lintel, which some have attributed to the workshop of the Pisan Master Biduino, is the Entry into Jerusalem (Matthew 21:1–9): Christ, riding a donkey, is greeted by four children in a tree, while two others lay garments on the road before him. The apostles, some holding objects and some singing, walk with a tonsured Leonard in a liturgical procession. That Leonard, a locally revered saint, is included in the procession seems to invite viewers to imagine themselves walking alongside Christ on a spiritual pilgrimage to Jerusalem.

17 | Game Piece with Hercules Slaying the Three-Headed Geryon

Germany, Lower Rhineland, Cologne, ca. 1150 Walrus ivory Diam. 2³/₄ in. (7 cm) The Cloisters Collection, 1970 (1970-324.4)

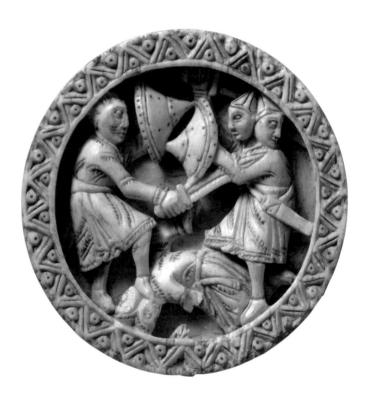

This carved disk was originally part of a set of thirty pieces made for the board game known as "tables," a precursor of backgammon. Classical and biblical themes are seen frequently on surviving tablemen, including episodes from the stories of Hercules and Samson, suggesting that these ancient heroes often represented opposing sides in the game. Here, Hercules, at left, is shown killing the three-headed monster Geryon—his tenth Labor. The monster, now slain, is represented again at the bottom of the scene. Like many other examples this tableman retains traces of paint. Color allowed one side to be easily distinguished from the other side, which was often left unpainted.

18 | Plaque with the Pentecost

South Lowlands, valley of the Meuse, ca. 1150–60 Copper gilt and champlevé enamel $4\frac{1}{8} \times 4\frac{1}{8}$ in. (10.3 × 10.3 cm) The Cloisters Collection, 1965 (65.105) The dignified figure of Saint Peter, flanked by other apostles, sits at the center of this exceptionally fine, well-preserved plaque. The hand of God appears above him radiating red and white lines. The scene represented here is the Pentecost, when, fifty days after Easter, the apostles were gathered and "... suddenly there came a sound from heaven, as of a mighty wind coming, and it filled the whole house where they were sitting. And there appeared to them parted tongues as it were of fire, and it sat upon every one of them" (Acts 2:2–3).

The plaque is one of a group of twelve enamels, all measuring close to ten centimeters square, divided between the Metropolitan

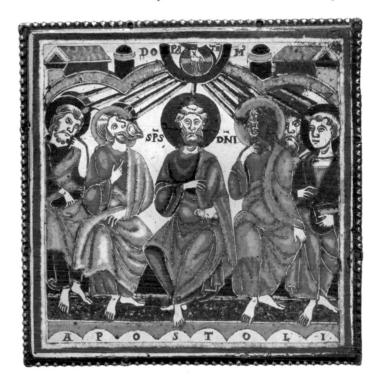

and several European museums. The group depicts scenes from the Old and New Testaments and must have originally decorated a large object in a church, such as an altarpiece or a pulpit. Together they demonstrate the high quality achieved by Mosan enamelers as well as the complexity of the monuments they created. As seen here, the faces of the apostles are fluidly engraved in a style that recalls drawing in pen and ink, while the drapery and architectural elements are marvelously rendered in a rich palette of more than twelve colors. The translucency of some of the enamel allows for the reflective play of light off metallic foil beneath.

19 | Pair of Doors with Ironwork

France or Spain, Pyrenees, 12th century Oak and iron 9 ft. 6 in. \times 39 ½ in. \times 2 in. (289.6 \times 100.3 \times 5.1 cm) The Cloisters Collection, 1925 (25.120.291, .292)

When closed and bolted, these massive doors provided considerable defense against weapons such as battering rams and other war machines. Their vertically arranged oak planks are reinforced with spiked iron bands on the exterior and crossbeams on the interior. Except for the fifteenth-century lock, the doors and ironwork are believed to have come from a twelfth-century building in the Pyrenees. The twenty-four iron bands affixed horizontally to the doors are pierced with geometric patterns such as diamonds, dots, and rectangles. The terminals of the bands are decorated with fanciful motifs resembling animal heads, treetops, or wheels. The wheel-shaped terminal directly above the lock contains an image of the crucified Christ.

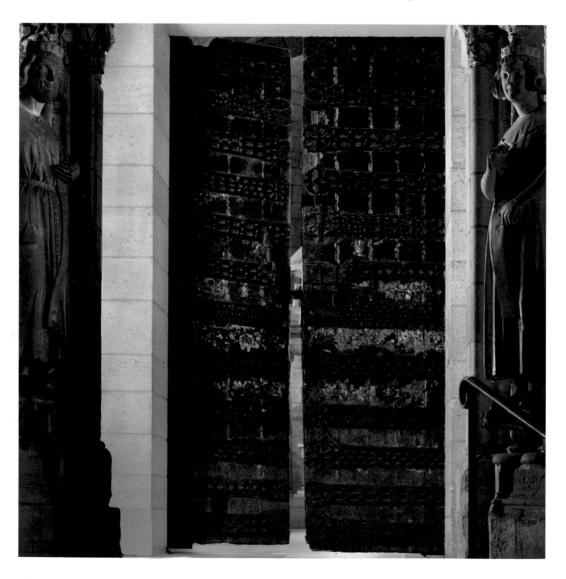

20 | Chapel from Notre-Dame-du-Bourg at Langon

France, Aquitaine (Gironde), after II26 From the church of Notre-Dame-du-Bourg at Langon, near Bordeaux Limestone 22 ft. $4\frac{1}{2}$ in. × 16 ft. $5\frac{1}{2}$ in. (682 × 502 cm) overall Rogers Fund, I934 (34.II5.I-.269)

Parts of this chapel-like gallery were constructed with twelfth-century limestone blocks from the church of Notre-Dame-du-Bourg at Langon, located about nineteen miles east of Bordeaux. According to one seventeenth-century document, the small parish church—which had a single-aisle nave, slightly projecting transepts, and a semicircular apse—was founded in 1126 as a dependency of the nearby abbey of Notre-Dame-de-la-Grande-Sauve (see no. 28). Seven capitals from the crossing and choir of Langon are installed in this gallery, all of them decorated with human heads or figures carved almost in the round. The crowned female bust on one of the capitals has often been identified as Queen Eleanor of Aquitaine (1122?—1204),

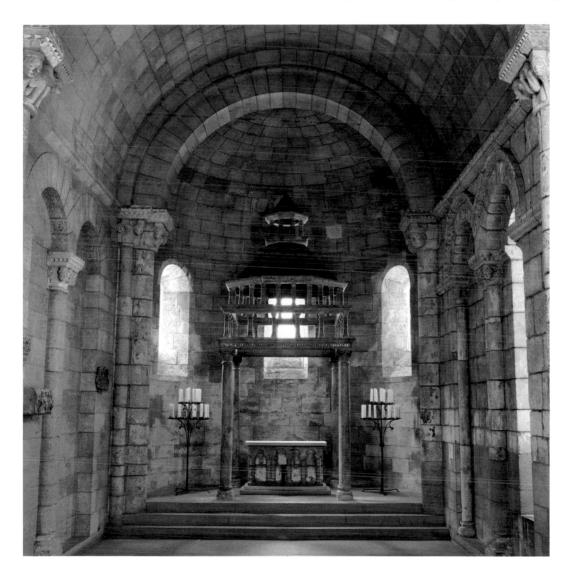

Sacks of tobacco hanging in the upper level of the former chapel, 1934

one of the most remarkable women of the Middle Ages. However, other than a trip she took to the region with her husband, King Henry II of England (r. 1154–89), in the 1150s—when they might have spent one night at the nearby Notre-Dame-de-la-Grande-Sauve—there is no documentary evidence that Eleanor ever visited Langon or that the bust was intended to portray her. The blind arches lining the walls (below, left) and the predominantly geometric patterns decorating the abaci, arches, and cornices (below, right) are all characteristic of late-twelfth-century architecture in western France.

Like many religious monuments in France, Notre-Dame-du-Bourg suffered repeated damage, especially from the Hundred Years' War and the French Revolution. By the early nineteenth century the choir had been divided into two levels: the lower served as a stable, while the upper became a dance hall, then a theater. When the Museum purchased the chapel fragments in 1934, the upper level was being used to store tobacco (above). The reconstructed chapel is about three-quarters of its original size.

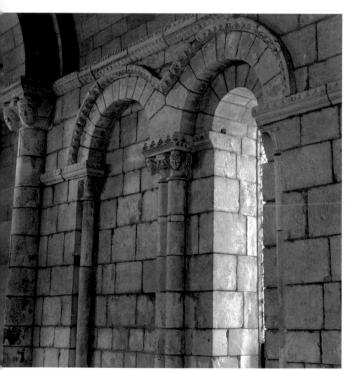

Left: Detail of blind arches, with the so-called busts of Eleanor and Henry II visible on the capital at far left

Below: Detail of capital and abacus

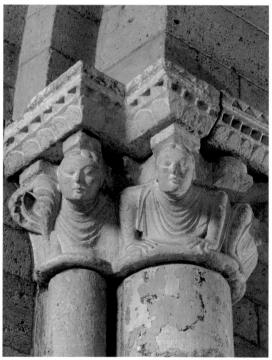

21 | Chapter House from Notre-Dame-de-Pontaut

France, Aquitaine (Landes), 12th century
From the Cistercian abbey of Notre-Dame at Pontaut, south of Bordeaux Limestone, brick, and plaster 37 ft. 9 in. \times 25 ft. 4 in. (II.5 \times 7.7 m)
The Cloisters Collection, 1935 (35.50)

Notre-Dame-de-Pontaut, south of Bordeaux, was founded in III5 as a Benedictine abbey but became a Cistercian house in III5. As in most medieval monasteries, much of the abbey's liturgical and administrative business was conducted in the chapter house, where monks attending daily meetings would have sat on the continuous stone bench running along the walls. The chapter house was also the location for certain liturgies and rituals, such as the annual reenactment of Christ washing the feet of his disciples before Easter. The walls of this chamber are constructed of limestone and brick and lined with engaged columns, each surmounted by a capital decorated with plant, animal, or geometric motifs. Two freestanding monolithic columns support the rib vaults above. Typical of monastic plans, the room opens onto the cloister walk through three large arches.

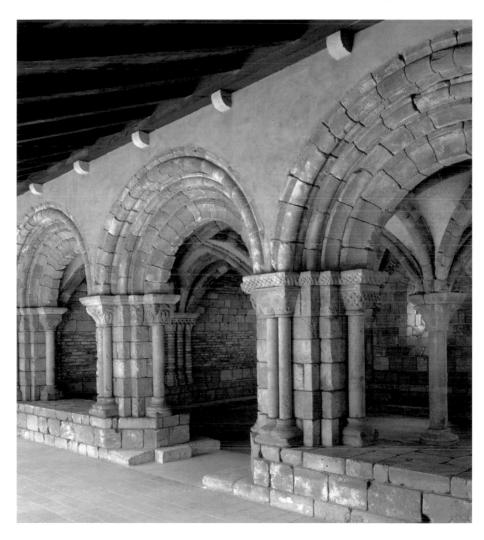

Much of Notre-Dame-de-Pontaut was damaged during an attack by the Huguenots in 1569, including the floor above the chapter house, where the dormitory might have been located. Following the sale of the monastic buildings to a local family, the chapter house was converted into a stable (below). It was purchased in 1932 by Parisian dealer Paul Gouvert, who sold it to the Metropolitan two years later. Although the tile floor and the plaster vaults are modern replacements, the rest of the chapter house has been reconstructed with original materials.

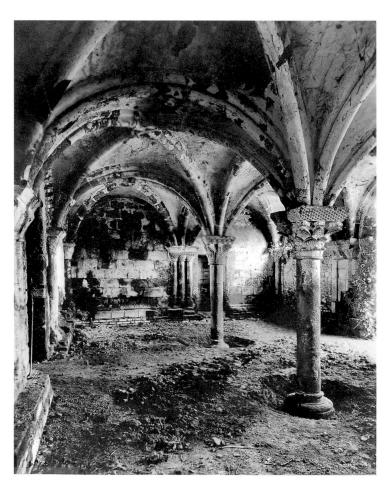

Chapter house from Pontaut serving as a stable, 1930

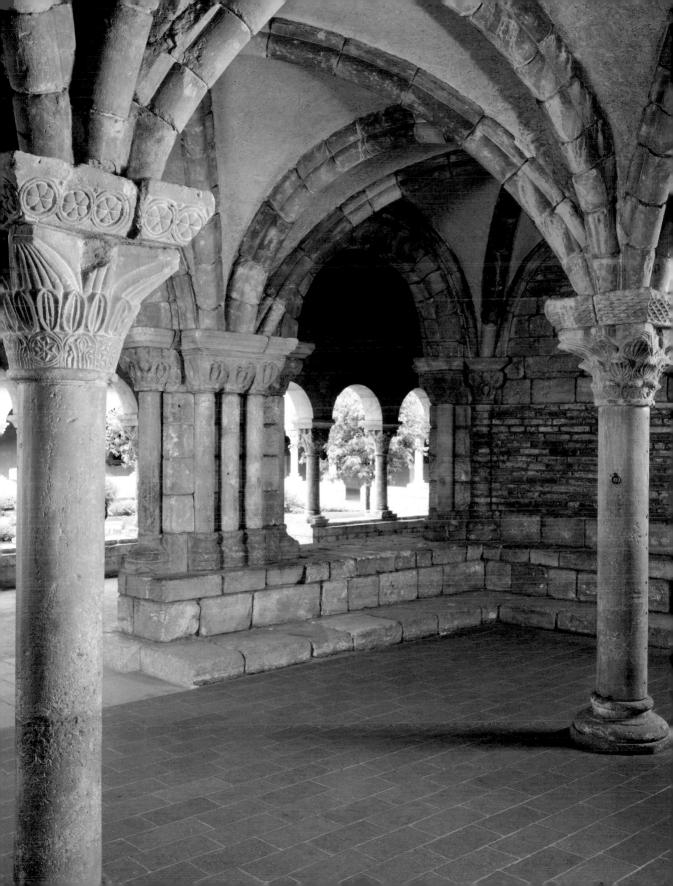

England, Suffolk, ca. 1150–60 Possibly from the abbey at Bury St. Edmunds Walrus ivory with traces of paint $22\frac{5}{8} \times 14\frac{1}{4}$ in. (57.5 \times 36.2 cm) The Cloisters Collection, 1963 (63.12)

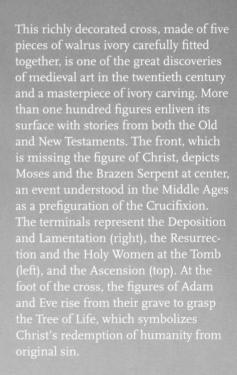

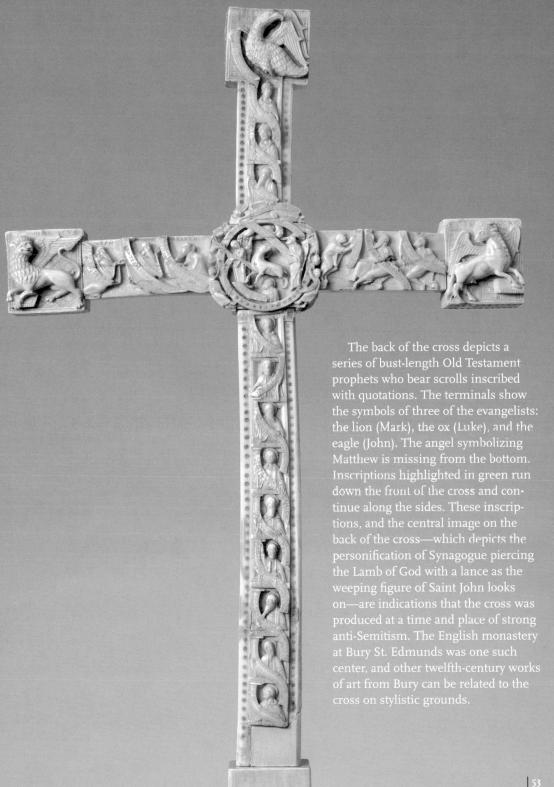

23 | Martyrdom of Saint Lawrence

England, Kent, ca. 1175–80 From Christ Church Cathedral at Canterbury Pot-metal glass and vitreous paint $25\frac{1}{2} \times 12\frac{5}{8}$ in. (65 × 32 cm) The Cloisters Collection, 1984 (1984.232) In scenes of his martyrdom Saint Lawrence is most often depicted stretched out on a gridiron (or grill). Here, however, Lawrence is shown in an attitude of supplication, an image inspired by the writings of Saint Augustine and Saint Ambrose. These doctors of the church contended that Saint Lawrence overcame the external fire—the red flames seen licking at his feet—by the power of three fires within: the ardor of faith, the love of Christ, and the true knowledge of God. These internal fires are represented by the two horizontal bands of rose-colored flame and the flame above Lawrence's head.

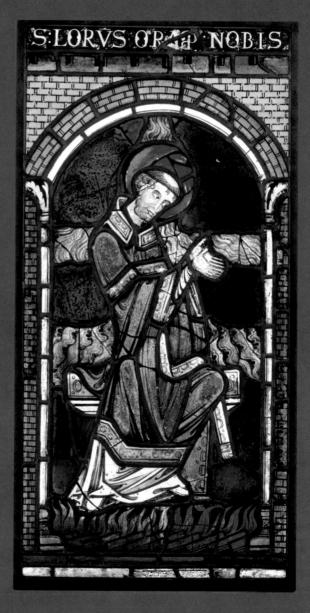

In its architecture and decoration, including an important program of stained-glass windows, Christ Church Cathedral at Canterbury is a major monument of the transitional style between Romanesque and Gothic that emerged about 1200. The importance of Canterbury increased dramatically after the murder of its archbishop, Thomas Becket, in 1170. Becket was canonized only three years later, and his tomb quickly became an important destination for pilgrims.

24 | Initial V from a Bible

France, Burgundy (Yonne), ca. 1175–95 From the abbey at Pontigny Tempera on parchment $10\% \times 6$ in. $(27.5 \times 15.2$ cm) The Cloisters Collection, 1999 (1999.364.2)

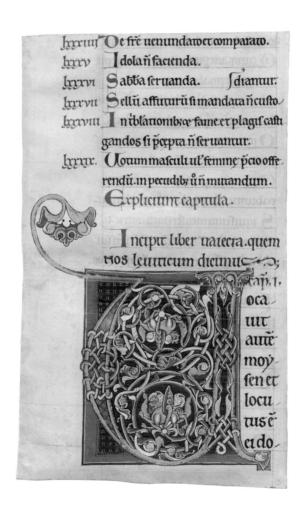

The Bible that originally contained this initial and a second example at The Cloisters has been lost. Both initials were removed from the manuscript, undoubtedly by an admiring collector, sometime during the nineteenth century. The *V*, which encloses two energetic lions amid vibrant foliage, marked the opening of the Book of Leviticus: "Vocavit autem Moysen et locutus est ei Dominus de tabernaculo"

(And the Lord called Moses, and spoke to him from the tabernacle).

Impressively large multivolume Bibles (some nearly twenty inches or more in height) are among the greatest achievements of twelfth-century manuscript illumination, and the Cistercian abbey of Pontigny in the diocese of Sens—where the Bible that once contained this initial came from—was renowned in the twelfth century for its collection. The monastery was a haven for the exiled English prelate Thomas Becket after his dispute with King Henry II of England and just before his martyrdom in Canterbury Cathedral in 1170. During the French Revolution the library at Pontigny was confiscated, the fate of so much French ecclesiastical art.

25 | Plaque with Censing Angels

France, Limousin (Haute-Vienne), Limoges, ca. 1170–80 Champlevé enamel and copper gilt $4\frac{3}{8} \times 8\frac{3}{4}$ in. (II × 22.I cm) The Cloisters Collection, 2001 (2001.634)

The two mournful, half-length angels on this plaque are set against stylized clouds and a brilliant gilt background engraved in a delicate scrolling pattern known as vermiculé. As they swing censers, the angels incline their heads to look down on what once was the crucified figure of Christ below. The plaque originally decorated what must have been one of the largest crosses produced in the prolific workshops of Limoges. The power of the design, the richness of the enameling, the control of the engraving, and the fine stippled decoration that accents the gilded lines of copper testify to the extraordinarily accomplished work made in that city by the end of the twelfth century. Judging from the size of surviving Limoges crosses, it is estimated that the cross embellished with this plaque would have stood at least four feet high. Although no cross of a size even approaching that survives, documents attest to the presence of monumental enameled crosses in Limoges and the surrounding

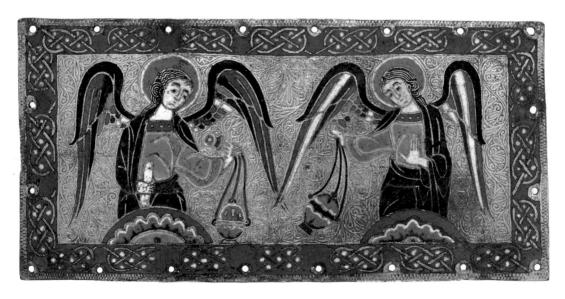

area. Three other surviving pieces from the cross are known: from the bottom, a plaque depicting Adam rising from his tomb (Museo Sacro Vaticano, Vatican City), and from the lateral terminals the mourning figures of Saint John the Evangelist and the Virgin (British Museum, London).

26 | Reliquary Cross

France, Limousin (Haute-Vienne), Limoges, ca. 1180 Silver gilt, crystal, and glass cabochons; wood core $11\frac{1}{4} \times 4\frac{7}{8} \times 1$ in. (29.8 × 12.5 × 2.5 cm) with tang Purchase, Michel David-Weill Gift, The Cloisters Collection, and Mme. Robert Gras Gift, in memory of Dr. Robert Gras, 2002 (2002.18)

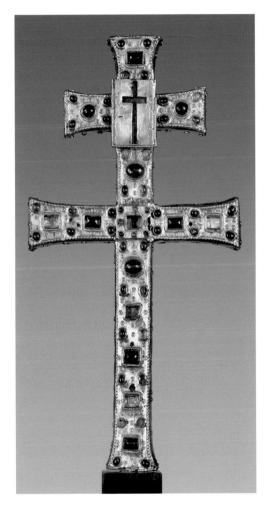

This well-preserved. double-armed silver reliquary cross is bejeweled on both sides with more than sixty glass cabochons. The surface is further embellished with twisted wire, beading, repoussé florets, and engraved concentric circles. The relics, showcased in the gilded rectangular plaque at the intersection of the upper arm and set behind rock crystal cabochons on the principal face of the cross, are identified in inscriptions engraved on the sides. The most important is a piece of the True Cross, which was reputedly found in the fourth century by Helena, mother of

Constantine the Great, and was thought to be the actual cross on which Christ was crucified. That relic, along with the double-arm form of the cross (derived from early Byzantine examples), underscores the well-known connections with the Holy Land that existed in central France during the twelfth century as a result of the Crusades. Some Romanesque churches in the region, for example, incorporated domes in imitation of the Holy Sepulcher in Jerusalem.

27 | Cloister from Saint-Guilhem-le-Désert

France, Languedoc-Roussillon (Hérault), late 12th century From the abbey church of Saint-Guilhem-le-Désert, near Montpellier Limestone 30 ft. 3 in. \times 23 ft. 10 in. (922 \times 726 cm) The Cloisters Collection, 1925 (25.120.1–.134)

Approximately 140 elements from the abbey church of Saint-Guilhem-le-Désert, such as columns, pilasters, and capitals, were used to reconstruct this cloister. Installed here on the ground level, most of them are in fact believed to have come from the upper level of the original two-story structure. The carving reveals considerable classical influence, especially in the use of motifs such as acanthus leaves and meander patterns. Deep, cylindrical drill holes create a marvelous contrast of light and shadow on the carved surfaces of the stone blocks. Some of the columns and pilasters even resemble tree trunks or scrolling leaves. In addition to a variety of foliate designs, a few of the capitals are decorated with narrative scenes, such as the Presentation in the Temple and the Mouth of Hell (see p. 60).

The cloister was part of a Benedictine abbey founded in 804 by Guilhem, duke of Aquitaine, count of Toulouse, and later saint (canonized 1066). The lower level of the cloister was completed in the early twelfth century, but the upper story, referred to as the "new cloister" (claustrum novum), is not mentioned in documents until 1206. The abbey, a regular stop on the pilgrimage route to Santiago de Compostela in northwestern Spain, suffered severe damage during the Wars of Religion and the French Revolution. By about 1850 some architectural and sculptural components of the cloister had been purchased by Pierre-Yon Vernière, a local judge, for display in his garden (below). In 1906 his heir sold the fragments, which were soon purchased by George Grey Barnard.

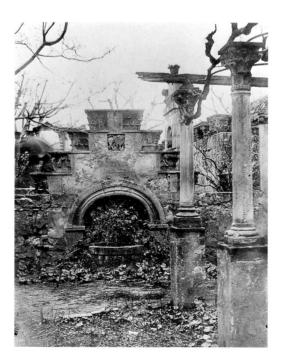

Architectural elements from Saint-Guilhem-le-Désert on display in the garden of Pierre-Yon Vernière, before 1906

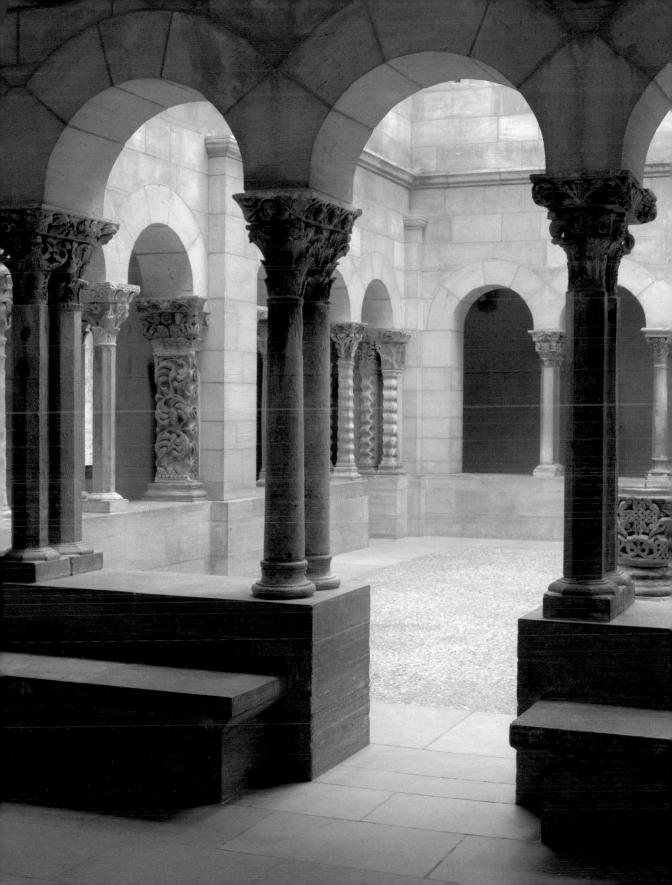

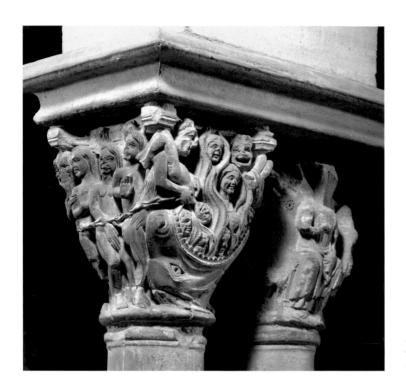

Details of capitals from Saint-Guilhem Cloister, showing the Mouth of Hell (above) and acanthus leaves (below).

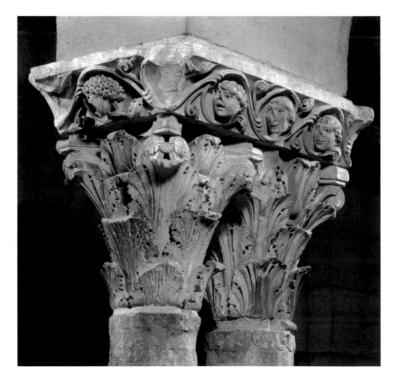

28 | Corbel

France, Aquitaine (Gironde), II50–I200 From the abbey of Notre-Dame-dela-Grande-Sauve, near Bordeaux Limestone $32 \times 15^{\frac{3}{8}} \times 18^{\frac{1}{2}}$ in. (81.3 \times 39.1 \times 47 cm) Gift of George Blumenthal, 1934 (34.21.2)

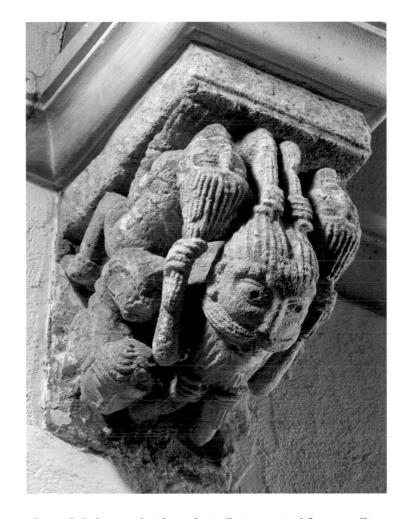

This corbel, decorated with acrobatically intertwined figures pulling at one another's hair, belongs to a group from the Benedictine monastery of Notre-Dame-de-la-Grande-Sauve. They once supported the exterior cornice of the twelfth-century church and are embellished with a wide range of patterns and motifs. Many are still at the abbey; others are in different French and American collections. As a group, the corbels reveal a preference for acanthus leaves, a stylized rendering of anatomy, and a calligraphic treatment of hair, mane, and other linear details. Of the ten corbels now at The Cloisters, two are decorated with foliate motifs. Several of the others display more mischievous activities, such as hair or beard pulling and mouth poking, and a few are even sexually suggestive, perhaps an allusion to humanity's inner demons and licentious fantasies. Corbels like these enjoyed a lasting popularity and can be found on the exterior of many medieval churches.

29 | Torso of Christ from a Deposition

France, Auvergne (Haute-Loire), late 12th century Said to come from the abbey at Lavaudieu Poplar, gesso, paint, and metal leaf $43 \times 13^{3/4} \times 9^{1/2}$ in. (109.2 \times 34.9 \times 24.1 cm) The Cloisters Collection, 1925 (25.120.221)

This fragmentary but sensitively carved sculpture was for many years considered to be from a crucifix. The position of Christ's body,

however, which is bent slightly at the waist, suggests that the piece more likely was one of a group of sculptures that represented the Deposition, or the removal of Christ's body from the Cross.

Despite major losses, the torso retains great sculptural power arising from the careful modeling of the body and the rhythmic patterns of the drapery. When discovered by George Grey Barnard near Lavaudieu, the piece was being used in a field as a scarecrow. The arms, legs, and (probably) head were originally separate pieces held in place by dowels in mortise-and-tenon joints.

The original paint is obscured by a fourteenth-century overpainting. Examination has revealed that one layer of the loincloth was originally lapis lazuli blue studded with applied tin leaf and a brilliant red lining.

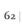

30 | Altar Frontal

Catalunya, Lleida, ca. 1225 From the parish church of Ginestarre de Cardós Wood with gesso, canvas, and paint $37^{3/4} \times 58 \times 2^{3/4}$ in. (95.9 × 147.3 × 7 cm) The Cloisters Collection, 1925 (25.120.256)

The altar, before which the Mass is celebrated, is the most important piece of liturgical furnishing within a church. In a large church there are often many altars—the high altar, in the choir, and several more in various chapels and other spaces. At the center of this altar frontal from the church of Ginestarre de Cardós are the Enthroned Virgin and Child encircled by a mandorla, which is supported by four angels (the bottom two damaged). Eight apostles, haloed and standing under round arches, accompany the central group. Painted inscriptions along the upper border give the names of six saints: Simon, Jude, Matthew, John, Thomas, and Barnabas. The composition is surrounded by a procession of prancing lions, each enclosed in a roundel. The bottom edge is missing.

This altar frontal was decorated using a technique that sought to imitate the gold or silver frontals made for large cathedrals or wealthy monasteries. To achieve the luxurious appearance of the enamels and gemstones often set into more elaborate examples, the design was molded in low relief in gesso and then embellished with paint.

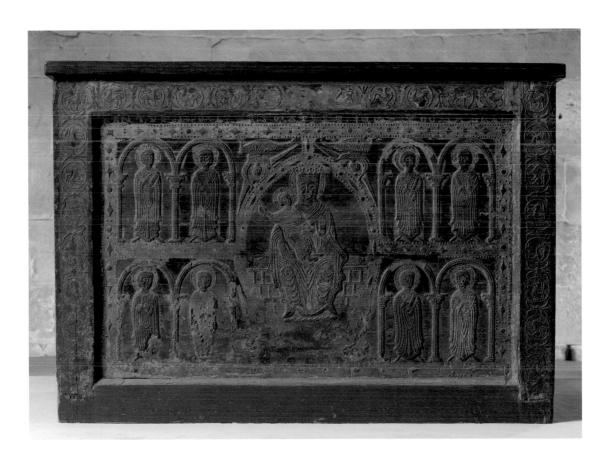

31 | Segment of a Crosier Shaft

North Spain, late 12th century Elephant ivory H. 11 ¹/₄ in. (28.6 cm); Diam. 1 ³/₈ in. (3.5 cm) The Cloisters Collection, 1981 (1981.1)

This richly carved ivory shaft was once a section of a crosier, the staff carried by bishops and abbots as a symbol of their office. The carving is divided into four zones. At the top, Christ is enthroned within a mandorla embellished with bust-length figures of the Elders of the Apocalypse. On the reverse of that register, the Virgin and Child appear enthroned within another mandorla. Filling the two middle registers are angels dressed as deacons. They are set within arcades, and each carries an orb and a staff surmounted by a lantern. The lower register depicts an angel presenting a miter to an enthroned bishop as a kneeling, secular donor hands him his crosier. Because the bishop is not represented as a saint, it seems likely that the scene refers to the installation of a historical bishop.

32 | Bowl of a Drinking Cup

England or Scandinavia, late 12th century Silver, silver gilt, and niello H. 2¾ in. (7 cm); Diam. 6¾ in. (17.1 cm) The Cloisters Collection, 1947 (47.101.31) With its lively nude male figures and dragons entwined in foliage, this bowl was likely part of a secular drinking cup rather than a ciborium (a vessel that holds the Host) or a chalice for use in the Mass, as was once thought. Between the principal compartments inhabited by the nude figures and dragons are smaller areas with

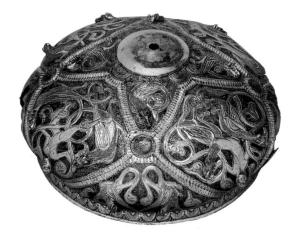

basilisks. The heads of the men and beasts are in high relief, and the bands between the compartments and the palmette frieze below the rim are crisply rendered. The decoration of the bowl has parallels in twelfth-century English art, but similar pieces have also been found in Sweden This example was discovered near the Ob' River in Siberia, an indication of how objects in the Middle Ages sometimes circulated far from their place of manufacture.

33 | Clasp

South Lowlands, valley of the Meuse, about 1200 Gilt copper alloy $2\frac{1}{8} \times 2\frac{7}{8} \times \frac{5}{8}$ in. (5.4 × 7.3 × 1.6 cm) The Cloisters Collection, 1947 (47.101.48)

Richly decorated and probably destined for secular use, this clasp depicts an enigmatic scene. A crowned male figure holding an orb is enthroned at right, his feet resting on the back of a lion, as a kneeling attendant places a hand on his shoulder. On the other side

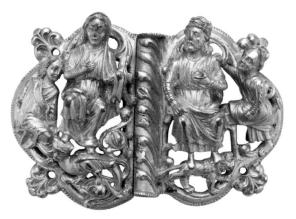

is a veiled female figure, also accompanied by an attendant, resting her feet on a basilisk. Although the couple has sometimes been seen as Solomon and Sheba or as Esther and Ahasuerus, no conclusive identification has emerged. Compositionally, the figures recall late-twelfth-century depictions of the Coronation of the Virgin. The stylistic features of the clasp, such as the drapery drawn tight around the figures and the foliage they inhabit, can be compared to goldsmith works produced in the Meuse valley about 1200.

34 | Relief with the Annunciation

Italy, Tuscany, ca. 1180-1200 From the church of San Piero Scheraggio in Florence Marble and serpentine $26\frac{1}{2}\times24\times4\frac{3}{4}$ in. $(67.3\times61\times12.1$ cm) The Cloisters Collection, 1960 (60.140)

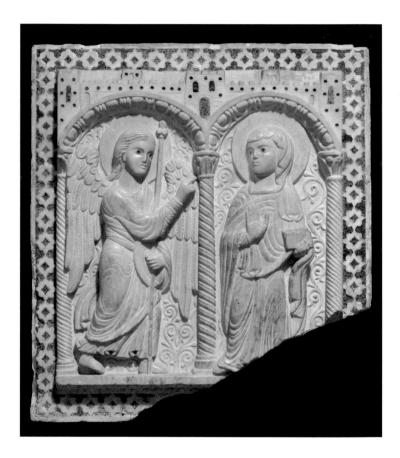

The pulpit was a prominent element in the medieval church. It was usually raised on columns above the choir and, during the Middle Ages, used for readings from the Gospels and the Epistles. In this panel from a pulpit, the Archangel Gabriel announces to the Virgin that she will be the mother of Christ. The figures appear beneath an elaborate arcade supported by twisted columns; the arches are embellished with egg-and-dart molding and surmounted by a design evoking a city wall. The marble relief, with its decorative border inlaid with serpentine, is characteristic of Tuscan sculpture at the

end of the Romanesque period (about 1200). It is one of seven figurative carvings from a rectangular pulpit originally in the Florentine church of San Piero Scheraggio (now incorporated into the Uffizi). In 1782 the other six panels were moved to the suburban church of San Leonardo at Arcetri.

35 | Lion Passant

Spain, Castilla-León (Burgos), after 1200
From a room above the chapter house of the monastery of San Pedro de Arlanza, near Burgos
Fresco transferred to canvas 7 × 11 ft. (213 × 335 cm)
The Cloisters Collection, 1931 (31.38.1a, b)

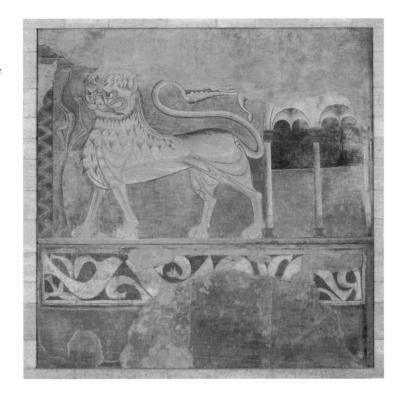

The Benedictine monastery of San Pedro de Arlanza, in northern Spain, was founded in 912 by Fernán González, count of Castile. A two-story square structure stood southeast of the monastic church. The ground level of that building served as the chapter house; the room on the upper level was decorated with an extensive fresco cycle, including this mustachioed, prancing lion. The beast is framed within a rectangular field set against a background of solid bands of earth tones. Human and animal figures, both realistic and fantastic, fill the horizontal borders below the lion and its companion piece, which depicts a winged dragon. The Cloisters' lion was half of an imposing pair of lions on the east wall (the other is in the Museu Nacional d'Art de Catalunya, Barcelona). The Cloisters' dragon faced a griffin (also in Barcelona) across a double window on the south wall.

Although the date for the construction of the building is unknown, the style and subject matter of the frescoes suggest they were executed in the early thirteenth century. The frescoes were hidden beneath a layer of plaster applied as part of an eighteenth-century renovation and were only rediscovered in 1894, when a fire destroyed some of the plaster. By that time the monastery was already in private hands. The frescoes, along with everything else on-site, were removed and sold in the late 1920s to different institutions and private collectors.

36 | Doorway from Notre-Dame at Reugny

France, Loire Valley (Indre-et-Loire), late 12th century From the church of Notre-Dame at Reugny, near Clermont-Ferrand Limestone 14 ft. $9^{3/4}$ in. \times 11 ft. $2^{5/6}$ in. $(452 \times 342 \text{ cm})$ Gift of George Blumenthal, 1934 (34.120.1-.120)

Priory of Notre-Dame at Reugny, 1920

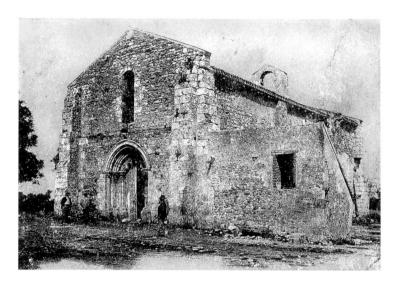

This doorway once stood on the west facade of the small Augustinian priory of Notre-Dame at Reugny (above), not far from Clermont-Ferrand in central France. The three pairs of columns flanking the door have molded archivolts above them, which form a gently pointed arch typical of the mid- to late twelfth century. A five-lobed arch crowns the door opening; on the tips of its four cusps are the symbols of the Four Evangelists, and four flowerlike decorations adorn the spandrels in between. The remnant of a statue is visible on the right jamb.

The doorway belongs to a sizable yet little-known group of polylobed doorways, typically having about three to seven lobes, found in central France. Sometime after 1920 this example was sold to George Blumenthal, who installed it in his Paris home as the main entrance to his freestanding "Salle de Musique." In 1934 Blumenthal donated the doorway to The Cloisters, where it now stands at the entrance to the Saint-Guilhem Cloister.

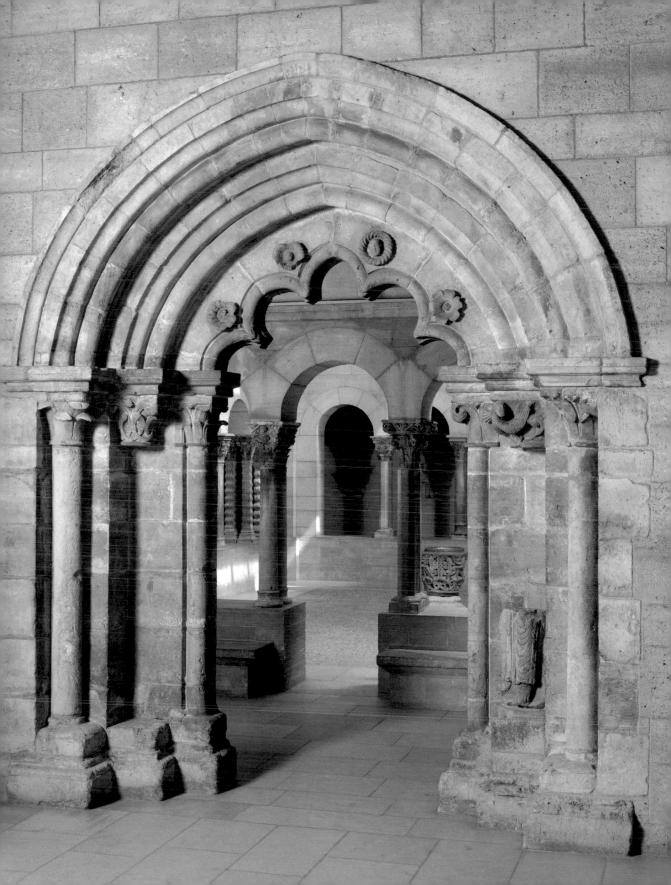

37 | Doorway from Moutiers-Saint-Jean

France, Burgundy (Côte-d'Or), ca. 1250
From the abbey of Moutiers-Saint-Jean, near Dijon
Limestone with traces of paint
15 ft. 5 in. × 12 ft. 7 in. (4.7 × 3.8 m)
The Cloisters Collection, 1932 (32.147)
The Cloisters Collection, 1940 (40.51.1)

The tympanum of this doorway, framed by a trefoil arch, is decorated with the Coronation of the Virgin attended by two kneeling angels. Six other kneeling angels on the surrounding archivolt hold liturgical instruments. On each side of the door is a row of biblical figures in niches. Two large crowned figures, identified in a 1567 description as the Merovingian kings Clovis and Clothar, stand before the jamb columns. According to the same document, the doorway, from the monastery of Moutiers-Saint-Jean, probably served as the south transept portal, facing the cloister.

Founded in the sixth century by followers of Saint John of Réome, Moutiers-Saint-Jean and its archives suffered severe damage during the Wars of Religion and the French Revolution. Our knowledge of the abbey and its physical appearance can only be gleaned from the handful of drawings produced by the Maurist brothers whose

congregation took over the monastery in the mid-1630s. In 1797 the surviving remains of the monastery were sold into private hands; it was probably during this period that the doorway, without the royal figures, was refitted for a farm structure (left). In the 1920s the owner of the farm sold the doorway, which entered The Cloisters' collection in 1932. The figures of Clovis and Clothar, decapitated probably in the eighteenth century and variously reassembled since, were acquired from a different owner eight years later.

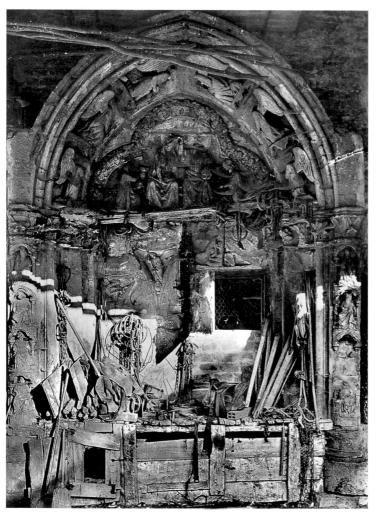

Doorway from Moutiers-Saint-Jean fitted into a farm building, 1929

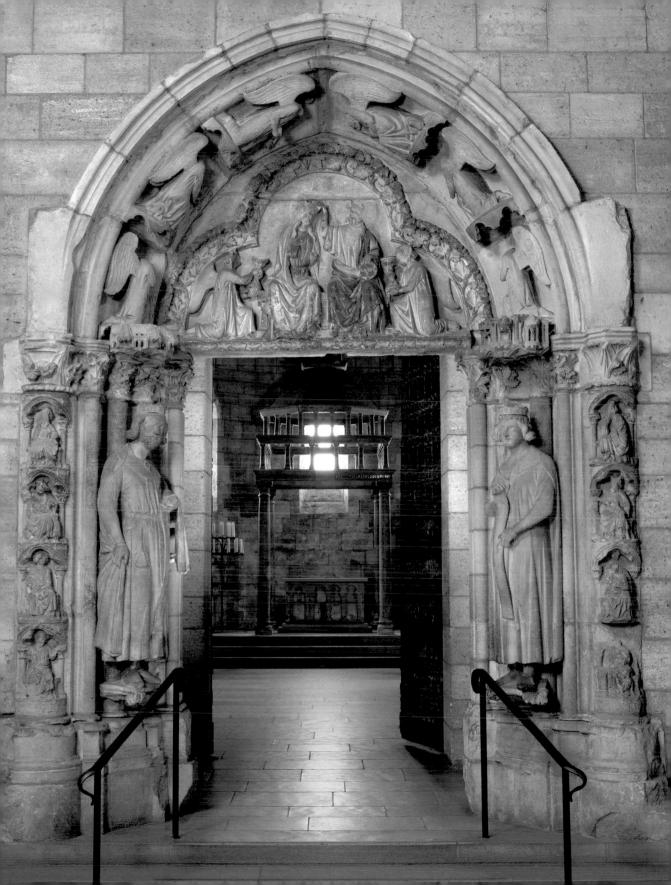

38 | Theodosius Arrives at Ephesus

France, Normandy (Seine-Maritime), ca. 1200–1205 From the nave aisle of the cathedral of Notre-Dame at Rouen Pot-metal glass and vitreous paint $25\times28^{1/8}$ in. $(63.5\times71.5$ cm) The Cloisters Collection, 1980 (1980.263.4) This panel is part of an extensive cycle depicting the legend of the Seven Sleepers, who, having converted to Christianity during the time of the Roman emperor Decius (r. 249–51), hid in a cave near Ephesus in Asia Minor to avoid being persecuted. As Roman soldiers sealed the cave with a boulder, God answered their prayers for safety by putting the group into a deep sleep. Awakening two centuries later in the reign of the Christian emperor Theodosius II (r. 408–50), one of the Seven Sleepers tried to buy bread with an obsolete gold coin and was thought to be a thief. Only after the Sleepers had been brought before the authorities was their story recognized as a miracle.

The cycle was originally made for side-aisle windows in the nave of the cathedral of Notre-Dame in Rouen in the early thirteenth century. Side-aisle chapels were added in the 1270s, so the glass was refitted in the windows of the new chapels. This one depicts Theodosius arriving at Ephesus to visit the Sleepers. The lively gestures and vivid colors attest to the superb quality of the glass, ranked among the best cycles of the period.

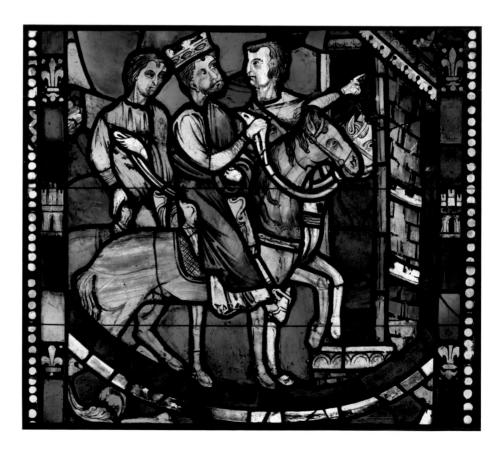

39 | Scenes from the Life of Saint Nicholas

France, Picardy (Aisne), ca. 1200–1210 From the cathedral of Saint-Gervais-Saint-Protais at Soissons Pot-metal glass and vitreous paint $21\frac{1}{2}$ 8 × 16 in. (54.2 × 40.7 cm); $21\frac{1}{2}$ 2 × 16 $\frac{1}{4}$ 4 in. (54.6 × 41.3 cm) The Cloisters Collection, 1980 (1980.263.2, .3)

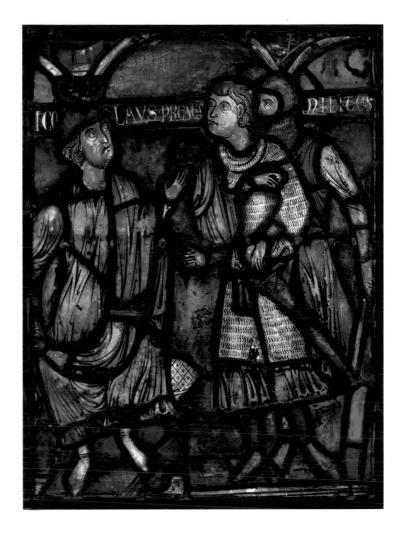

This scene and the one on the following page illustrate an carly episode in the life of Saint Nicholas, soon after he was elected bishop of Myra in Asia Minor in the fourth century. The one above shows two knights, identified by their shirts of mail, being falsely accused of treason and condemned to death by the consul. A third knight, the right arm of the consul, and the beginning of the inscription—[s n]ico/lavs: pr[a]eses/milites (Nicholas protects the soldiers)—were lost when the panel was cut down at an undetermined time. In the second scene, Nicholas responds to the knights' prayers by appearing before the consul to plead for their release. A palace guard looks on from the left.

The panels probably came from an ambulatory chapel dedicated to Saint Nicholas in the cathedral of Soissons, whose choir was under construction in the 1190s. This type of composition, in which

each narrative element is framed under an arcade, is among the earliest known examples of its kind and is strongly associated with Soissons. The elegant figural style and flowing drapery patterns exemplify a classicizing trend found in northern France from the late twelfth through the early thirteenth century.

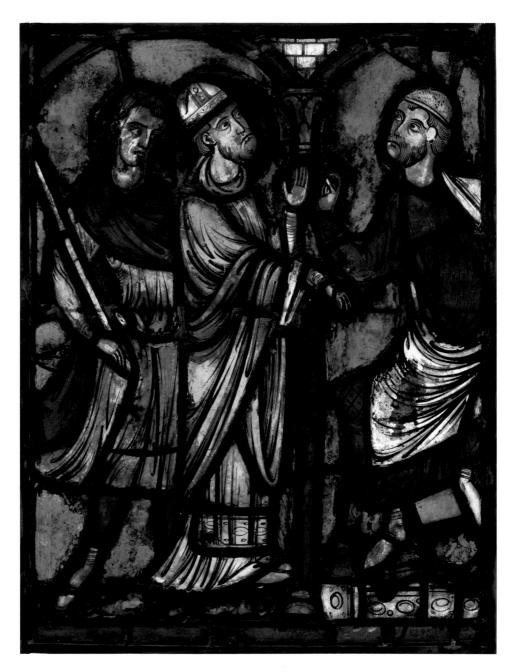

40 | Chalice

Northern Europe, possibly valley of the Meuse, dated 1222 Silver and silver gilt H. 7½ in. (19.1 cm); Diam. 5¾ in. (13.7 cm) The Cloisters Collection, 1947 (47.101.30)

The Latin inscription on the foot of the chalice reads: AD HONOREM B. MARIE VIRGINIS F. BERTINUS ME FECIT AO MCCXXII (In honor of the Blessed Virgin brother Bertinus made this in the year 1222). The inscription is remarkable because historians of medieval art rarely have the advantage of a date or the name of a patron or maker. It is all the more frustrating, then, that brother Bertinus has not been further identified, and that the place where this chalice was manufactured thus remains unknown. The style, apparent in the richly decorated knop with encircling dragons, is closely related to the metalwork production in the Meuse valley, in present-day Belgium. Mosan metalworkers were widely admired, though, so it is possible the chalice was produced elsewhere in northern Europe by a silversmith imitating the Mosan style.

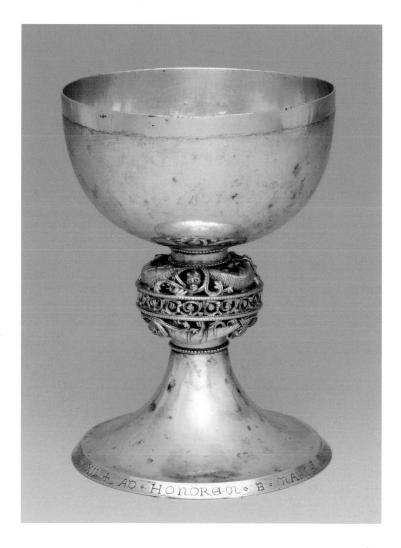

41 | Arm Reliquary

South Lowlands, valley of the Meuse, ca. 1230 Silver and silver gilt over wood core, niello, and gems $25\frac{1}{2} \times 6\frac{1}{2} \times 4$ in. (64.8 × 16.5 × 10.2 cm) The Cloisters Collection, 1947 (47.101.33)

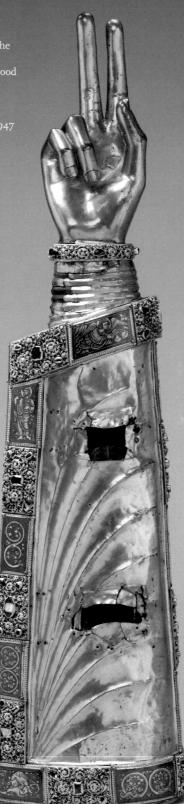

Documents tell us that reliquaries in the form of hands and arms were made beginning in the early Middle Ages. Traditionally such reliquaries contained relics of the part they represented. In this example the hand gestures in benediction, with the thumb and first two fingers raised. The sanctity of the relics, regardless of their type, would have served to increase the sacral power of this gesture. The two large holes in the arm served as cavities for the relics (now lost) and were probably originally covered with artistically by a series of fine filigree and niello plaques, which compare closely with Mosan work of about 1230. Some of the niello plaques are purely decorative in figurative images such as Saints Peter and Paul.

42 | Chalice, Paten, and Straw

Germany, Upper Rhineland, probably Freiburg im Breisgau, ca. 1230–50 From the Benedictine monastery of Saint Trudpert at Münsterthal, near Freiburg im Breisgau Silver, silver gilt, niello, and jewels Chalice: H. 8 in. (20.3 cm); Diam. 7¾ in. (19.7 cm) Paten: Diam. 8¼ in. (22.2 cm) Straw: H. 1 in. (2.5 cm); W. 8½ in. (21.6 cm); Diam. ¼ in. (0.6 cm) The Cloisters Collection, 1947 (47.101.26–29)

The chalice, paten, and straw were all used to celebrate the Eucharist, the commemoration of Christ's sacrifice by the taking of consecrated bread and wine believed to be transformed into his body and blood during Mass. The chalice contained the consecrated wine, which was sipped with the straw to prevent spilling even a drop, and the paten held the bread. The four Old Testament scenes represented in relief on the foot of this chalice were seen as prefigurations of the New Testament scenes on the knop above: Moses and the Burning Bush (the Annunciation); the Flowering of Aaron's Rod (the Nativity); Noah's Ark (the Baptism of Christ); and Moses and the Brazen Serpent (the Crucifixion). The niello decoration on the exterior of the bowl represents Christ enthroned with the standing figures of the Twelve Apostles. The paten includes a half-length figure of Christ holding a chalice and the Host. He is flanked by the Old Testament figures Abel, offering a lamb, and Melchisedech, clad as a bishop and raising a chalice. The fourth figure on the paten is Saint Trudpert, who holds a martyr's palm, indicating that this set of implements comes from the monastery of Saint Trudpert, near Freiburg im Breisgau.

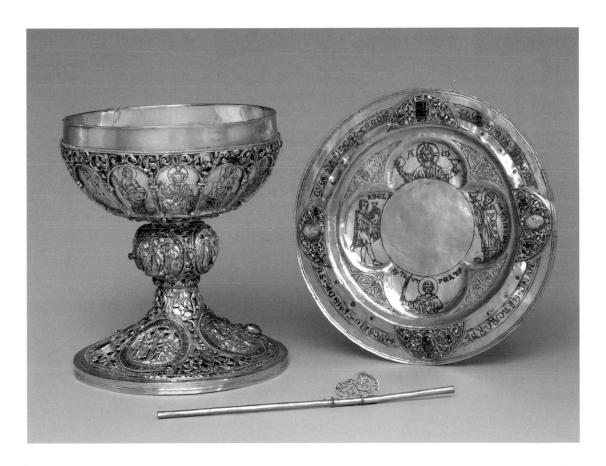

43 | Virgin

Germany (modern France), Alsace, ca. 1250
From the former choir screen of the cathedral of Strasbourg
Sandstone with original paint
H. 58½ in. (148.6 cm)
The Cloisters Collection, 1947
(47.101.11)

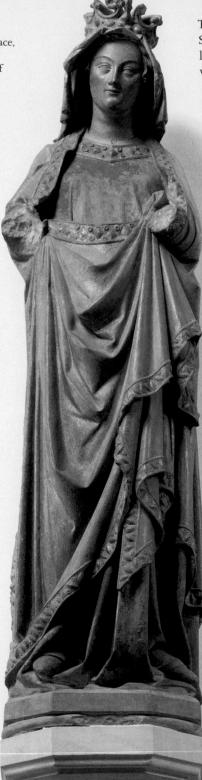

The monumental choir screen at Strasbourg Cathedral, where this almost lifesize statue of the Virgin once stood, was demolished in 1682 in response to changing liturgical practices. A 1630 engraving by Isaac Brunn (ca. 1590–after 1657) shows the original appearance of the screen, which stood at

the juncture of the nave and crossing. It was constructed with two parallel rows of seven arches.

Above the arches was a parapet platform decorated with openwork quatrefoils from which announcements were made and sermons delivered. The standing statues, including this Virgin, were installed between the gabled arches facing the nave. Another image from about 1660 (opposite, top) shows our statue as the fourth figure from the left. To her right was the Christ Child (now missing) sitting on a rosebush, a symbol of the Virgin as a "rose without thorns." The now armless Virgin gazes gently at the viewer. The tender expression on her face and the cascading drapery of her robe combine to create a sense of realism that is at once elegant and engaging. The statue is all the more remarkable because much of its painted decoration survives, a reminder that most Gothic sculpture was embellished this way.

Jean-Jacques Arhardt (active 17th century). Choir Screen of Strasbourg Cathedral, ca. 1660. Engraving, 14⁵/8 x 7¹/8 in. (37 x 18 cm). The Elisha Whittelesey Collection, The Elisha Whittelesey Fund, 1951 (51-501.6551 [8])

44 Head

France, Île-de-France, Paris, ca. 1250 Limestone H. 9 1/8 in. (24.5 cm) Purchase, Michel David-Weill Gift, 1990 (1990.132) Scientific analysis of the limestone used for this engaging head, perhaps that of an angel, confirms that it is the same as the stone with which the cathedral of Notre-Damc in Paris was built. The sensitive carving of the smiling face and the deeply cut, lively treatment of the hair link the head to the sculpture on the cathedral's north transept, which dates to about 1245. The well-preserved surface, however, suggests that the head was originally from an interior ensemble, possibly the cathedral's massive jubé, or choir screen (destroyed in the seventeenth century), or, alternatively, the interior of a transept. The head could also have come from another Parisian church of the mid-thirteenth century.

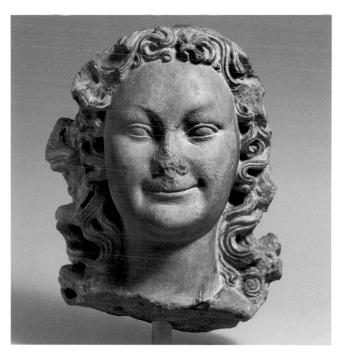

45 | Two Scenes from the Legend of Saint Germain of Paris

France, Île-de-France, Paris, 1247–50 From the former Lady Chapel of the Benedictine abbey of Saint-Germain-des-Prés in Paris Pot-metal glass and vitreous paint $25\frac{1}{8}\times15\frac{3}{4}$ in. (63.8 × 40 cm) each The Cloisters Collection, 1973 (1973.262.1, .2)

Prior to its demolition in 1802, the Lady Chapel of the royal abbey of Saint-Germain-des-Prés was glazed with an extensive program of stained glass. Legends of the Virgin Mary, Saint Vincent of Saragossa, and Saint Germain of Paris, on color-saturated glass, occupied the seven windows in the apse. Ornamental grisaille glass decorated windows along the straight bays. The two panels at The Cloisters depict scenes from the legend of Germain and the history of his relics. In the first panel, a servant girl appears carrying two wine flasks, one of which contains poison. Unaware of the danger, she serves the wine to Germain and his unfortunate companion, who drinks the poison and dies instantly. In the second panel, a dreaming monk is reassured by Germain himself that the saint's relics would remain unharmed during the imminent Norman invasion.

As originally arranged, each narrative scene in the Lady Chapel would have included four glass panels forming a complete oval. Some of these ovals constituted one scene, while in others the top and bottom halves contained one scene each. The ovals were arranged vertically and interlocked by a single quatrefoil at every

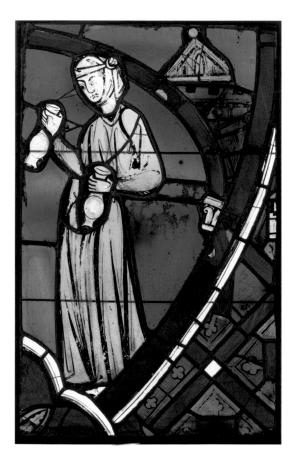

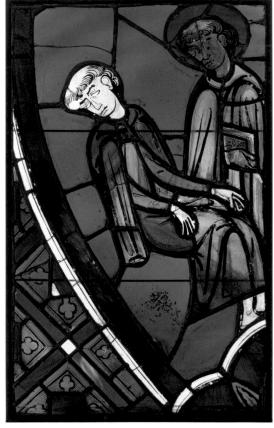

contact point. The Lady Chapel's windows were probably made by an itinerant workshop whose stained glass can be traced to several sites in the Île-de-France.

46 | Enthroned Virgin and Child

France, Île-de-France, Paris, ca. 1260-80 Elephant ivory with traces of paint and gilding $7^{1/4} \times 3$ in. $(18.4 \times 7.6$ cm) Purchase, The Cloisters Collection and Michel David-Weill Gift, 1999 (1999.208)

Paris emerged as the cultural capital of western Europe during the reign of King Louis IX (1226–70), a time when ivory became an important medium for sculpture. Ivory had often been a scarce commodity during the earlier Middle Ages, but it appears that a continuous supply of African elephant ivory was available in Paris beginning about the middle of the thirteenth century until nearly the end of the fourteenth. The delicate features of this Virgin and the sensitively carved folds of her mantle reveal the extraordinary skill of Parisian ivory carvers. Even though the head of the Christ Child is a modern replacement and the statuette has lost all but traces of its original painted and gilded decoration, the work still conveys the intimate communication between mother and child intended by the sculptor.

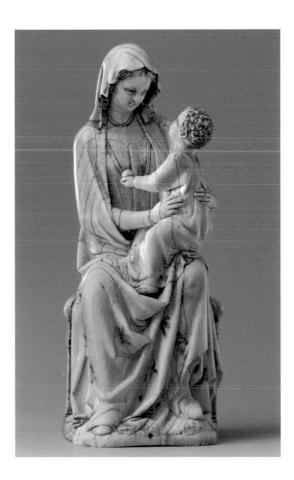

47 | Diptych with the Coronation of the Virgin and the Last Judgment

France, Île-de-France, probably Paris, ca. 1260–70 Elephant ivory $5 \times 5^{1/6}$ in. (12.7 × 13 cm) The Cloisters Collection, 1970 (1970.324.7a, b)

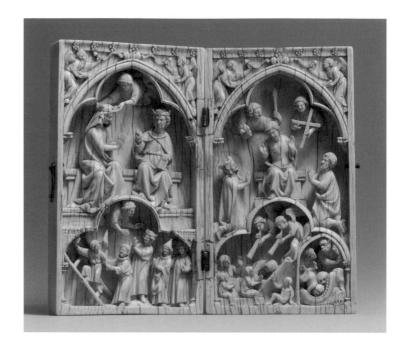

The new market for ivory carving that arose in Paris during the reign of Louis IX was fueled at least in part by the growing demand for works of art to be used for private devotion. The diptych form, seen here, proved ideal because they are highly portable, with the fragile carving protected inside the closed leaves. Thus ivory diptychs, rare in western Europe before the thirteenth century, became relatively commonplace by the fourteenth century.

This example is extraordinary for the fine quality of its deeply carved figures and the vivid imagery. At right, in the upper register, is Christ enthroned in Judgment and displaying the wounds from his Crucifixion. Angels appear bearing the Instruments of the Passion, and the Virgin and Saint John kneel in supplication. Below, trumpeting angels herald the rising of the dead, and the damned are hurled into the Mouth of Hell in the lower right corner. The Coronation of the Virgin is depicted in the upper section of the left leaf, while in the lower section we see the saved—including a friar followed by a king, a pope, and another cleric—being led by an angel up a ladder to heaven.

48 | Enthroned Virgin and Child

England, probably London, ca. 1300 Elephant ivory $10^{34} \times 5^{38} \times 3^{34}$ in. $(27.3 \times 13.5 \times 9.6$ cm) The Cloisters Collection, 1979 (1979.402)

Gothic ivory carving first emerged in Paris and in northern France, but by about 1300 other centers had begun to appear. Although English ivories are comparatively rare, stylistic comparisons with architectural sculptures and with some ivories displaying English coats of arms indicate that this grand statuette was probably carved there. Most of the figure of the Christ Child is now missing, but the remaining part of his leg by the Virgin's left knee suggests that he was probably carved in a lively pose. The cavity in the Virgin's chest may have originally held a jewel, and she was probably seated on a throne made of a different material. The unusually dark color of the ivory might be the result of an application of walnut oil—as recommended by the twelfth-century monk Theophilus in his treatise *On Divers Arts*—or an effect of exposure to extreme heat.

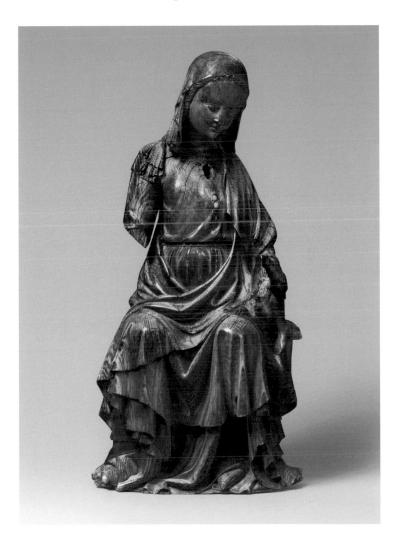

49 | Cloister from Bonnefonten-Comminges

France, Pyrénées-Aquitaine (Haute-Garonne), late 13th or early 14th century
From the Cistercian abbey at
Bonnefont-en-Comminges and
other nearby monasteries
Marble
54 ft. 3 in. × 49 ft. (16.6 × 14.9 m)
The Cloisters Collection, 1925
(25.120.778)

Bonnefont-en-Comminges, a Cistercian abbey, was founded in 1136 by monks from Morimond in Burgundy. The carving style of the twenty-one double capitals from its cloister installed at the Museum is comparable to that found in late-thirteenth- and early-fourteenth-century cloisters in nearby Toulouse. The designs fall loosely into two groups: those with bulbous curled leaves and those with flattened foliage (below). During the French Revolution the abbey archives were burned and its buildings demolished, and many Bonnefont elements eventually found their way into the homes of local residents. The extent of the dispersal is attested by the manner in which the Bonnefont fragments entered the Museum: partly donated by J. P. Morgan (1916), and partly purchased from George Grey Barnard (1925) and Joseph Brummer (1944).

Not copied after any specific model, the layout of the Bonnefont Cloister garden approximates that of a medieval herb garden, with raised beds bordered by bricks and wattle fences. Grouped and labeled according to their medieval usage (e.g., medicinal, culinary, magic, household), all of the plants grown in the garden are species documented in medieval sources, such as the ninth-century *Capitulare de villis vel curtis imperialibus* (Directive for the Administration of Imperial Courts). Of particular interest are the plants used by medieval artists, including those providing pigments for manuscript painting and textile dyeing.

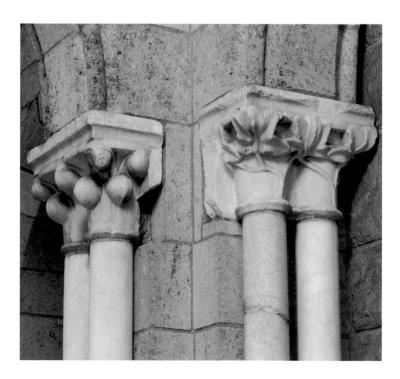

Detail of capitals

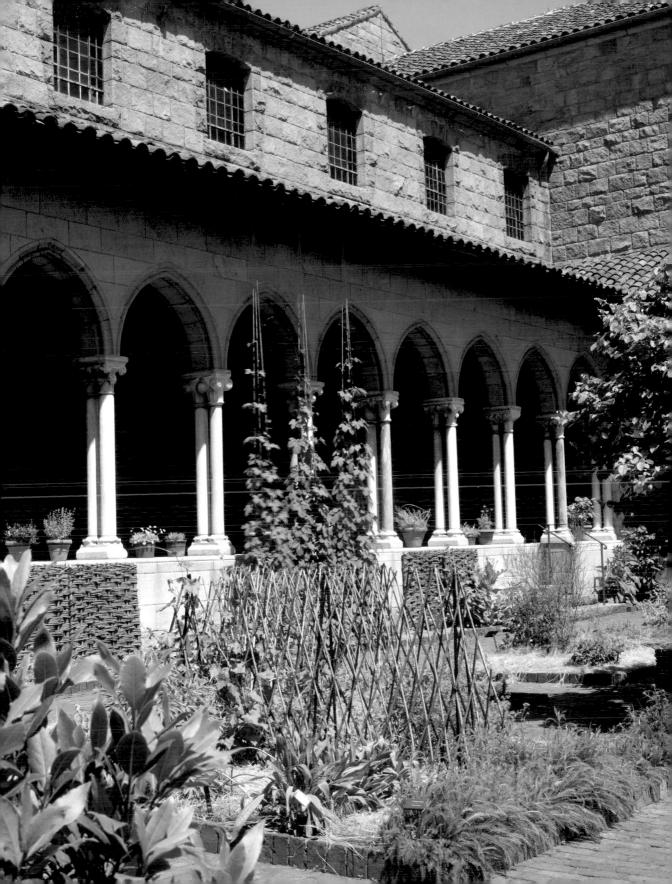

50 | Double-Lancet Window

France, Poitou-Charentes (Vienne), ca. 1275-1300From the church of La Tricherie, near Châtellerault Limestone 13 ft. 6 in. \times 7 ft. $\frac{5}{8}$ in. $(411.5 \times 214.9 \text{ cm})$ The Cloisters Collection, 1934 (34.20.1)

This limestone window from La Tricherie, a small village near Châtellerault (between Tours and Poitiers), is constructed in a style typical of the late thirteenth century. The overall opening is organized into two identical lancets topped by a circle (oculus), which circumscribes a quatrefoil—a basic scheme that first appeared in window designs in the late twelfth century. In this version new elements have been introduced, such as trefoils composed of pointed, rather than rounded, leaf forms. The desire to create a diaphanous effect is evident in the piercing of the remaining surfaces between traceries, which leaves no solid fields in the skeletal structure. Small capitals decorate the vertical members (mullions) of the inscribed lancets. On the interior face the capitals are carved with broad, flattened leaves; on the exterior face the outer two are transformed into whimsical male and female heads.

51 | Tomb Effigy of Jean d'Alluye

France, Loire Valley (Indre-et-Loire), mid-13th century From the Cistercian abbey of La Clarté-Dieu, north of Tours Limestone $83\frac{1}{2} \times 34\frac{1}{2} \times 13\frac{3}{4}$ in. (212.1 × 87.6 × 34.9 cm) The Cloisters Collection, 1925 (25.120.201)

The effigy of Jean d'Alluye shows the knight in full armor, including the surcoat he wears over a long-sleeved mail shirt. His sword hangs from a belt and is partially obscured by a large shield. The arms and armor depicted are typical thirteenth-century chivalric accoutrements, as is his footrest in the form of a lion, a symbol of bravery and valor. The youthful features of the recumbent effigy, a type known as a gisant, are probably idealized portrayals of a knight in his prime rather than a representation of his actual age at death. Jean assumed the title of seigneur of Châteaux and Saint-Christophe in 1209 and returned from a visit to the Holy Land with a fragment of the True Cross. He died before July 1248.

The tomb was once in the Cistercian abbey of La Clarté-Dieu, founded in 1239/40 on a property over which Jean had seigneurial rights. Following the French Revolution, the abbey was destroyed,

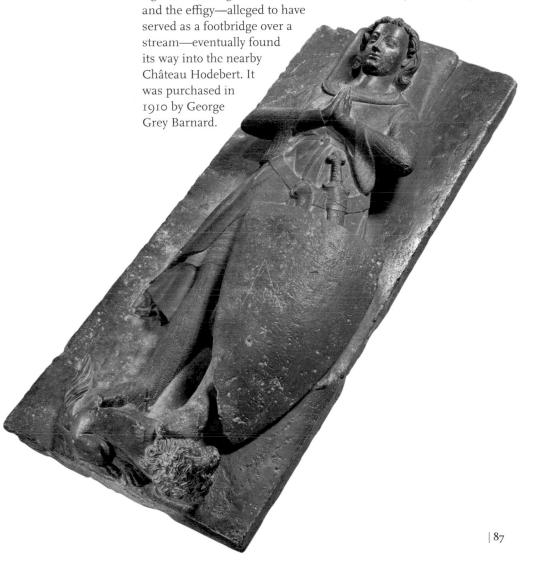

52 | Sepulchral Monument of Ermengol VII, Count of Urgell

Catalunya, Lleida, ca. 1300–1350 From the Premonstratensian monastery of Santa María de Bellpuig de les Avellanes Limestone and traces of paint $89\times79^{1/2}\times35$ in. (226.1 × 201.9 × 88.9 cm) The Cloisters Collection, 1928 (28.95)

This elaborate structure, supported by three stone lions, is the sepulchral monument traditionally associated with Ermengol VII, count of Urgell. The various styles and disparate dimensions of the individual parts of the tomb suggest that it was assembled from elements originally intended for several different monuments. The effigy itself shows the count resting his head on two tasseled cushions, with his eyes closed and his hands crossed above a sheathed sword. A group of mourners, now damaged, is carved into the same slab, just behind the effigy. Below is a carved panel showing Christ in Majesty, at center, accompanied by the Twelve Apostles, all standing under traceried arches. A separate relief above the effigy shows a funeral rite, with three celebrants, at center, standing beneath pointed arches. At the top, on a much smaller rectangular panel, are angels transporting a soul to heaven.

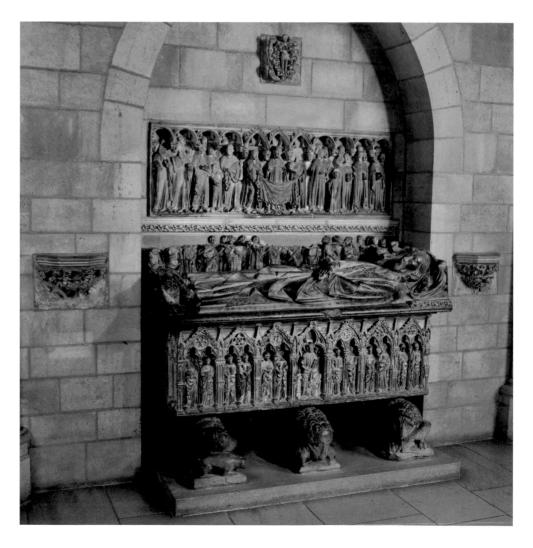

According to tradition, the monastery of Santa María de Bellpuig de les Avellanes was founded by Ermengol VII and his wife, doña Dulcia. Ermengol died in 1184, but not until about 1300 were plans made by Ermengol X to construct a chapel as the family necropolis. Little progress had been made at the time of the latter's death in 1314, and the chapel was not completed until the eighteenth century. The original appearance and intended placement of the tombs can thus no longer be ascertained, but their refined execution ranks them among the outstanding examples of Catalan Gothic sculpture.

53 | Stained Glass with Emperor Henry II and Queen Kunigunde

Austria, Carinthia (Lavanttal), 1340–50
From the choir and north chapel windows of the church of Saint Leonhard at Bad St. Leonhard in Lavanttal, near Klagenfurt
Pot-metal glass, white glass, and vitreous paint 39 × 17³/₄ in. (99.1 × 45.1 cm); 38 ½ × 17½ in. (97.8 × 44.5 cm)
The Cloisters Collection, 1965 (65.96.3–.4)

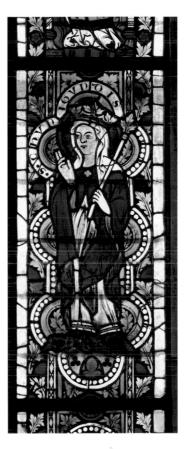

The church of Saint Leonhard was constructed in the early decades of the fourteenth century, with some of its choir and chapel windows in place by 1350. The program of the choir windows included scenes from the life of Christ as well as images of the Twelve Apostles and locally venerated saints. Seventeen panels from six different windows at Saint Leonhard are now installed in three lancet windows in the Gothic Chapel. The center window contains narrative scenes, while more static, iconic images occupy the two flanking windows. Some

of the figures are framed within so-called keyhole medallions: polylobed variations on the traditional circles used as framing devices in France a century earlier. The background is composed largely of foliate motifs and schematic architectural members, providing a colorful, intricate contrast to the heavyset figures often admired for their simple, childlike features.

Standing at the bottom register of the left window are two crowned figures, identified in an inscription as Holy Roman Emperor Henry II (r. 1014–24) and his queen, Kunigunde. They are the patron saints of Heinrich and Kunigunde Kropf, who paid for a window in the choir of the church. Panels with depictions of the Kropfs are still in the church today. It is believed that the glass at Saint Leonhard was made by an itinerant workshop from Judenburg, where the Kropfs lived.

54 | Stained Glass with the Baptism of Christ and the Agony in the Garden

Austria, Lower Austria, ca. 1390 From the choir of the castle chapel at Ebreichsdorf, south of Vienna Pot-metal glass, colorless glass, vitreous paint, and silver stain $28 \times 12^{1/4}$ in. (71.1 × 31.1 cm); $28^{3/4} \times 12^{1/2}$ in. (72.8 × 31.7 cm) The Cloisters Collection, 1986 (1986.285.4, .5)

Seven scenes from the private chapel of the Ebreichsdorf castle are installed in the Gothic Chapel. Representing episodes from the life of Christ—the Annunciation, Adoration of the Magi, Presentation in the Temple, Baptism, Agony in the Garden, Trial before Pilate, and Harrowing of Hell—they constitute almost all of the surviving

panels from the original stained-glass program. The scenes are organized into vertical groups of four rectangular panels, arranged two over two; the lower panels in each group are narrative, while the upper panels represent architectural canopies. Most of the narrative panels contain a single scene, as is the case with the Annunciation, which was originally paired with a Visitation (now in Vienna). Others, however, combine to form a unified episode, such as the Adoration of the Magi.

The glazing program of the chapel has been attributed to a "ducal workshop" favored by the local nobility and best known for its use of rich colors, fanciful architectural forms, and elegant figural styles. In the Baptism panel (opposite, left), the figures of Christ, John the Baptist, and the dove, representing the Holy Spirit, are positioned to create an upward thrust that lends movement and drama to the overall effect.

55 | Diptych with Scenes of the Life of Christ and the Virgin, Saint Michael, John the Baptist, Thomas Becket, and the Trinity

Germany, Lower Rhineland, Cologne, ca. 1350 Elephant ivory $10 \times 8\%$ in. $(25.5 \times 21.1 \text{ cm})$ The Cloisters Collection, 1970 (1970.324.8a, b)

This large, richly carved diptych is distinct from the many surviving fourteenth-century French diptychs. Stylistically, it can be compared to a number of German sculptures, especially the marble reliefs from the high altar of Cologne Cathedral dating before 1322. The diptych also incorporates a number of scenes that, in terms of iconography, are unusual to ivory carving. The sequence begins at lower left, with two standard episodes from the life of Christ: the Annunciation, and the Nativity with the Annunciation to the Shepherds. This routine narrative is interrupted at lower right by scenes of saints, which are rarely depicted in ivory carving. Saint Michael Triumphant over the Dragon and Saint John the Baptist with the Sacrificial Lamb appear to the left of the Martyrdom of Saint Thomas Becket. The second and third registers continue with well-known images: the Adoration of the Magi and the Presentation of Christ in the Temple, with the Crucifixion to the right, and the Resurrection of Christ and Descent into Limbo, with the Ascension to the right. Atypical scenes return in the upper register: the Coronation of the

Virgin, at upper left; the Trinity surrounded by symbols of the Four Evangelists, to the right of center; and, in the upper right corner, the Virgin nursing the Christ Child as she is crowned by angels.

56 | Grisaille Lancet

France, Normandy (Seine-Maritime), ca. 1325
From the abbey church of Saint-Ouen at Rouen
White glass, pot-metal glass, vitreous paint, and silver stain
10 ft. 7½ in. × 36¼ in. (323.8 × 92 cm)
The Cloisters Collection, 1948
(48.183.2)
The Cloisters Collection, 1984
(1984.199.1–11)

The five panels of this lancet window once decorated three different windows in the radiating chapels of the abbey church of Saint-Ouen at Rouen, in Normandy. As reassembled here, the lancet is only one-third its original height. Grisaille glass, which is colorless and translucent, was a popular glazing device in the thirteenth and four-teenth centuries. It not only allows more light into the interior than color-saturated pot-metal glass, grisaille also functions as an unobtrusive background for ornamental motifs painted with fine brush lines. Our glass panels are decorated with stylized yet recognizable plants such as periwinkle, strawberry, and artemisia, forming an elegant network of foliate motifs. The central bosses of the panels are richly colored with deep blue, red, yellow, and green. The bosses would have echoed the brilliantly hued horizontal bands once located at the windows' midpoints, which contained scenes from the life of the saint to whom the chapel was dedicated.

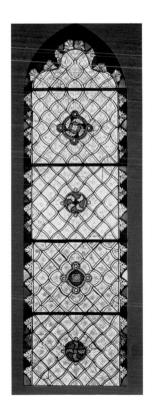

57 | Pair of Altar Angels

France, Artois (Pas-de-Calais), ca. 1275–1300 Oak with traces of paint H. 29½ in. (75 cm); 29 in. (73.7 cm) The Cloisters Collection, 1952 (52.33.1, .2) We know from illuminated manuscripts that angels such as these in all likelihood were originally placed on freestanding colonettes around an altar in groups of four or six. The colonettes would have been linked by rods supporting curtains. Our examples are carved in the round and are now missing their wings, which were attached in sockets behind the shoulders. Their hands, also missing, would have held candles, censers, or the Instruments of the Passion. Like most sculpture of the period, the angels were almost surely once painted and gilded. They were probably carved in the late thirteenth century, but they exhibit the enduring popularity of the style of the exterior sculpture of Reims Cathedral, particularly in their smiling faces and curling hairstyle, which dates to about the middle of the century.

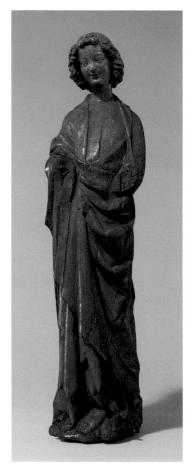

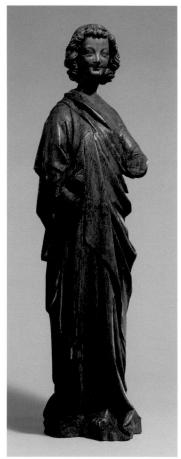

58 | Standing Virgin and Child

France, Île-de-France, possibly Paris, 1340–50 Limestone, paint, gilding, and glass H. 68 in. (172.7 cm) The Cloisters Collection, 1937 (37.159)

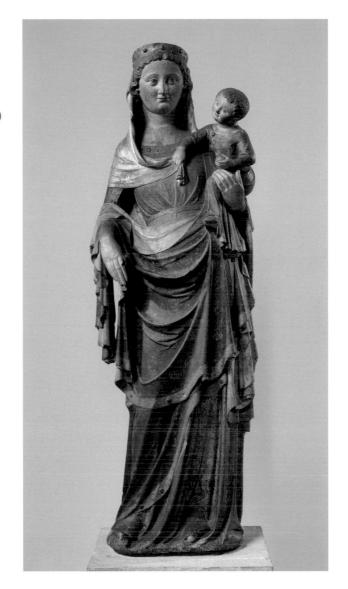

This monumental image of the Virgin and Child is carved in the style of Parisian sculptures from about 1340. For example, a silver-gilt statuette given to the abbey of Saint-Denis in 1339 by Jeanne d'Evreux, widowed queen of Charles IV (now in the Musée du Louvre, Paris), has essentially the same composition. In both groups the Virgin's mantle is pulled across her hips and falls over her right arm. In The Cloisters' sculpture the Christ Child playfully reaches for the Virgin's veil, while in the Louvre statuette he reaches for her chin. The Cloisters' piece also retains most of its original paint and gilding and appears today much as it would have in the fourteenth century.

59 | Mirror Case with Scenes of the Attack on the Castle of Love

France, Île-de-France,
Paris, ca. 1320–40
Elephant ivory
Diam. 5½ in. (14.1 cm)
The Cloisters Collection, 2003
(2003.131.1)

Among the most appealing products of the prolific Parisian ivory-carving workshops were mirror cases, combs, caskets, and other precious objects decorated with secular scenes. In this complex circular relief, twenty-eight figures and five horses occupy the battlements, windows, and grounds before a castle. At the top is the crowned and winged figure of the god of Love bending down as he

prepares to launch an arrow from his bow. The castle is defended by a force of ladies armed with roses, which they hurl at the attacking knights (one of whom, at lower left, wields a crossbow). Some of the women greet the knights with welcoming gestures and smiles; in the upper left, a lady offers a crown to one of the two trumpeters flanking the castle and heralding the playful joust about to occur before the portcullis. Two armed and helmeted knights, their shields decorated with roses, ride in from the right to face their female opponents. To the left of the castle entrance is a third knight, who has lost his shield and removed his helmet. He stands on his horse to embrace a lady in a window.

60 | Panel with Hunting Scenes

France, Île-de-France,
Paris, ca. 1350
Elephant ivory
43/8 × 123/8 in. (11 × 30.8 cm)
The Cloisters Collection, 2003
(2003.131.2)

Three scenes from a stag hunt are deeply carved into this exceptionally large rectangular plaque, the only surviving panel from an ivory casket with a hinged lid. (The other panels are known from an eighteenth-century engraving.) The narrative flows from left to right, beginning with an attendant on horseback. Accompanied by a hound, he emerges from the castle gate blowing his horn as two ladies look down on him from the ramparts above. The hunt takes place in a dense woods. The party comprises two men and two

women on horseback; one woman is feeding a falcon, and the other pursues a bird with a lure. One of the hunters has released an arrow from his bow that has struck the stag, while the other hunter drives his sword into the beast, already tormented by the hounds. The hunt continues on the right with the stag drinking from a fountain as the hunter again stabs the animal with his blade.

61 | Support Figure of a Seated Cleric or Friar

France, Champagne-Ardenne (Marne), Reims(?), ca. 1280 Copper alloy with mercury gilding 2^{5} /s × 1^{3} /s in. (6.7 × 3.4 × 4.3 cm) The Cloisters Collection, 1991 (1991.252)

The pose of this statuette of a cleric or friar, echoing ancient figures of Atlas, and the indentation cast into its back tell us that it was originally intended as a support for a larger object. Like the carved

pair of altar angels in The Cloisters' collection (no. 57), the style of this cast figure derives ultimately from the seminal sculpture of thirteenth-century Reims Cathedral—in this case from the console figures on the west facade and nave exterior. No thirteenth-century shrine survives intact with support figures like this one, but there are examples from the later Middle Ages. Furthermore, a number of the scenes depicted in the Hours of Jeanne d'Evreux (no. 62) are set in architectural frameworks supported by similar bent figures.

62 | The Hours of Jeanne d'Evreux, Queen of France

Jean Pucelle (active ca. 1319–ca. 1334) France, Île-de-France, Paris, 1324–28 Grisaille, tempera, and ink on vellum $3\frac{1}{2} \times 2\frac{5}{8}$ in. (8.9 × 6.7 cm) each leaf The Cloisters Collection, 1954 (54.1.2)

This tiny devotional prayer book was painted by Jean Pucelle, one of the greatest artists of the fourteenth century, for Jeanne d'Evreux, third wife of King Charles IV (r. 1322–28). The queen would have used it at regular intervals throughout the day in imitation of the prayer cycles observed by monks and nuns. Although the manuscript lacks some of the ostentation we might associate with a royal book, such as large scale and lavish use of color and gold, in terms of the quality and subtlety of its decoration it ranks among the great masterworks of medieval manuscript illumination. The predominance of gray enables the painter to render the figures in a remarkably sculptural way. Here, we see the manuscript opened to an image of Christ carrying the Cross on his way to the Crucifixion (fol. 61v, left). The architectural frame is supported by two seated figures quite similar to the cast-bronze support figure of a cleric or

friar, also in the collection (no. 61). On the facing page is a depiction of the Annunciation to the Shepherds (fol. 62r). Characteristic of this inventive artist's work, the illustrations on this page extend beyond the frame to surround the miniature scene with angels and shepherds in the margins.

63 | Reliquary Shrine

Attributed to Jean de Touyl (d. 1349/50) France, Île-de-France, Paris, ca. 1320–40 From the convent of the Poor Clares at Buda, Hungary Silver gilt, translucent enamel, and paint $10 \times 16 \times 3^{3/4}$ in. $(25.4 \times 40.6 \times 9.5 \text{ cm})$ open The Cloisters Collection, 1962 (62.96)

This reliquary is in the form of a polyptych, with folding wings that can be closed over the central portion. In the center of the arcaded canopy is the Enthroned Virgin about to nurse the Christ Child; flanking her are angels displaying relics. The wings of the polyptych are decorated in translucent enamel, a technique that evokes stained glass—highly appropriate given the architectural form of the shrine. Scenes from the life of the Virgin and the infancy of Christ appear below music-making angels on the insides of the wings, while additional angels, four female saints, and figures of the apostles decorate the exterior. Although the reliquary belonged to the convent of the Poor Clares in Budapest, the style of the goldsmith work and enamel is purely Parisian and can be associated with the goldsmith Jean de Touyl. It is possible the shrine was purchased in Paris for or by Queen Elizabeth of Hungary, who founded the convent in 1334.

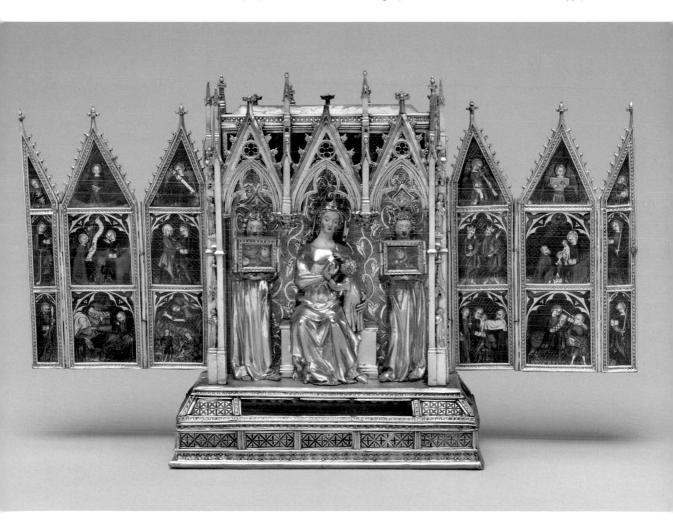

64 Double Cup

Germany or Bohemia, possibly Prague, 1330–60 Silver, silver gilt, and opaque enamel H. 4½ in. (10.6 cm); Diam. 4½ in. (12.4 cm) The Cloisters Collection, 1983 (1983.125a, b)

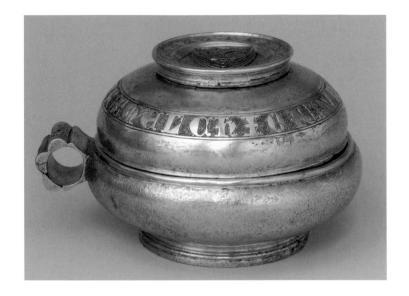

In the fourteenth century, the Epiphany, or Three Kings' Day, was frequently celebrated with special toasts, and decorative cups like this one were often given as gifts in emulation of the biblical Magi. This double cup comprises two vessels stacked rim to rim. Around the exterior of the upper vessel, which served as a second cup as well as a lid, is an inscription with the names of the Three Magi—Caspar (Gaspar), Melchior, and Waltazar (Balthasar). The interior of the lower cup bears an enamel image of a helmet surmounted by three conical hats of the type Jews were forced to wear (below, left). Inside the foot of the upper cup are three similar hats, conjoined at their tips at the center of a heraldic escutcheon (below, right). The presence of the hats suggests the cup's owners were Jews or converts from Judaism, which is possible since the Epiphany was also observed outside of Christian contexts.

65 | Covered Beaker

Vessel: Italy, Veneto, Venice, 1325–50 Mounts: Austria, Vienna, 1340–60 Silver gilt, rock crystal, and translucent enamels H. 8¼ in. (21 cm); Diam. 3¾ in. (8.6 cm) The Cloisters Collection, 1989 (1989.293)

Hard-stone vessels such as this twelve-sided rock crystal example are among the most treasured products of the Middle Ages. This beaker was likely produced in Venice, known as an important center for the cutting and polishing of rock crystal. The silver-gilt mounts, however, compare closely with pieces produced in Vienna. The silver is inscribed in verse around the base in a German dialect: Wer/Hie·v/·dr/ince/et·w/inde/r·mv/ezz/e·iem/er·s/elig/sin (He who drinks wine from me, ever shall happy be). That exhortation leaves little doubt that this vessel was intended for secular use.

66 | Enthroned Virgin

Italy, Tuscany, late 14th century Terracotta $17\% \times 10 \times 9\%$ in. (44.8 \times 25.4 \times 24.1 cm) The Cloisters Collection and Rogers Fund. 1998 (1998.214)

This work is a rare surviving example of medieval sculpture in terracotta—no other Italian examples from the period exist today. The sketchiness of the modeling and the omission of the figure of the

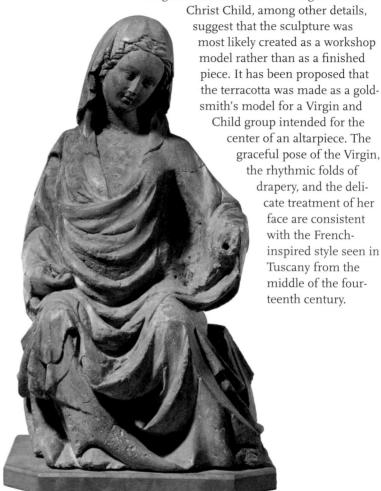

67 | Relief with Saint Peter Martyr and Three Donors

Giovanni di Balduccio (active 1318–49) Italy, Lombardy, ca. 1340 From the church of Sant'Eustorgio, Milan Marble $31^{1/2}\times33^{7/8}\times5^{3/4} \text{ in. } (80\times86\times14.5 \text{ cm})$ The Cloisters Collection, 2001 (2001.221)

With quiet monumentality, this panel depicts the standing, bearded Saint Peter Martyr wearing Dominican garb. The head wound, the saint's primary attribute, is clearly visible, along with a (restored) palm of martyrdom in his right hand. His cloak, which he holds open with outstretched arms, frames three praying donor figures; he places his hands on the heads of the oldest and youngest of them. The relief is carved in a white, fine-grained marble set into a frame of slightly coarser, grayer marble.

The sculpture is one of three surviving panels from a tomb originally in the Milanese church of Sant'Eustorgio. The damaged

center panel (Castello Sforzesco, Milan) depicts the Enthroned Virgin and Child between two angels. The relief originally on the viewer's left (still in Sant'Eustorgio) shows Saint John the Baptist with four kneeling donors in a composition that mirrors the Museum's panel, which must have been on the right. Details such as the molding beneath the ledge supporting the figures and the buttons on the undersides of the sleeves suggest that the reliefs were meant to be seen from below, and thus were presumably positioned above eye level. The artist, Giovanni di Balduccio, was trained in Pisa and is noted for having brought the innovations of Tuscan sculptors to northern Italy.

68 | The Crucifixion and the Lamentation

Master of the Codex of Saint George (active ca. 1325–50) Italy, active in France (Avignon), ca. 1340–45 Tempera and gold leaf on wood panel Whole: $18 \times 11\frac{1}{4}$ in. $(45.7 \times 29.8 \text{ cm})$ each Painted surface: $15\frac{1}{8} \times 10\frac{1}{8}$ in. $(39.7 \times 27 \text{ cm})$ each The Cloisters Collection, 1961 (61.200.1, .2) The grieving faces and bold gestures on these exquisitely painted panels, highlighted against a stark gold ground, dramatically convey the emotion of the Passion of Christ. The panels are among the few surviving works by the so-called Master of the Codex of Saint George, who is named for a missal he illuminated now in the Biblioteca Apostolica Vaticana, Vatican City. Although trained in Florence, the Master of the Codex of Saint George spent much of his career in Avignon, home of the papal court from 1309 to 1377, where he assimilated characteristics of Sienese and French painting of the period.

These panels were once thought to constitute a complete devotional diptych, but careful examination has shown that they were originally part of a folding polyptych probably composed of six panels organized in an accordion-like fashion, with the pairs of panels closing over one another face-to-face. The cycle likely began with the Annunciation and the Nativity (both missing), continued with the two Cloisters panels, and concluded with the Resurrection and the Coronation of the Virgin (both Museo Nazionale del Bargello, Florence).

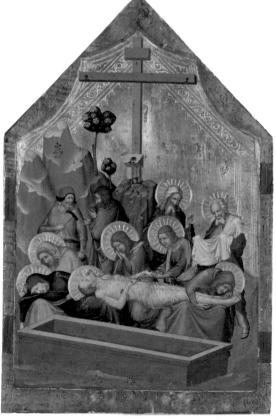

69 | The Adoration of the Shepherds

Bartolo di Fredi (active by 1353–d. 1410) Italy, Tuscany, Siena, ca. 1374 Probably from the convent of San Domenico in San Gimignano Tempera, gold, and gesso on wood Whole: $69\% \times 45\%$ in. (175.6 × 114.6 cm) Painted surface: $63\% \times 45\%$ in. (160.7 × 114.6 cm) The Cloisters Collection, 1925 (25.120.288)

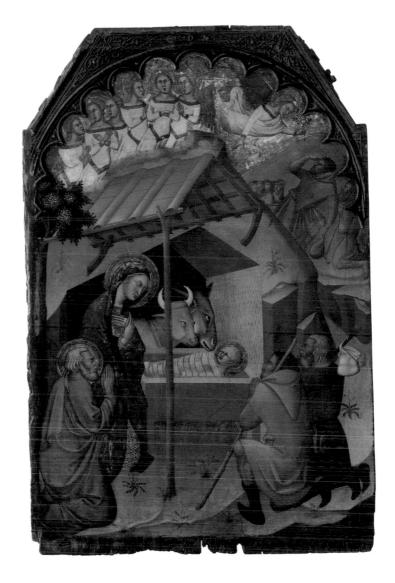

In all likelihood this panel was originally the center element of a large altarpiece in the convent of San Domenico in San Gimignano. It is described here by an early-nineteenth-century writer: "A Nativity of our Lord. At the sides are the Four Evangelists; above the Virgin of the Annunciation, the Coronation of the Virgin, the Baptism of the Saviour; in the predella Saint John the Evangelist with two other saints. At the base is written Bartholus M[agister] Fredi. 1374." Although neither particularly innovative nor especially refined, Bartolo di Fredi, the artist who signed and dated the altarpiece, was nevertheless a highly successful Sienese painter of frescoes and panels. The appeal of his work is evident in the wealth of details in

this narrative scene. A choir of angels sings above the manger—occupied by the Holy Family, the ox and the ass, and two adoring shepherds—as the Annunciation to the Shepherds appears at the upper right. In addition to its well-preserved paint surface, the panel retains much of the decorative gilt gesso at the top.

70 | Chalice

Attributed to the workshop of Tondino di Guerrino and Andrea Riguardi Italy, Tuscany, Siena, ca. 1341–42 Silver gilt and translucent enamel H. 8½ in. (21.7 cm); Diam. 5% in. (14.9 cm) The Cloisters Collection, 1988 (1988.67)

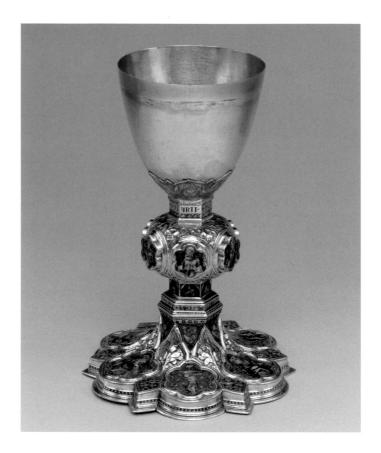

This richly decorated chalice is representative of the finest achievements of Sienese craftsmen. Comparison with signed works indicates that the chalice can be assigned to the workshop of the goldsmiths Tondino di Guerrino and Andrea Riguardi. On the foot are six enamel plaques: an image of Christ on the Cross flanked by representations of the Virgin and Saint John the Evangelist, and depictions of Saint Louis of Toulouse, John the Baptist, and Saint Anthony of Padua. On the knop are Saints Michael, Francis, an unidentified female saint (possibly Mary Magdalen), Catherine of Alexandria, and Elizabeth of Hungary. The Latin inscription above the knop links the chalice with a noted Franciscan leader and a member of an important papal tribunal: + FRA/T(R) IS P/ETRIPENIT/ENTI/ARII +

/DOMI/NI PA/PE (of Brother Peter Penitentiary of the Lord Pope). Continuing below the knop, the inscription reads: + LOCI/SAS/SIFERATI/NON VEN/DATVR/NEC DI/STRATVR (of the place of Sassoferrato neither sell nor destroy). The silver cup is an early replacement.

71 | Aquamanile in the Form of a Dragon

North Germany, ca. 1200 Copper alloy $8\frac{3}{4} \times 7\frac{1}{4}$ in. (22.2 × 18.4 cm) The Cloisters Collection, 1947 (47.101.51) Aquamaniles, which are water vessels used for washing hands, served both liturgical and secular purposes. Those made in the shape of an animal are among the most distinctive products of medieval craftsmen. The most commonly seen zoomorphic aquamaniles are lions, but dragons, griffins, and many other forms were also produced (see nos. 72 and 73 for other examples).

This striking vessel represents a dragon, which is supported by its legs in front and on the tips of its wings behind, with a tail that curls up into a handle. It was filled through an opening in the tail, now missing its hinged cover. Water was poured out through the spout formed by the hooded or cowled figure held between the dragon's teeth. In addition to its visual power, this aquamanile is distinguished by fine casting, visible in the carefully chased dragon's scales and other surface details.

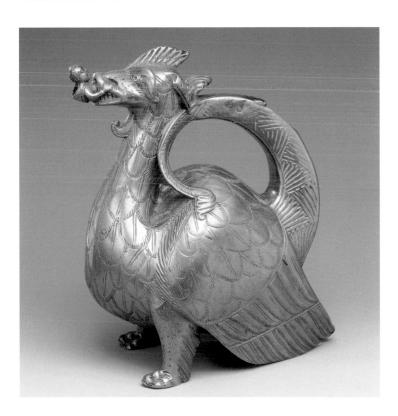

72 | Aquamanile in the Form of a Cock

Germany, Lower Saxony, 13th century Copper alloy $10 \times 3^{1/2}$ in. (25.4 \times 9 cm) The Cloisters Collection, 1989 (1989.292)

A carefully observed, naturalistic sculpture in the round, this vessel, like the slightly earlier dragon aquamanile (no. 71), was cast using the lost-wax process. Surface details were then skillfully engraved in the cold metal. The ewer was filled through a covered hole hidden between the rows of tail feathers, and water was poured out through the bird's open beak. Although the cock is not without religious significance (most notably in the story of Saint Peter's denial of Jesus), it seems most likely that this aquamanile served a secular function. The cock was a popular character in such twelfth-century literature as the tale of Renart the Fox and is perhaps best known today from Chanticleer, the rooster in Chaucer's fourteenth-century "The Nun's Priest's Tale."

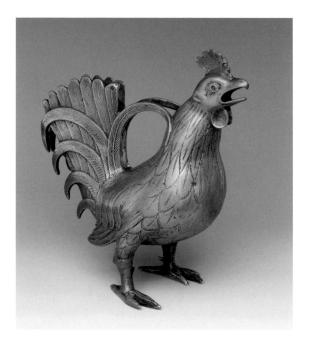

73 | Aquamanile in the Form of a Lion

Germany, Franconia, Nuremberg, ca. 1400 Copper alloy $13\frac{1}{8} \times 4\frac{3}{4}$ in. $(33.3 \times 12.1$ cm) The Cloisters Collection, 1994 (1994.244) This lion aquamanile is certainly one of the Museum's most magnificent examples of this type of utilitarian object. The animal's energized stance, with its chest pushed forward and its tongue extended, instantly conveys a sense of great pride and power. There is the familiar covered opening at the top of the lion's head for filling the vessel with water, but unlike the earlier examples we have seen (nos. 71 and 72), the lion has a spout and spigot attached to its chest. Comparison with other aquamaniles suggests that this one was cast in the free imperial city of Nuremberg, a leading artistic center from the middle of the fourteenth century until the sixteenth century.

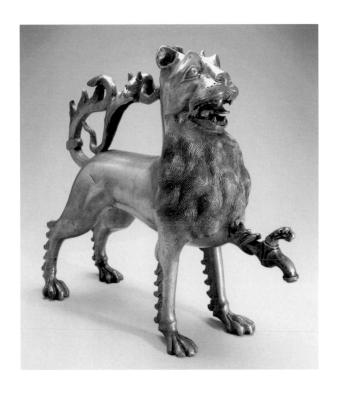

74 | Brooch

Germany, Saxony or South Germany, 1340–60 Gold and freshwater pearl $1\frac{1}{4} \times \frac{7}{8} \times 1\frac{1}{2}$ in. (3 $2 \times 2.2 \times 3.8$ cm) closed The Cloisters Collection, 1986 (1986.386)

In terms of its function, decoration, and inscription, this intimate piece of jewelry conveys the chivalric ideal of love. Made in the shape of the letter *E*, the brooch has a hinged cover that allowed it to function as a locket. The cover bears the figure of a man holding arrows aimed at his heart, while the interior inscription (in a Saxon dialect?) reads: • v/REWELININ • VRME DEI + HRZE • LEVE•/ NSTE • MOIS IC IN •/•SIN (Fair lady, may I always remain close to your heart).

75 | Altar Cruet

Central Europe, mid-14th century Silver and silver gilt H. 8¾ in. (22.2 cm); Diam. 4 in. (10.2 cm) The Cloisters Collection, 1986 (1986.284)

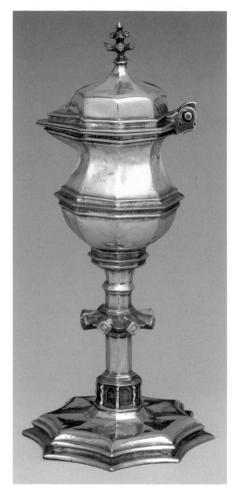

Altar cruets were used to mix water with wine for Holy Communion and were thus usually made in pairs. Although frequently crafted in silver throughout the Middle Ages, cruets, because they held the water and wine before consecration, were not required to be made of precious metals. For the same reason, the shape and decoration of the cruet were less standardized than those of the chalice and paten. This mid-fourteenthcentury example is notable for its strong profile and restrained decoration. The form is characteristic of the silver production of a broad area of central Europe, making it difficult to determine a precise place of manufacture.

76 | The Bishop of Assisi Giving a Palm to Saint Clare

Germany, Franconia, ca. 1360 Probably from the convent of the Poor Clares at Nuremberg Tempera and gold on oak panel $13\frac{1}{4} \times 8\frac{3}{4}$ in. (33.5 × 2.2 cm) The Cloisters Collection, 1984 (1984.343)

On Palm Sunday 1212, the bishop of Assisi presented a palm to Clare, the daughter of a nobleman and an early follower of Saint Francis. She is seen in this charming panel wearing richly decorated garments, but soon after the event depicted here she renounced her life of luxury and entered the Franciscan order. Her entry into monastic life was the first step toward the creation of the sister order known as the Poor Clares, which Pope Innocent III permitted to live on alms alone, with no property at all.

The Cloisters' panel is one of several with scenes from the saint's life to survive from altarpieces probably created for the convent of the Poor Clares in Nuremberg. The crown on Clare's head is an allusion to her eventual coronation in heaven. Standing behind the bishop is the tonsured figure of Saint Francis holding a pair of scissors, with which Clare's hair was shorn.

77 | Embroidered Hanging

Germany, Lower Saxony, late 14th century Silk on linen with painted inscriptions and faces $63 \times 62 \frac{1}{2}$ in. (160 × 158.8 cm) Gift of Mrs. W. Murray Crane, 1969 (69.106)

This large but fragmentary embroidery, with charming, doll-like figures, is characteristic of work produced in the region of Lower Saxony, probably by nuns. Moving from left to right, the scenes are arranged horizontally in pairs, with each New Testament episode prefigured by one or more from the Old Testament. In the top row: the Flowering of Aaron's Rod and Gideon's Fleece; the Annunciation; the Closed Gate of Ezekiel and the Burning Bush; and the Nativity. In the second row: David Acclaimed; the Entry into Jerusalem; the Sacrifice of Isaac; and Christ Carrying the Cross. In the third row:

Moses Receiving the Law; the Pentecost; Moses Striking the Rock, with the Gathering of Manna, at right; and Christ Appearing in the Bread of the Consecration.

78 | Pietà (Vesperbild)

Bohemia, possibly Prague, ca. 1400 Limestone $15 \times 15^{\frac{3}{8}} \times 5^{\frac{1}{12}}$ in. $(38.1 \times 39.1 \times 14 \text{ cm})$ The Cloisters Collection, 2001 (2001.78)

Although the term usually used by English speakers to refer to this image is Pietà, Italian for "pity," the German word used since the Middle Ages is Vesperbild, literally "evening image." As such, Vesperbild refers to the moment in the Passion narrative when Christ's body was removed from the Cross, in the late afternoon; it is also a reference to the office of Vespers on Good Friday. Interestingly, the specific scene the word describes—after the body is removed from the Cross but before the Entombment—is not mentioned in the Gospels. Nonetheless, the image was increasingly popular in private devotional practice during the late Middle Ages. As made apparent in this finely carved, small sculpture, the Vesperbild was intended to evoke empathy in the viewer as it confronted him or her with the intense suffering of the now dead Christ and his grieving mother. The sculpture is a moving example of the Schöne Stil, or "Beautiful Style," popular in central Europe at the end of the fourteenth century. Prague was a key center for works in this style, and it is likely that the sculpture was carved there.

79 Credenza

Italy, 1440-50 Walnut and intarsia $58 \times 125 \times 25$ in. $(147.3 \times 317.5 \times 63.5$ cm)
The Cloisters Collection, 1953 (53.95)

The credenza was originally a functioning sideboard intended for the preparation and serving of food, but it evolved in the late Middle Ages into a display for expensive plates and other vessels and was thus often draped in luxurious fabrics. Whereas most medieval furniture has suffered from use and climate over the centuries, this credenza is unusually well preserved. It has been attributed to the brothers Lorenzo (1425–1477) and Cristoforo Canozi (ca. 1426–1491) from Lendinara, in northern Italy, and associated with their early style. The piece is decorated with a total of eight panels. The top two-thirds of each panel contains a circular form resembling a rose window, with a row of intricate lancets below; square fields, each covered with rectilinear patterns in intarsia, occupy the bottom thirds of the panels. The six panels that form the front face are divided into three pairs of doors, each opening into a two-shelf interior where dishes could be stored.

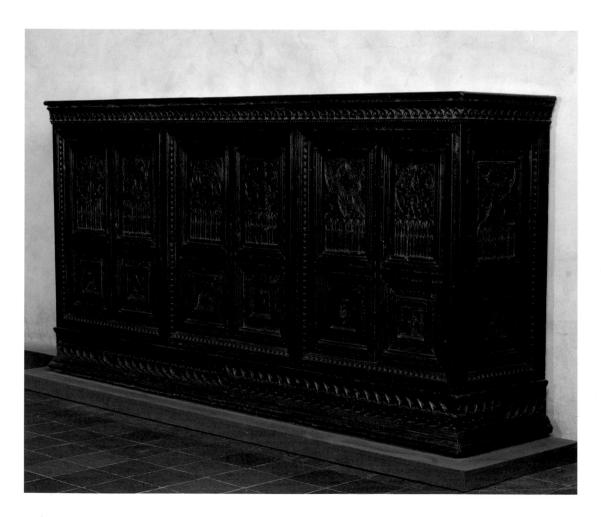

80 | Plate with the Arms of Blanche of Navarre

Spain, Valencia, Manises, 1427–38 Tin-glazed and lustered earthenware Diam. 15³/₄ in. (40 cm) The Cloisters Collection, 1956 (56.171.148)

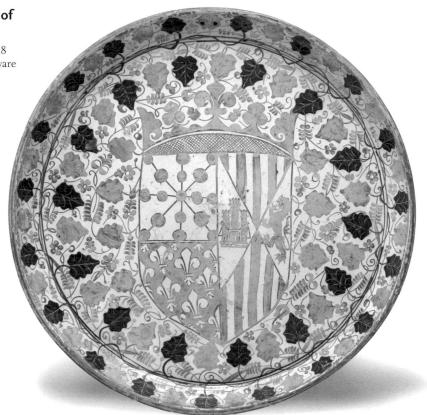

The prolific workshops of Manises, near the city of Valencia, made colorfully decorated tin-glazed earthcnware vessels in many shapes. Such wares were widely appreciated across Europe, but Italians appear to have been the biggest customers for them. This plate, which bears the prominent arms of Queen Blanche of Navarre (1391–1441) and her husband, John II of Aragon, was probably part of a larger service. In a letter of 1454, for example, Maria of Castile, consort of Alfonso V of Aragon, ordered just such a service, including dishes for meat, washing basins, porringers, broth bowls, pitchers, vases, and other objects to be "lustered inside and out." During the fifteenth century, Italian maiolica workshops gradually began to surpass Spanish ones in terms of quality and sheer numbers.

81 | Julius Caesar and Attendants, from the Nine Heroes Tapestries

South Lowlands, 1400–1410 Wool warp and wefts 13 ft. 9½ in. × 91 in. (420.4 × 231.1 cm) Gift of John D. Rockefeller Jr., 1947 (47.101.3)

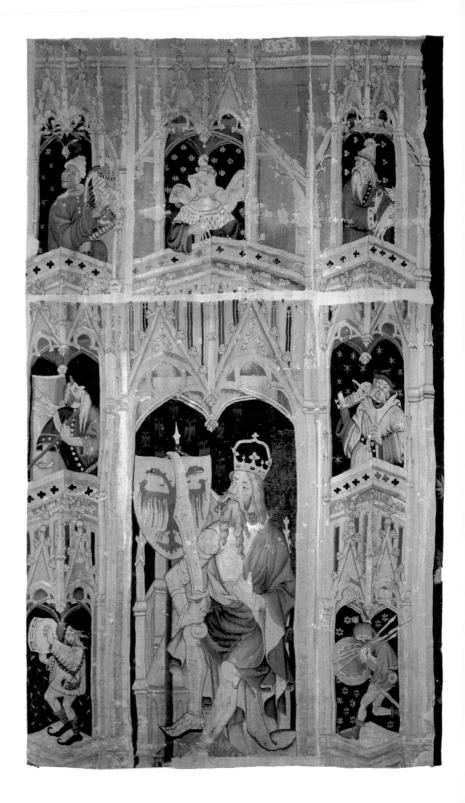

The subject of the Nine Heroes first appears about 1312 in a romance by the poet Jacques de Longuyon called *Les Voeux du paon* (The Vows of the Peacock). The nine worthies in Longuyon's tale were considered to embody both wisdom and valor, the consummation of chivalric ideals. Of the nine, three are classical (Hector of Troy, Alexander the Great, and Julius Caesar), three are Hebrew (Joshua, David, and Judas Maccabaeus, who led the Jews against the Syrians), and three are Christian (Arthur, Charlemagne, and Godfrey of Bouillon, who recaptured Jerusalem during the First Crusade).

Although fragmentary, The Cloisters' Nine Heroes constitute one of the very few extant tapestry sets from the turn of the fifteenth century. They were originally three large horizontal hangings, each with a trio of protagonists sitting across its width beneath vaulted spaces. Architectural elements such as crenellation and tracery windows functioned as compartmentalizing devices and helped create convincing spatial depth. The group was later cut down and used as curtains, and now just five heroes from this remarkable set remain: Julius Caesar (opposite), Hector, David, Joshua, and Arthur. Many of the details included in the tapestries are meant to enhance our understanding of the heroes depicted. Julius Caesar, for example, is surrounded by musicians and courtiers, some of whom appear to be African or Asian—perhaps an allusion to his military campaigns outside Europe. Arthur, on the other hand, is portrayed as a Christian ruler, accompanied, fittingly, by a group of clergymen of different ranks. The small attendants in secondary spaces are comparable to similarly marginalized and equally elusive figures often found in contemporary stained glass and manuscript paintings.

82 | The Belles Heures of Jean de France, Duc de Berry

The Limbourg Brothers (active by 1399–1416) France, Paris or Bourges, 1406–1408/9 Ink, tempera, and gold leaf on vellum $9\% \times 6\%$ in. (23.8 × 16.8 cm) The Cloisters Collection, 1954 (54.1.1)

Jean de France, duc de Berry (1340–1416), was the son, brother, and uncle of three different French kings, but it is as an art patron, collector, and connoisseur that he is guaranteed a prestigious place in the history of France. Books, in particular, were the duke's guiding passion, and his books of hours were among the most richly embellished of all his illuminated manuscripts. The Belles Heures, described in the duke's inventory as "very well and richly illustrated," has 172 miniatures, including 94 full-page scenes like this one, in rich colors and gold leaf. This page (fol. 223v), which illustrates a prayer for safe journey, shows the duke on a white horse followed by his entourage as he rides toward an impressive, turreted castle.

The artists who painted the Belles Heures, the Limbourg brothers, were originally from the South Lowlands and first trained as goldsmiths, a fact evident in the refined details of the manuscript. Among the greatest artists of their time, they were especially adept at narrative scenes and carefully observed depictions of the natural

world. Although the Limbourg brothers created other important works for the duke, the Belles Heures was the only manuscript they completed for him.

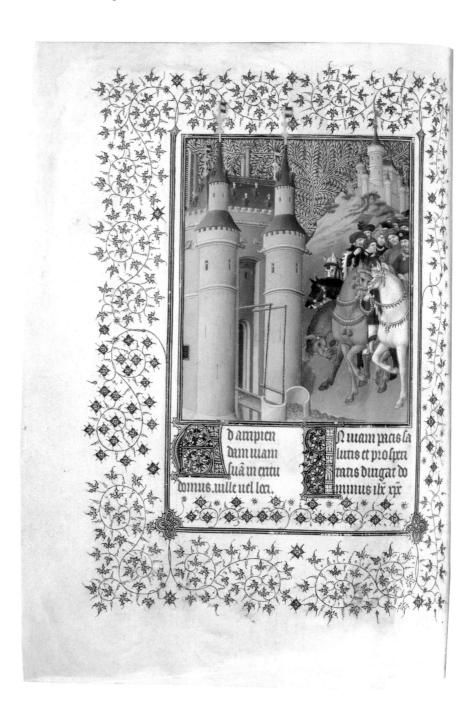

83 | Beaker with Apes

South Lowlands, probably the Burgundian territories, ca. 1430–40 Silver, silver gilt, and painted enamel H. 7% in. (20 cm); Diam. 45% in. (11.7 cm)

The Cloisters Collection, 1952 (52.50)

The exterior of this cup depicts a sleeping peddler being robbed by apes, a popular tale in the late Middle Ages. In all, thirty-five of the mischievous creatures cavort amid the cup's scrolling foliage. Two more can be seen on the interior, which is embellished with an elaborate scene of a stag hunt. The apes are equipped with hunting horn and bow and arrow and are accompanied by hounds as they pursue two stags in a forested setting. A sixteenth-century gold medallion forms the bottom of the beaker.

Such a precious vessel, ornamented with great sophistication, was most likely commissioned by the Burgundian court. It is decorated in what was then the relatively new and exacting technique of painted enamel. In that process, before the enamel is fired it is freely applied to the surface without wire strips (cloisons) or shallow depressions (as in champlevé enamel) to hold the colors in place. Here the artist has mastered an especially difficult biconical shape, which is adorned inside and outside in grisaille.

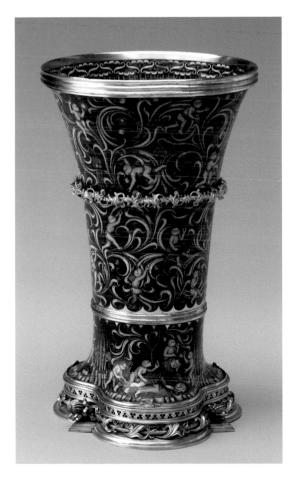

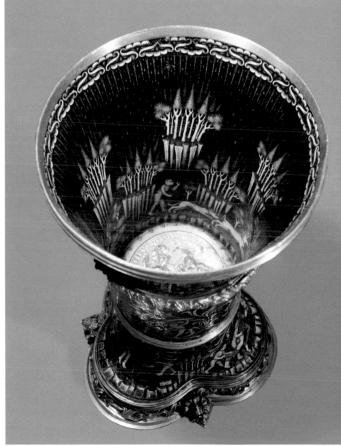

84 | The Intercession of Christ and the Virgin

Attributed to Lorenzo Monaco (Piero di Giovanni) (active 1390–1423) Italy, Tuscany, before 1402 From the Trinity Chapel of the cathedral of Santa Maria del Fiore in Florence Tempera on canvas $94\frac{1}{4} \times 60\frac{1}{4}$ in. (239.4 × 153 cm) The Cloisters Collection, 1953 (53.37)

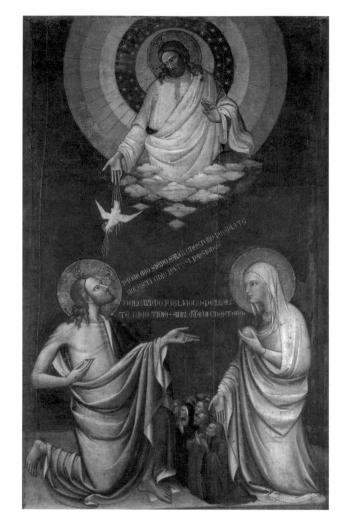

One of the earliest surviving large-scale paintings on canvas from Italy, this grand work depicts the kneeling figures of Christ and the Virgin praying to a half-length God the Father on behalf of a group of eight smaller figures at bottom center. The Virgin, holding her breast and looking directly at Christ, pleads: "Dearest son, because of the milk that I gave you, have mercy on them." Christ gazes up to God the Father and the dove of the Holy Spirit, gestures to the wound in his side, and asks: "My father, let those be saved for whom you wished me to suffer the Passion." Although it has been suggested that the canvas might have originally been painted for use as a banner, by the early 1400s it was already hung just inside the main (west) entrance to the cathedral of Florence, behind the altar in the chapel then dedicated to the Trinity. From this prominent location it would have been visible across the entire length of the nave.

85 | Retable with Christ, Saint John the Baptist, and Saint Margaret

Andrea da Giona (active mid-15th century)
Italy, Liguria, 1434
From the church of San Giovanni Battista at Savona
Marble $72 \times 80 \times 5$ in. (182.9 \times 203.2 \times 12.7 cm)
The Cloisters Collection, 1962
(62.128a-h)

This marble retable is a rarity because it is signed and dated at the bottom of the center panel: HOC OPUS FECIT MAGISTER AND[R]EAS DA GIONA, MCCCCXXXIII (made by Master Andrea da Giona, 1434). The retable itself comes from Savona, west of Genoa (in today's Liguria), but the sculptor, Master Andrea, was from the town of Giona in the Ticino, which in the fifteenth century was part of Lombardy. Here Master Andrea, like some of his fellow Lombard sculptors, has clearly assimilated aspects of Venetian art in his style—for example, the foliate decoration at top. Also, while he has retained such Gothic decorative elements as the pointed arches, other details, including the contrapposto posture of Saint Margaret and the scalloped niche above her, reveal his familiarity with the emerging Renaissance style.

At the center of the relief is Christ enthroned in majesty in a mandorla and surrounded by music-making angels. Symbols of the Four Evangelists fill the spandrels. Christ is flanked on the left by Saint John the Baptist, in a hair shirt, and on the right by Saint Margaret, with a dragon by her feet. The figures of the two saints are surmounted by the Archangel Gabriel (at left) and the Annunciate Virgin (at right), both framed by gables.

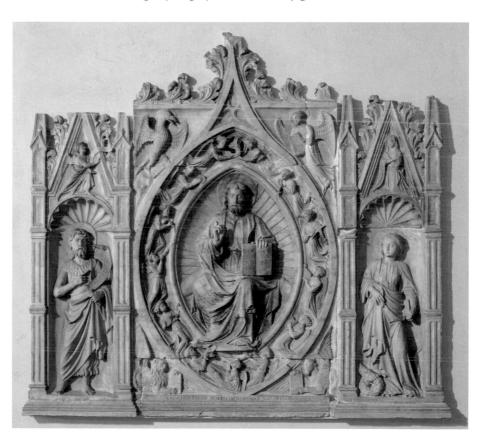

86 | Fragment of a Tapestry Hanging

Switzerland, Upper Rhineland, Basel, ca. 1420–30 Linen warp with wool weft $29^{1/2} \times 33^{5/8}$ in. $(74.9 \times 85.4$ cm) The Cloisters Collection, 1990 (1990.211) With a thick mane covering its neck and upper body and a scaly hindquarter, the fantastical beast on this tapestry fragment is a composite creature similar to those illustrated in medieval bestiaries. It wears a collar hung with bells, attached to which is a spiral-striped cord leash held by a person whose left hand is still visible. Such animals were often depicted alongside courtly couples, shown leading or subduing them, and they are frequently associated in inscriptions on surviving tapestries with themes of love or unspoiled nature.

This fragment comes from a large hanging that was cut into three pieces, one of which is now kept in the Benedictine monastery at Muri-Gries near Bolzano, at the foot of the Alps. It was woven in the early fifteenth century by one of the earliest-known workshops in Basel. These domestic pieces, also called *Rücklaken*, were typically modest in size and often suspended from a molding or frieze high on a wall. The bold colors of the fierce, virile animals made such hangings popular items in late medieval homes.

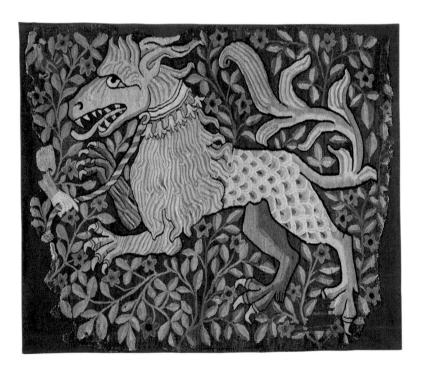

87 | Altar Frontal with Man of Sorrows and Saints

Germany, Franconia, Nuremberg, ca. 1465 Linen warp with wool and silk wefts $35\frac{1}{4} \times 65\frac{1}{2}$ in. $(89.5 \times 166.4 \text{ cm})$ The Cloisters Collection, 1991 (1991.156) This altar frontal, or "antependium," is a superb example of tapestries made in Nuremberg. Christ, represented as the Man of Sorrows, stands at the center, his hands raised to reveal his wounds. John the Baptist and the Virgin stand at his right, while John the Evangelist and Saint Jerome are at his left. The group appears amid a stylized meadow abloom with flowers, set against a pomegranate-patterned background. The varying shades of red, the highly expressive depiction of the Crown of Thorns, and Christ's lacerated body covered with blood combine to make this a particularly moving work. The antependium might have been one of seven donated by Margarete Toppler to the church of Saint Lawrence in Nuremberg after the death of her husband, Martin Pessler, in 1463. The coats of arms of both families appear at the bottom of the two vertical borders of climbing foliate scrolls.

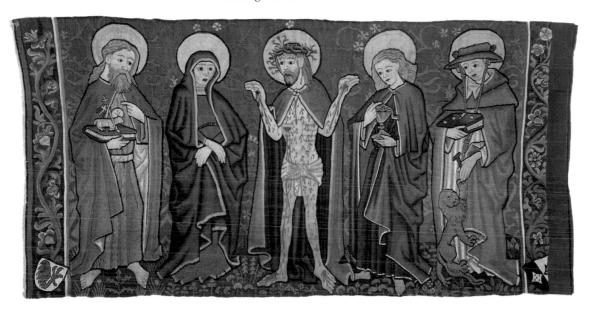

88 | Retable with Scenes from the Life of Saint Andrew

Attributed to the Master of Roussillon Catalunya, ca. 1420–30
Said to come from a church at Perpignan in Roussillon (modern France)
Tempera and gilding on panel 10 ft. 3½ in. × 10 ft. 3½ in. (313.1 × 314 cm) Rogers Fund, 1906 (06.1211.1–.9)

Physically imposing but delicately painted, this large altarpiece, which retains much of its original frame, is notable for its skillful use of color, careful design, and rich narrative content—for example, the various species of fish in the scene at upper left. The uppermost image, above the bearded figure of the apostle Saint Andrew in the center, is of the Enthroned Virgin and Child with Saint Catherine of Alexandria, Mary Magdalen, and angels. The other panels illustrate various episodes of Andrew's life taken from the thirteenth-century *Golden Legend*. The upper left panel depicts the calling of Saint Andrew, with the punishment of a wicked mother, below. In the upper right is his crucifixion, and below that he is seen saving a

bishop from the devil disguised as a fair woman. The predella depicts six additional scenes (one is lost) flanking a central image of Christ as the Man of Sorrows. From left to right, these are: Saint Andrew and the woman who prayed to Diana on behalf of her sister; a woman bringing the saint to her sister; Andrew driving away devils in the form of dogs; Andrew raising a dead youth; and Andrew bringing drowned men to life.

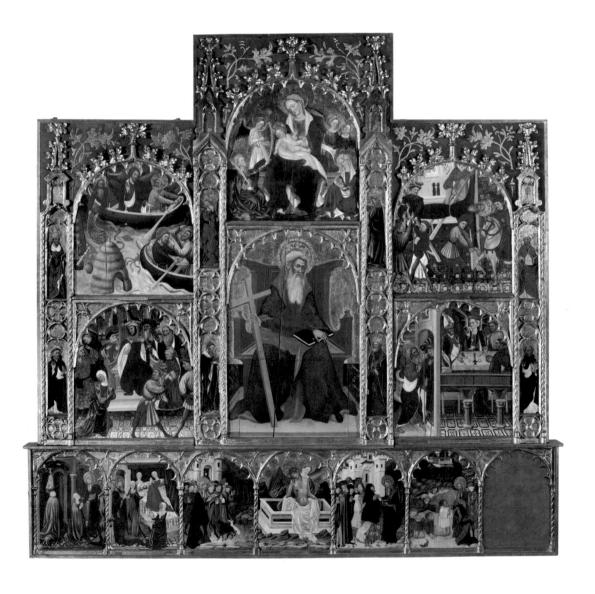

89 | The Annunciation Triptych (Mérode Triptych)

Robert Campin (ca. 1375–1444) South Lowlands, Tournai, ca. 1425–30 Oil on oak Center panel: $25\frac{1}{4} \times 24\frac{7}{8}$ in. (64.1 × 63.2 cm); each wing: $25\frac{3}{8} \times 10\frac{3}{4}$ in. (64.5 × 27.3 cm) The Cloisters Collection, 1956 (56.70) One of the best-known works of art at The Cloisters, this masterful triptych is notable for the superb quality of its execution, its fine state of preservation, and the innovative treatment of the subject matter. In the center panel, the Annunciation to the Virgin takes place in a carefully detailed domestic interior rather than in the usual church setting. The Archangel Gabriel arrives in the room followed by a tiny image of the Christ Child borne on rays of light and carrying a cross. Their entrance appears to have extinguished the candle burning on the table, but the Virgin, her eyes downcast on devotional reading, seems unaware of her heavenly guests. The right wing of the triptych is devoted to Saint Joseph, who is rarely accorded such prominence in medieval art. The carpenter Joseph is shown at work

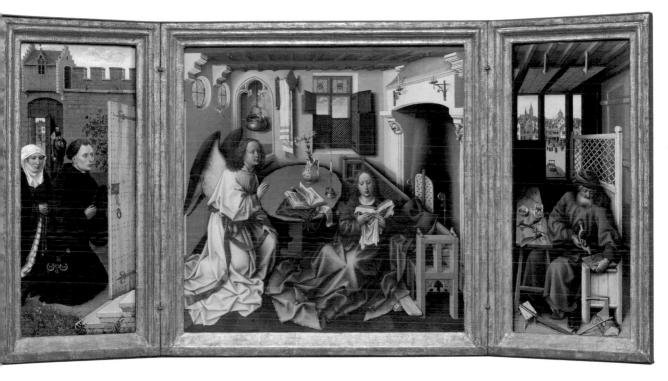

in his shop, with an unfinished mousetrap on the workbench and a completed one on the window ledge. This detail might allude to Saint Augustine's analogy that the Cross was the Devil's mousetrap and the crucified Christ his bait. The left wing was probably painted by an assistant in Campin's workshop, perhaps a young Rogier van der Weyden. It depicts the donor with his wife witnessing the center scene through a door; a messenger, echoing Gabriel, stands in the background. Heraldic emblems on the stained-glass panels behind the Virgin have helped identify the kneeling male donor as Peter Engelbrecht, who probably commissioned the piece for his home.

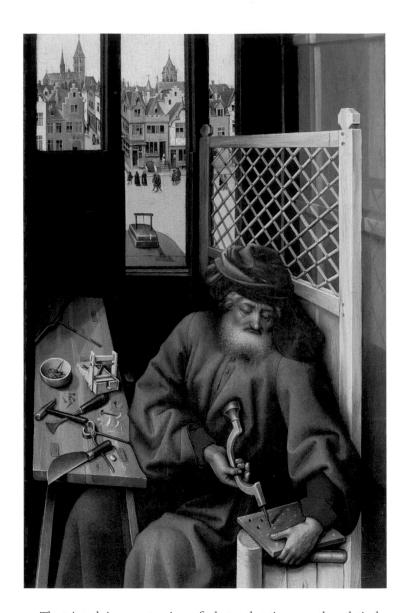

Detail of right panel, showing Joseph in his workshop

The triptych is a masterpiece of what at that time was the relatively new medium of oil, which was replacing tempera (color pigments mixed with egg yolks) as the preferred material for painting panels. Just as significant (and typical of northern European art of the period) is the careful attention to detail, evident in the meticulous depictions of strands of hair, folds of drapery, and the cityscape seen through Joseph's window. The representation of three-dimensional space on a two-dimensional surface is achieved with foreshortening; for example, in the way the ceiling beams in the center panel recede into the background to create a convincing sense of spatial depth.

90 | Kneeling Angel

Burgundian Lowlands or Rhineland, ca. 1430–40 Alabaster 14 $\frac{1}{2} \times 3^{\frac{3}{4}} \times 8^{\frac{1}{4}}$ in. (36.8 × 9.5 × 22.2 cm) The Cloisters Collection, 1965 (65.215.3)

This elegant angel was originally part of a group of statuettes depicting either the Annunciation to the Virgin or Christ as the Man of Sorrows; if the latter, the angel's crossed hands may have held Instruments of the Passion. The angel's refined features, the loose curls of long hair, and the fluid treatment of the folds in the thin drapery recall a group of alabaster sculptures from a retable with the Crucifixion and the Twelve Apostles formerly in Santa Maria delle Grazie, Rimini-Covignano (now in the Städtische Galerie Liebieghaus, Frankfurt). The anonymous artists responsible for the ensemble probably worked in the Burgundian Lowlands or the Rhineland, but, as the Rimini altar suggests, they appear to have produced many sculptures in alabaster for export. The personal style of the Rimini Master is closely linked to the widespread, so-called International Gothic style of about 1400, seen in this and many other alabaster statuettes of the first half of the fifteenth century.

91 | The Virgin Mary and Five Standing Saints Above Predella Panels

Germany, valley of the Middle Rhine, 1440–46 From the north nave of the former Carmelite church at Boppard-am-Rhein in Rheinland-Pfalz (Rhein-Hunsrück-Kreis), near Koblenz Pot-metal glass, white glass, vitreous

paint, and silver stain $148\frac{1}{2} \times 28\frac{1}{4}$ in. (337.2 × 71.8 cm) each The Cloisters Collection, 1937 (37.52.1–.6)

The Carmelite church at Boppard-am-Rhein was once the home of an extensive program of stained glass. The six windows from the church now installed at The Cloisters were originally arranged on two levels, three over three, to form a single unit on the north wall of the north nave, whose construction began in 1439. The three virgin saints occupied the lower level, each carrying attributes associated with her legend: Catherine with the wheel and the sword; Dorothea with the Christ Child and a basket of roses; and Barbara holding a miniature tower. The three other figures constituted the upper tier: Saint Servatius holding a key and subduing a dragon; the Virgin Mary in a corn robe; and Saint Lambert, the bishop of Liège. Each of the six figures stands beneath an elaborate architectural canopy anchored

at the bottom by a small panel containing a subject related to the larger panel above. The Archangel Michael, for example, who is depicted weighing souls and trampling on a dragon, is a visual mirror of Saint Servatius; so are the three roses springing from Dorothea's basket, which correspond to the Trinity below. The figural style is elegant and gentle, particularly for the female saints, who have high foreheads, delicate features, and slender bodies under their robes. In addition, the generous use of white glass in the ensemble adds considerable radiance to the primarily red and blue palette. These six lancets constitute the only window from Boppard to have survived in its entirety.

92 | Paschal Candlestick

Spain, Castilla-León, ca. 1450-1500 Wood with paint and gilding $77 \times 17^{1/4}$ in. $(195.6 \times 43.8 \text{ cm})$ Fletcher Fund, 1944 (44.63.1a, b)

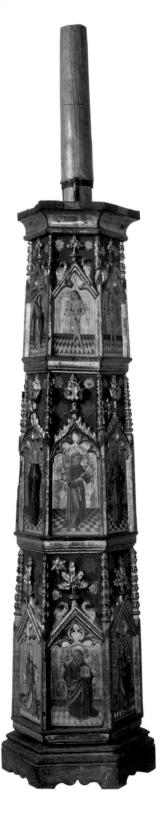

Paschal candlesticks figure prominently in the liturgy of the Easter vigil as part of the celebration of the Resurrection. In a practice that dates to the early church, the congregation gathers around the candlestick while the deacon inserts grains of incense into five holes in the wax of the candle arranged in a cruciform pattern. The ceremony, known as Lumen Christi, concludes with the lighting of the paschal candle, which is raised above the congregants—in the case of this example, more than six feet above them. The decoration of the hexagonal candlestick is organized in three tiers. The upper register is devoted to the Old Testament: Adam and Eve, the Expulsion of Adam and Eve (depicted on two faces), and the prophets Jeremiah, Ezekiel, and Zachariah. The second register depicts Saint Benedict and five Franciscan saints: Francis. Bernardine, Anthony of Padua, Louis of Toulouse, and Clare. Six of the apostles appear at the bottom: Saints Bartholomew, Thomas, Barnabas, John, Philip, and Matthias.

93 | Altar Predella and Socle of Archbishop Don Dalmau de Mur y Cervelló

Francí Gomar (active 1443–ca. 1493) Spain, Aragon (Saragossa), ca. 1456–58 From the chapel of the archbishop's palace at Saragossa Alabaster with traces of paint and gilding 8 ft. 11 in. × 15 ft. 3 in. × 26 ¼ in. (271.8 × 464.8 × 66.7 cm) Gift of J. Pierpont Morgan, 1909 (09.146) Frederick C. Hewitt Fund, 1914 (14.101.1, .2) Gift of Emile Pares, 1916 (16.79) This massive structure, extending across five bays on two levels, was commissioned by don Dalmau de Mur y Cervelló, archbishop of Saragossa from 1434 to 1458/9, for an altar in the chapel of the archiepiscopal palace. The upper level (intended as the predella for the altarpiece or retable) contains five scenes: Saint Martin of Tours dividing his cloak with a beggar and Christ appearing to him in a dream (left panels); the Descent of the Holy Spirit (center panel); and Saint Thecla listening to the preaching of Paul (far right panel) and, after her conversion, being saved by divine intervention from burning fire (second panel from right). Each of the two outer panels on the lower level (or socle) shows a bearded figure carrying the coat of arms of the archbishop. The central shield on the reconstructed altar, festooned against a cross, depicts the Arma Christi (the instruments associated with the Crucifixion).

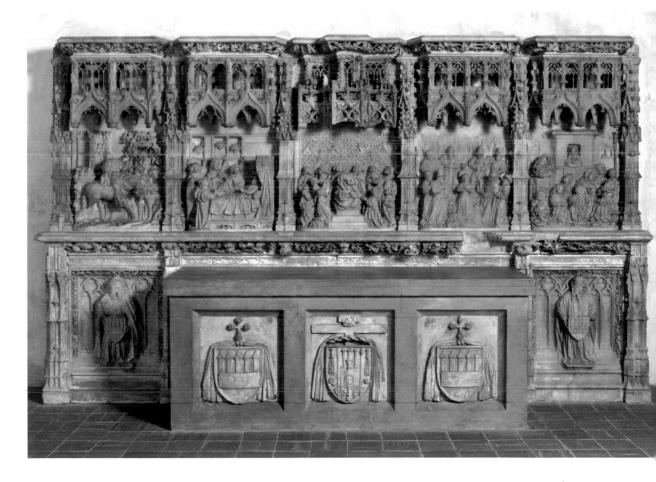

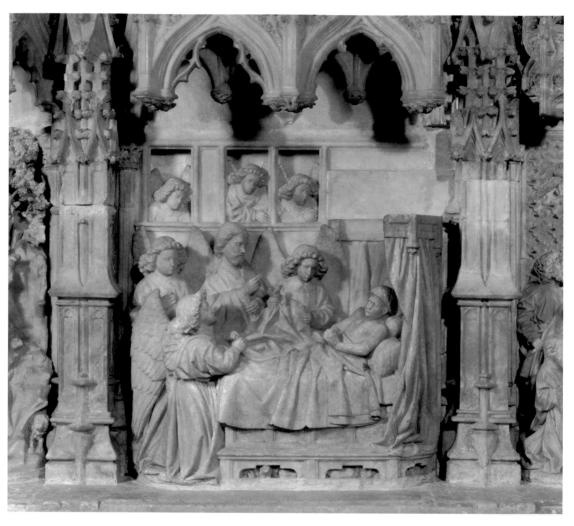

Detail of predella panel, showing Christ appearing in a dream to Saint Martin of Tours

The structure is made of alabaster, a soft yet compact stone with a translucent glow. The workability of the material allowed the sculptor, Francí Gomar, to create exquisite details. Only a few traces of the original painting and gilding remain. According to a 1458 contract, the painter Tomás Giner (active 1458–80) was commissioned to paint and gild panels intended to stand above the predella. The unusual combination of painted altarpieces with a stone predella may have been a necessary measure to speed completion of the ensemble before the archbishop's death.

94 | Saint James the Greater

Gil de Siloe (active 1475–1505) Spain, Castilla-León (Burgos), 1489–93 From the tomb of Juan II of Castile and Isabel of Portugal in the Cartuja de Miraflores, outside Burgos Alabaster, gold, and paint H. 181/s in. (45.9 cm) The Cloisters Collection, 1969 (69.88) This statuette of the apostle Saint James the Greater, patron saint of Spain, was originally part of the tomb of Juan II of Castile and Isabella of Portugal. The monument, which still stands in the church of the royal Carthusian monastery of Miraflores outside Burgos, was commissioned in 1486 by Isabel of Castile, daughter of the king and queen, and was carved by the master sculptor Gil de Siloe and his workshop. Lifesize effigies of the royal couple rest on a star-shaped platform, where they are surrounded by statuettes of the Four Evangelists. Originally these were accompanied by the Twelve Apostles. Saint James, who once stood at the queen's left, is seen here with a pilgrim's staff, water gourd, and cockleshells adorning his hat, cloak, and bag—attributes that evoke the dress of the pilgrims who traveled across northern Spain to reach his shrine at Santiago de Compostela, where his body lay.

During the late Middle Ages alabaster was frequently used for the decoration of tombs and altars. The soft stone is easily cut and polished, but it is also slightly soluble in water and therefore not suitable for outdoor sculpture.

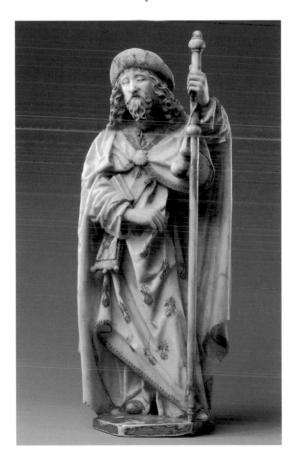

95 | Standing Virgin and Child

Attributed to Nikolaus Gerhaert von Leiden (active 1460–73?) Austria, probably Vienna, ca. 1470 Boxwood H. 13½ in. (33.6 cm) Purchase, The Cloisters Collection and Lila Acheson Wallace Gift, 1996 (1996.14)

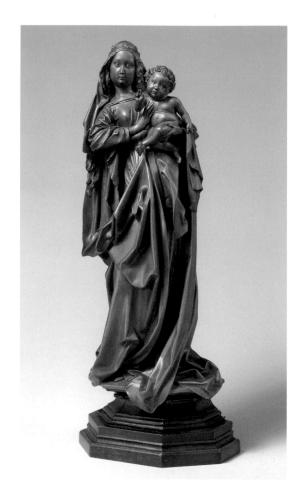

Like elephant ivory, boxwood is a dense, fine-grained material ideally suited to carving on a small scale. This carved boxwood Virgin and Child, a sculptural tour de force, conveys a sense of monumentality that far exceeds its small size. The group is masterfully conceived in the round, with extraordinary drapery that falls and loops around the Virgin in front as her veil and the long curls of her hair help carry the visual flow to the back. The cross-legged, active figure of the Child echoes the motion of the Virgin's mantle.

The artist, Nikolaus Gerhaert von Leiden, who was probably of Netherlandish origin, became the most important German sculptor of his generation. One can see in the statuette many of the distinguishing characteristics of Gerhaert's monumental works—the lively sense of movement, the complex treatment of the figure in space, and the richness of the textured surface. Gerhaert is best known for his work in Strasbourg, but this statuette likely dates to the end of his life, when he worked in Vienna.

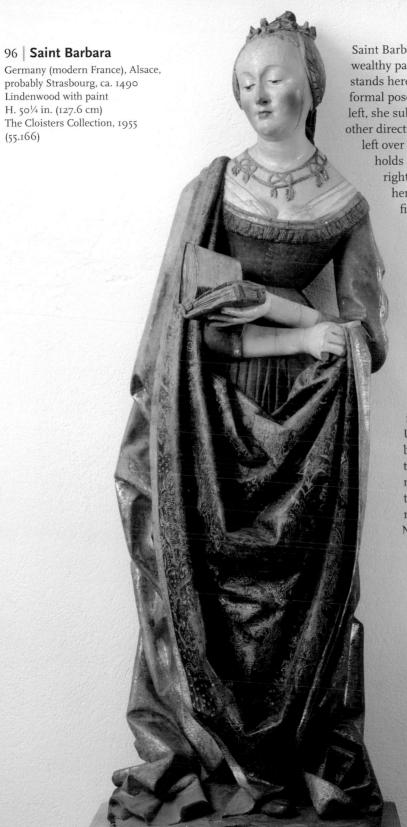

Saint Barbara, the daughter of a wealthy pagan of the third century, stands here in an elegant and complex formal pose. Leaning slightly to her left, she subtly tilts her head in the other direction; her arms are crossed,

left over right. In her left hand she holds an open book, and in the right one she grasps the hem of her voluminous mantle. The

> figure retains much of its original painted and gilded decoration, including the richly gilded foliate pattern in low relief on the mantle's interior. The sculpture can be associated with three other figures of saints, now dispersed, that once flanked the Virgin and Child in a large altarpiece from the church of Saint Mauritius in Kippenheim, in the Upper Rhine Valley. Strasbourg and other centers in that area were home to a number of innovative sculptors working in wood, beginning with the masterful Nikolaus Gerhaert von Leiden.

97 | The Death of the Virgin (The Dormition)

Workshop of Master Tilman Germany, Lower Rhineland, Cologne, late 15th century Oak $63 \times 73^{3/4} \times 17^{1/4}$ in. $(160 \times 187.3 \times 43.8 \text{ cm})$ The Cloisters Collection, 1973 (1973.348)

This shrine was originally painted and had two wings decorated in low relief with scenes of the Birth of the Virgin and the Adoration of the Magi (both now in the Rijksmuseum Twenthe, Enschede, Netherlands). The center image, seen here, represents the Death, or Dormition, of the Virgin, which is set in a domestic interior. Saint Peter stands at the back holding a book as he officiates at the sacrament of extreme unction. He is accompanied by ten other apostles. Through a doorway at far right we glimpse a depiction of a legend, recorded in the thirteenth century, in which Saint Thomas does not reach the Virgin before her death and is only convinced of her Assumption after her belt is dropped into his hands by an angel. Many of the other iconographic and stylistic elements of the shrine are derived from Netherlandish painting. This affinity is not surprising given that Master Tilman, the carver whose workshop made this piece, was active in the late fifteenth century in Cologne, a city that enjoyed close ties with the Lowlands.

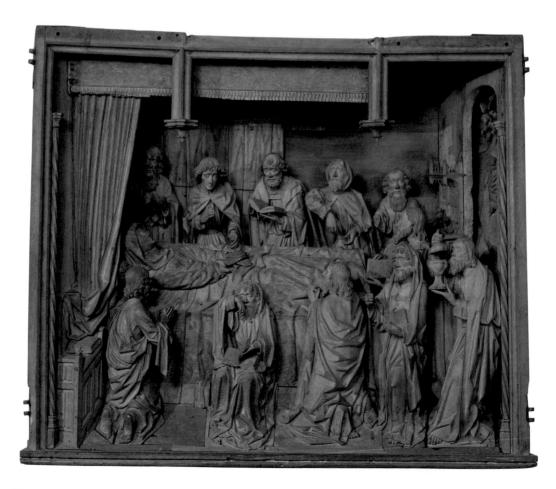

98 | The Lamentation

Spain, Castilla-La Mancha (Guadalajara), ca. 1480 From the Benedictine monastery at Sopetrán Walnut, paint, and gilding $83\times48\frac{1}{2}\times13\frac{1}{2}$ in. (211 × 123 × 34.3 cm) The Cloisters Collection, 1955 (55.85) The highly emotional, wrenching expressions on the faces of the standing figures in this shrine are heavily influenced by the work of the South Netherlandish painter Rogier van der Weyden (ca. 1399–1464). Indeed, it is possible the Spanish workshop that created this work included at least one Netherlandish artist, or perhaps the workshop had access to a sketchbook that included elements taken from Rogier's paintings. The shrine was originally the center section of an altarpiece from the ruined Benedictine monastery of Sopetrán, northeast of Madrid. The two panels with four painted scenes that formed the wings of the retable are now in the Prado, Madrid.

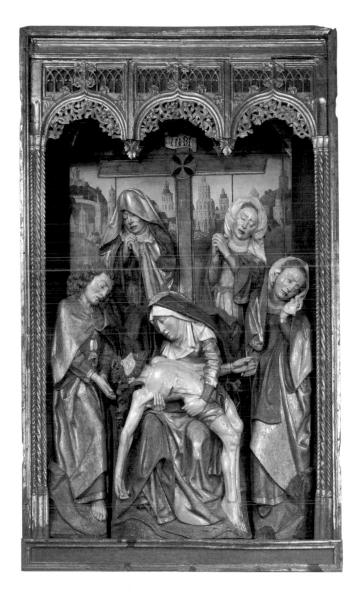

99 | Set of Fifty-two Playing Cards

South Lowlands, Burgundian territories, ca. 1470–80 Ink, tempera, and metal foil on pasteboard $5^{3}/8 \times 2^{3}/4$ in. (13.7 × 7 cm) each card The Cloisters Collection, 1983 (1983.515.1–.52)

The outstanding condition of these painted playing cards, the only known complete set to survive from the Middle Ages, suggests that they were never used. Each of the four suits is represented by number cards from one to ten and by a knave, queen, and king. Created before the standardization of the suits as we know them today, the set relies on symbols drawn from hunting paraphernalia: dog collars and horns (both red), and nooses and tethers (blue). The figures on the cards are dressed in elaborate costumes characteristic of the Burgundian court. Regrettably, we know little about how medieval card games were played.

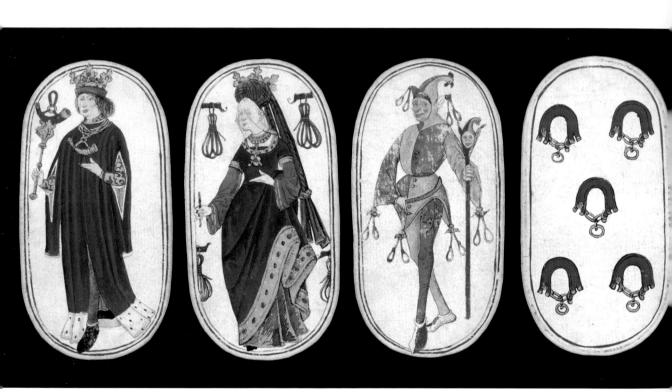

100 | Tau Cross

England, Lincolnshire, ca. 1485 Found in a field at Winteringham Cast and engraved gold $1^3/8 \times 1^1/8 \times 1/8$ in. (3.5 × 2.9 × 0.3 cm) The Cloisters Collection, 1990 (1990.283a, b)

A depiction of the Trinity is delicately engraved on the front of this pendant cross, which is actually a shallow capsule. An image of the Virgin and Child decorates the back. The stems that extend from beneath the arms of the cross at an angle originally held pearls; at the bottom edge there is a hole that once held a bell. The tau, or T-shaped cross, was associated with the Order of Saint Anthony Abbot. In the fifteenth century the disease called Saint Anthony's fire—a toxic condition caused by the consumption of spoiled rye—was widespread, and the order founded many so-called Antonine hospitals. The capsule most likely held an herbal compound used in treating the burning heat that was a primary symptom of the disease.

101 | Armorial Bearings and Badges of John, Lord Dynham

South Lowlands, 1488–1501 Wool warp and wefts with a few silk wefts 12 ft. 8 in. \times 12 ft. 1 in. (386.1 \times 368.3 cm) The Cloisters Collection, 1960 (60.127.1)

Although fragmentary, this large tapestry contains heraldic motifs with enough detail to allow us a glimpse into the life of John, Lord Dynham of Devonshire (1433–1501). Lord Dynham's personal badge (topcastle and broken mast) appears twelve times on the hanging, indicative of his long naval career under five English kings. But the hanging is dominated by his full achievement of arms, with his personal shield circumscribed by a blue garter, supported by a pair of stags, and surmounted by an ermine standing between two candles. The elaborate design marks the crowning moment of Lord Dynham's life—when he was elected to the Order of the Garter in 1487/88—and in all probability the hanging was commissioned to celebrate

this occasion. Quite a few tapestries from the second half of the fifteenth century employ this kind of millefleurs background interspersed with heraldic motifs, suggesting that the basic formula had become somewhat standardized. It is likely that clients would commission an artist to design an armorial device that would later be incorporated in such a tapestry.

102 | Fragment of a Chasuble

England, late 15th century Silk, metallic threads on linen and velvet $28^{3/4} \times 14^{1/4}$ in. $(73 \times 36$ cm) The Cloisters Collection, 1982 (1982.432)

A chasuble is an ecclesiastical vestment that is shaped like a sleeveless mantle and worn by the celebrant of the Mass. It is often made of luxurious fabrics such as silk and velvet and embellished with gold threads, precious stones, and other valuable materials. These splendid vestments reaffirm and enhance the prestige of the clergymen as well as the solemnity of the service. This chasuble fragment is decorated with two cherubim, each standing atop a wheel radiant with light, four fleurs-de-lis, and four thistles. The design and the shape of the fragment suggest that it formed the lower-right quadrant of the chasuble. The embellishments were embroidered

in England, whose workshops were known for producing some of the best embroideries, especially from the thirteenth to the fifteenth century. Indeed, the term opus anglicanum (English work), which became synonymous with English embroideries, appears more than one hundred times in the Vatican inventory of 1295.

103 | Seated Bishop

Tilman Riemenschneider (1460–1531) Germany, Franconia (Lower Franconia), Würzburg, ca. 1495-1500 Lindenwood $35^{1/2} \times 14 \times 5\%$ in. (90.2 × 35.6 × 14.9 cm) The Cloisters Collection, 1970 (1970.137.1)

Tilman Riemenschneider was one of the finest and most successful sculptors of the late Middle Ages. This well-conceived image of a venerable but unidentified bishop is representative of the carver's early work. With its seated, S-shaped pose and finely carved details, it can be compared to the evangelist figures of Riemenschneider's Münnerstadt altarpiece of 1492–94 (Staatliche Museen zu Berlin, Skulpturen Sammlung). There are no indications of painted decoration on the sculpture other than black in the irises and red on the lips. In fact, many of the figure's carefully realized details, such as the facial wrinkles and the fringe on the bishop's cope, would be

obscured by the layer of gesso applied beneath a paint. Riemenschneider was an innovator in the use of lightly stained sculpture, so it is likely that the bishop is an example of this aspect of his work. The fine grain of lindenwood, or limewood, made it well suited for this purpose.

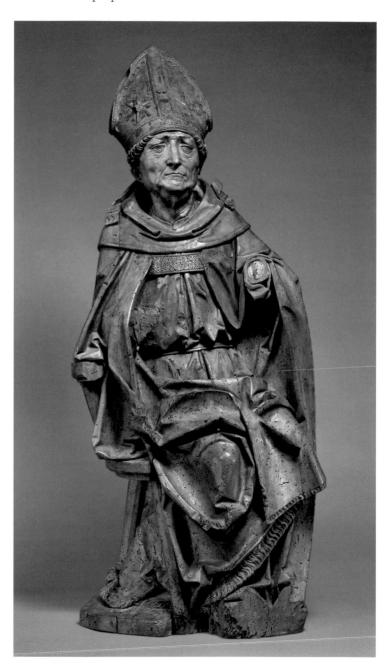

104 | Three Kings from an Adoration Group

Germany, Swabia, before 1489 From the high altar of the Cistercian abbey at Lichtenthal, near Baden-Baden, in Baden-Württemberg Poplar, paint, and gilding H. left to right: 64½ in. (163.8 cm); 40 in. (101.6 cm); 61½ in. (156.2 cm) The Cloisters Collection, 1952 (52.83.1–3) Ever since the Holy Roman Emperor Frederick Barbarossa acquired their relics for Cologne in 1164, the Three Kings, or Magi, have enjoyed great popularity in the art of northern Europe. By the late Middle Ages they were believed to have descended from the sons of Noah and were thus often represented as three distinct races: European, Asian, and African. These three almost lifesize statues, decorated with extensive painting and gilding, were once part of an altarpiece depicting the Adoration of the Magi. Two of the sculptures, the crowned Balthasar and the kneeling Melchior, would have stood on either side of the seated Virgin and Child group, which remains in the Cistercian convent at Lichtenthal. Together they form a descending diagonal balanced by the dancerlike Gaspar on the far right. In animated and playful poses, they bring to the Christ Child gifts of gold, frankincense, and myrrh.

The Lichtenthal altarpiece was originally flanked by two wings painted with scenes from the life of the Virgin. The date 1489 appears on one of the painted scenes along with the name Margarethe, the abbess of Lichtenthal who commissioned this impressive ensemble seven years before her death.

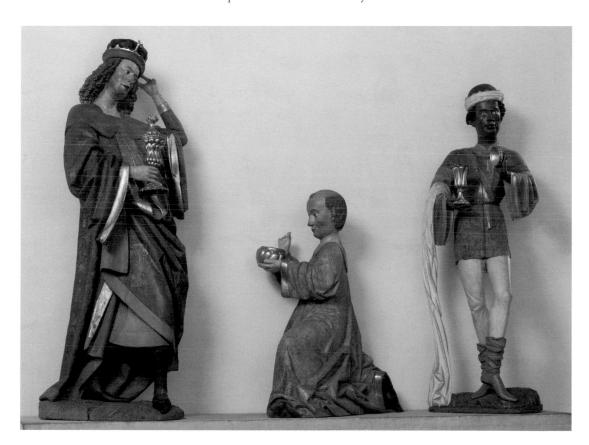

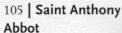

Attributed to Niclaus of Haguenau (ca. 1445–1538) Germany (modern France), Alsace, Strasbourg, ca. 1500 Walnut H. 44¾ in. (113.7 cm) The Cloisters Collection, 1988 (1988.159)

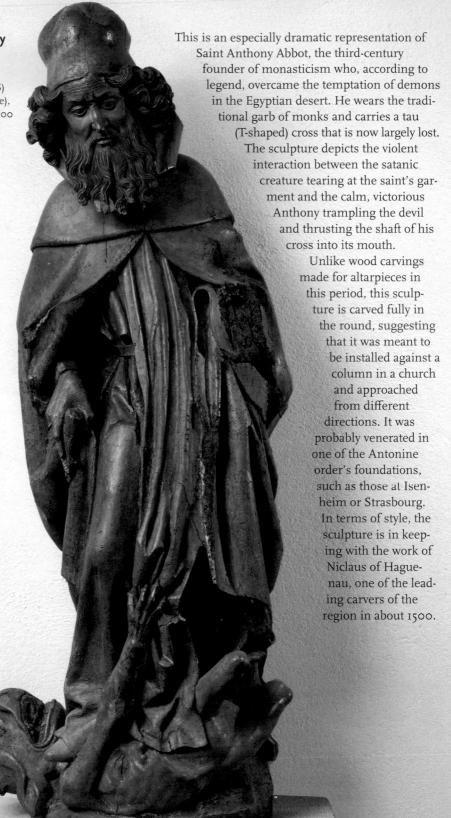

106 | Covered Beaker

Attributed to the workshop of Sebastian Lindenast the Elder Germany, Franconia, Nuremberg, ca. 1490–1500 Copper gilt H. 91% in. (23 cm); Diam. 31/4 in. (9.5 cm) The Cloisters Collection, 1994 (1994.270a, b)

During the Middle Ages, silversmiths in Nuremberg and other cities were generally prohibited from working in copper gilt in order to protect the lucrative market for precious wares. By imperial privilege, however, the Lindenast family was permitted to use copper, and this finely made vessel is probably from the workshop of Sebastian Lindenast the Elder. It is not marked, as it likely would be if it had been made in silver, but it is stylistically consistent with the work of Nuremberg silversmiths. In addition to its attractive profile and crisply engraved, lively design, the beaker is notable for its well-preserved gilded surface.

107 | Covered Chalice

Spain, Castilla-La Mancha, Toledo, late 15th century
Silver gilt with rubies, sapphires, diamonds, and crystals
H. 17½ in. (43.7 cm);
Diam. 7¾ in. (19.7 cm)
The Cloisters Collection, 1958
(58.39a, b)

The rare openwork cover on this Spanish chalice, with its elaborate ornament drawn from late Gothic architecture, nearly overwhelms the form of the vessel itself. The exterior of the bowl is engraved in Gothic letters with the Latin text of the Hail Mary-AVE MARIA GRACIA PLENA DOMINUS [TECUM]—the greeting of the Archangel Gabriel to the Virgin Mary when he announced the forthcoming birth of Jesus. The six facets of the knop and the cover are embellished with pointed arches beneath which appear busts of Christ, the Virgin and Child, and saints. On the lobes of the foot are representations of the Crucifixion, the Instruments of the Passion, the Virgin and Child, and the Lamentation. Both the base and the cover bear the mark used by goldsmiths in Toledo during the fifteenth century.

108 | Triptych with Scenes from the Passion of Christ

Possibly Master Pertoldus (Berthold Schauer?) Austria, Salzburg, 1494 From the Benedictine abbey of Saint Peter at Salzburg Silver, silver gilt, mother-of-pearl, bone, and cold enamel $27\frac{3}{8} \times 9\frac{3}{8} \times 7\frac{1}{4}$ in. $(69.5 \times 25.1 \times 18.4 \text{ cm})$ open Gift of Ruth and Leopold Blumka, 1969 (69.226) This triptych is remarkable for its completeness as well as for the high quality of its execution. At the center of the shrine is the Crucifixion, with Christ before Pilate on the bottom panel of the left wing, and the Bearing of the Cross above. On the right wing, the Agony in the Garden is at top, with the Entombment below. Above the center section are three medallions (the one on the left is a modern replacement) representing, from left to right: Saint Catherine, the Virgin and Child, and Saint George and the Dragon. The Annunciation appears on the large medallion below the Crucifixion. In addition to these carved appliqués and the silver figure of Christ at the top, the triptych is embellished with skillful engravings. Saints Andrew, Benedict, and Catherine appear on the base, while the Last Supper

Front

Back

is depicted on the reverse of the central shrine, flanked by the Flagellation and the Arrest of Christ (left), and the Crown of Thorns and the Resurrection of Christ (right).

The inscription above the Crucifixion—RUDBERTI ABBATIS PERSTO EGO IUSSO SUO (I stand by order of Abbot Rupert)—links the triptych to Abbot Rupert Keutzl of the Benedictine abbey of Saint Peter at Salzburg. The date 1494 appears three times on the object. Documents record a triptych made about this date by the goldsmith Pertoldus, but we cannot be certain that that work is the same as The Cloisters' triptych.

109 | Cloister from Trie-en-Bigorre

France, Pyrenees (Hautes-Pyrénées), late 15th century From monuments at Trie-sur-Baïse, Larreule, and possibly Saint-Sever-de-Rustan, near Tarbes Marble 35 ft. 8 in. \times 47 ft. $2^{1/2}$ in. (10.9 \times 14.4 m) The Cloisters Collection, 1925 (25.120.177) The capitals from the cloister of the Carmelite convent at Trie-en-Bigorre, near Toulouse, are decorated with scenes from the Old and New Testaments and the lives of the saints. The use of white marble for the capitals and colored marble for the shafts indicates that this was a prestigious commission. Since the original arrangement of the capitals is unknown, they are displayed sequentially, corresponding to their unfolding narratives. Many coats of arms are found on them (below); those of Catherine de Foix, queen of Navarre, and her husband, Jean d'Albret, who married in 1484, help establish the earliest possible date for the construction of the cloister. After the

Detail of capital, showing the French royal coat of arms

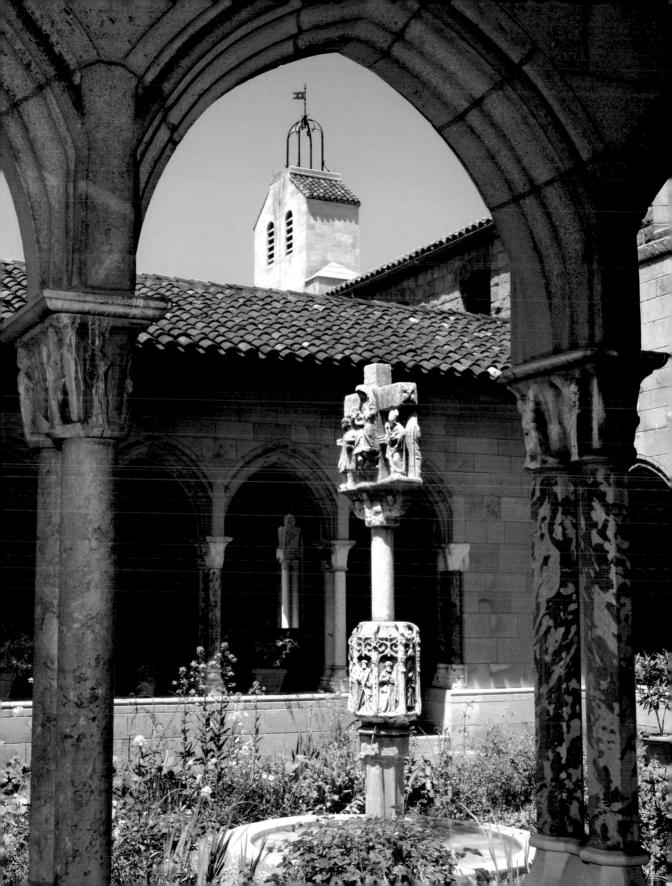

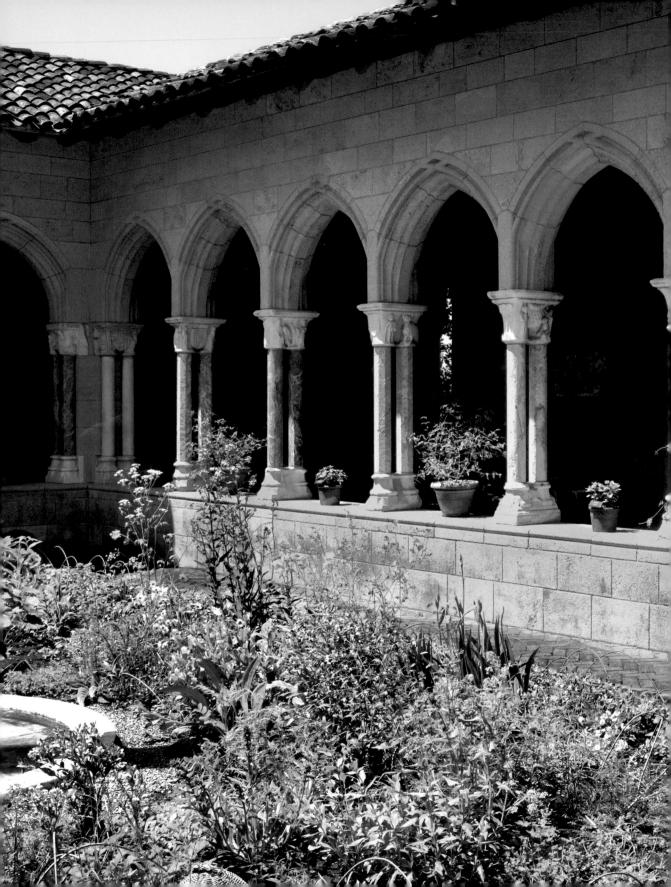

Huguenots destroyed all of the monastic buildings except for the church in 1571, some of the Trie capitals were sold to the Benedictine monastery of Saint-Sever-de-Rustan for the rebuilding of its own cloister. Twenty-eight of them changed hands again between 1889 and 1890, when they were sold to the city of Tarbes. Of the eighty-one capitals known to have been at Trie, eighteen are now at The Cloisters.

The flowery meadow familiar from so many medieval works of art is re-created in the Trie Cloister garden, where a multitude of plants blooms in different seasons on a ground bordered with periwinkles. The fragrant display is accompanied by the sound of running water from the central fountain, which is composed of late medieval and modern elements. Together with the chirping birds, butterflies, and bees, the plantings transform this delightful enclosure into a vivid display of the flora and fauna seen in tapestries of the Middle Ages.

Detail of capitals, with the Nativity in the foreground

110 | Doorway and Staircase Enclosure

France, Picardy (Somme), late 15th or early 16th century From 29, rue de la Tannerie, Abbeville Oak 14 ft. 10 in. \times 68½ in. \times 9 ft. 9½ in. (452.1 \times 174 \times 298.5 cm) Frederick C. Hewitt Fund, 1913 (13.138.1)

This intricately carved wood doorway and staircase enclosure come from a house in Abbeville, in northern France. Although long known as the "House of Francis I," the timber-framed, two-story home was probably built for an affluent tanner. The doorway opened into a passage connecting the street and the inner court-yard, while the adjacent enclosure provided entrance to a spiral staircase. Statuettes protected by delicate canopies originally stood on the carved pedestals. The openwork tracery at top exemplifies the complex and sophisticated design of the Flamboyant style. Below, the rectangular panels are carved with variations on a main motif, consisting of a central vertical stem with bifurcated terminals scrolling into a curving *V* at either end. A cord is knotted or tied to the stem, which in turn is flanked by a pair of interlacing arcs.

Before the doorway and enclosure were sold in 1907, the house had been used as a livery stable and a tavern (below). The area where the house once stood was completely destroyed during World War II, leaving no trace of the old block.

Lewis John Wood (1813–1901). Courtyard of the "House of Francis I," no. 29, rue de la Tannerie, Abbeville. Watercolor on paper, $19^{1/8} \times 13^{5/8}$ in. (48.6 x 34.6 cm). Rogers Fund, 1943 (43.92)

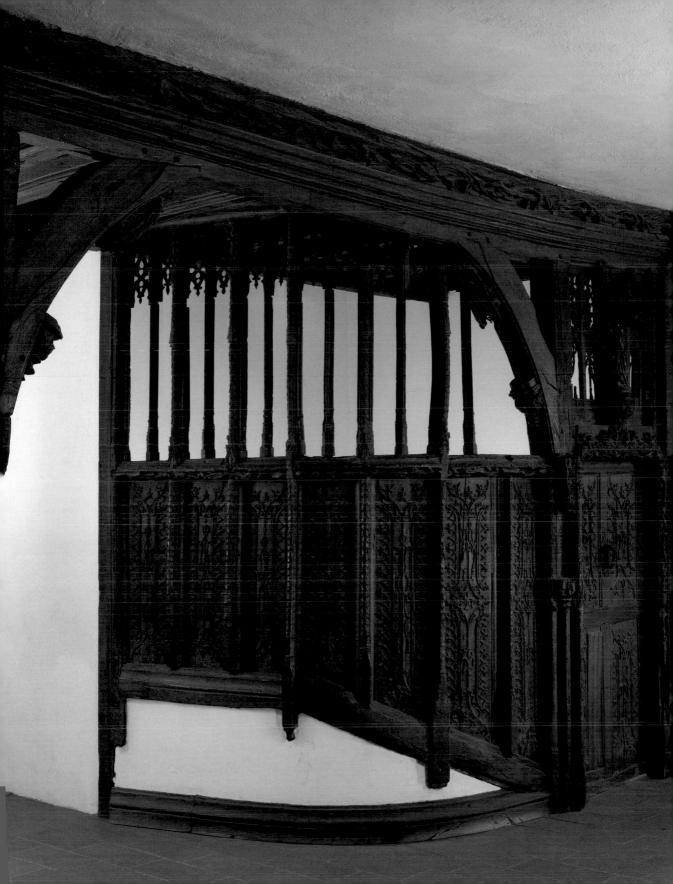

111 | One of a Pair of Ewers

Germany, Franconia, probably Nuremberg, ca. 1500 Silver gilt, enamel, and paint H. 25 in. (63.5 cm) The Cloisters Collection, 1953 (53.20.2)

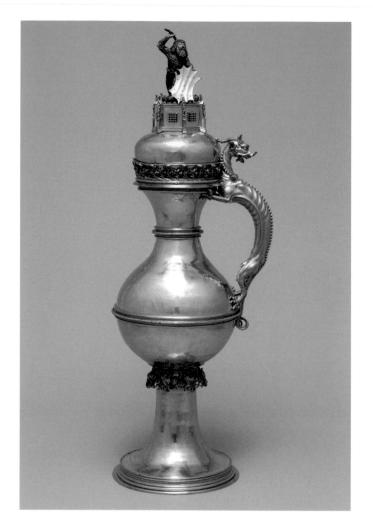

The lid of this large silver ewer bears the figure of a bearded "wild man" carrying a club over his shoulder. The mythical wild man, his body covered with a coat of green hair, was a popular figure in the art and literature of the late Middle Ages. He was associated not only with wildness but great strength, too. The beautifully formed handle thus represents a powerful dragon that, apparently, has been tamed by the wild man. The ewer and its mate, also at The Cloisters (53.20.1), have been associated with ewers described in inventories of the Order of Teutonic Knights, one of the military and religious orders of knighthood established during the Crusades and a powerful force in late medieval Germany. The coat of arms originally fixed to the shield held by the wild man might have been that of Hartmann von Stockheim, Master of the Order of Teutonic Knights from 1499 to 1510/13.

112 | Lectern in the Form of an Eagle

Attributed to Aert van Tricht the Elder South Lowlands, Maastricht (Limburg), ca. 1500 From the church of Saint Peter at Louvain Brass 79½ × 42½ in. (201.9 × 108 cm) The Cloisters Collection, 1968 (68.8)

Atop this large lectern, which was used for reading from the Gospels, is an impressive eagle, symbol of Saint John the Evangelist, perched with a dragon beneath its talons. A complex object assembled from many separately cast parts, the lectern is supported by three lion feet and embellished with figures of the Magi, Christ, Saint Peter, Saint Barbara, and Old Testament prophets. In the nineteenth century,

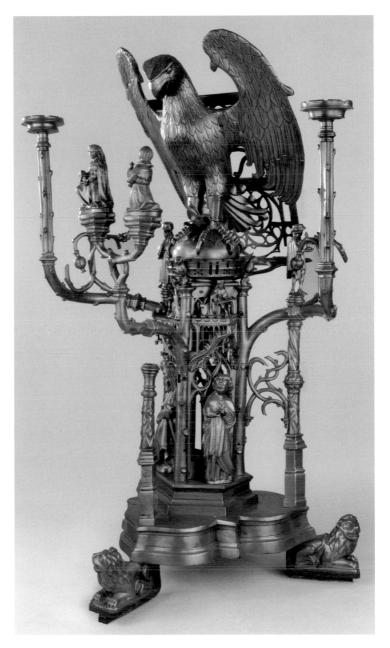

John Talbot, sixteenth earl of Shrewsbury, donated the lectern to the cathedral of Saint Chad in Birmingham, England, designed by the renowned Gothic Revival architect A. W. N. Pugin (1812–1852). The figures of Saint Barbara and the first Magus are nineteenth-century replacements, dating from the time of Pugin's involvement with the lectern.

113 | Man of Sorrows

South Germany, ca. 1500 Elephant ivory with paint and gilding 3^{3} /s \times 2^{1} /2 in. (8.6 \times 6.5 cm) The Cloisters Collection, 1999 (1999.227)

After a period of prolific production from the late thirteenth century through most of the fourteenth century, European ivory carving waned, becoming sporadic after about 1400. This finely carved plaque, which follows a composition by the influential printmaker Martin Schongauer (ca. 1430–1491), depicts the Man of Sorrows, the quintessential late medieval devotional image. The half-length figure of Christ, wearing the Crown of Thorns his tormentors placed on his head prior to his Crucifixion, appears between the mourning figures of the Virgin and Saint John the Evangelist. He is portrayed with his arms crossed over his chest, revealing the wounds on his hands. Two half-length winged angels appear above him holding a cloth behind the lower figures. This image of the suffering Christ, independent of any narrative, is intended to evoke pity and compassion in the beholder.

Scientific examination of the painted surface of the plaque has revealed that there are two layers of paint, with the second campaign following the scheme of the original. The plaque was most likely the central element in a devotional object, perhaps a triptych, that was made of silver or another metal.

114 | Memento Mori (Dives in Hell)

North Lowlands or Lower Rhineland, ca. 1500
Boxwood $2^{5/8} \times \frac{7/8}{8}$ in. (6.7 × 2.2 cm)
Gift of Ruth Blumka, in honor of Ashton Hawkins, 1985 (1985.136)

In about 1500 workshops in northern Europe produced a number of astonishingly detailed "microcarvings" in boxwood. Traditionally such carvings have been attributed to Brabant, in the South Lowlands, but convincing new arguments suggest that they were carved in the North Lowlands or Lower Rhineland. Of these, miniature altarpieces and rosary pendants survive in the greatest numbers. This memento mori, or reminder of the inevitability of death, is more unusual. The object takes the form of a casket embellished with scenes and inscriptions referring to the parable of the rich man who refused charity to Lazarus. In the Middle Ages, that man came to be identified with the name "Dives," Latin for rich, and inside the casket we see an image of Dives being tormented in hell for eternity.

115 | The Mater Dolorosa

Circle of Peter Hemmel von Andlau (Lautenbach Master) Germany, Swabia, ca. 1480 From the chapter house (formerly library) of the cathedral of Constance Pot-metal glass, colorless glass, silver stain, and vitreous paint $195\% \times 163\%$ in. (49.8 × 41.6 cm) The Cloisters Collection, 1998 (1998.215b)

Against a deep blue background patterned with scrolling foliate motifs stands the Virgin Mary, her hands folded across her chest. The soft, expressive features of the grieving Virgin lend the panel a somber aura of serenity. She is flanked by two trees, each with a branch extending toward the center to form a canopy above her head. A row of crocket finials lines the lower border of the panel.

About 1480 the dean and chapter of the cathedral of Constance commissioned a total of eighty-one panels of glass for the cathedral's chapter house. Today, only nineteen panels survive, including this serene portrayal of the Mother of Sorrows. The commission was awarded to Peter Hemmel von Andlau and his Strasbourg Workshop-Cooperative, an association formed just three years earlier that adhered to the style of the master. Especially characteristic of Hemmel's technique is the use of mattes, in which the brush and stylus were employed to create shades of volume. On stylistic grounds the panels have been attributed more specifically to the Lautenbach Master, who documents say was either the son or son-in-law of Peter Hemmel. The Lautenbach Master is named after the parish church where he executed his most ambitious glazing program.

116 | Quatrefoil Panel with Secular Scenes

Germany, Franconia, Nuremberg, 1490–1500 Pot-metal glass, white glass, vitreous paint, and silver stain Diam. 12¹/₄ in. (31.1 cm) Samuel P. Avery Memorial Fund, 1911 (11.120.2) This roundel is decorated with the arms of the Holy Roman Empire, at center, surrounded by four medallions that represent secular subjects associated with feasting and courtship. In the bottom medallion, for example, a fool helps himself to food, perhaps an allusion to the period preceding Lent, when carnivals, tournaments, and masquerades were held. A companion panel in The Cloisters' collection (II.I2O.I) depicts scenes of heralds announcing the start of tournaments, which as we see here were participated in by knights and fools alike. Such images, really parodies or mockeries of chivalric ideals, were a popular form of social satire in the late medieval period.

Roundels of this type were luxury items used to decorate windows in nonreligious buildings. The presence of the imperial arms indicates that this panel's intended destination had courtly connections. Sufficient examples have survived to attest to the popularity of quatrefoil roundels, most of which were produced in workshops in Nuremberg.

117 | The Hunters Enter the Woods

South Netherlands, 1495–1505 Wool warp with wool, silk, silver, and gilt wefts 12 ft. 1 in. \times 10 ft. 4 in. (368.3 \times 315 cm) Gift of John D. Rockefeller Jr., 1937 (37.80.1)

This tapestry is one of seven hangings at The Cloisters that depict the hunt of the unicorn, a mythical creature first mentioned by the Greek physician Ctesias in the fourth century B.C. In the Middle Ages the animal was best known for its supposed invincibility and for the therapeutic property of its horn. So strong was the belief in the horn's miraculous cures that by the twelfth century the tusks of male narwhals, a small whale native to the Arctic, came to be regarded as "unicorn horns."

The Unicorn Tapestries, as the group of seven is known, were probably designed in Paris but woven in Brussels. They are first documented in 1680, when they hung in the Paris home of François VI de La Rochefoucauld. By 1728 five of them decorated a bedroom at the family's château in Verteuil, in western France. The tapestries were looted during the French Revolution but were recovered in the 1850s; by 1856 they had been restored and rehung in the château's salon. No documentation sheds light on the early history of the tapestries, including either their commission or sequence of hanging. Striking differences in dimension and composition have prompted scholars to question whether the hangings constitute one set or are, in fact, from multiple sets.

The Hunters Enter the Woods, like The Unicorn in Captivity (no. 123), is set against a millefleurs background: a field of dark green spangled with blossoming trees and flowers. Of the 101 species of plants represented, 85 have been identified, including the prominent cherry tree behind the hunters and the lush date palm in front of the sniffing hound. The cipher "AE" that is woven into each of the Unicorn Tapestries—and repeated here five times—alludes to their original owners, who remain unknown.

118 | The Unicorn Is Found

South Netherlands, 1495–1505 Wool warp with wool, silk, silver, and gilt wefts 12 ft. 1 in. \times 12 ft. 5 in. (368.3 \times 378.5 cm) Gift of John D. Rockefeller Jr., 1937 (37.80.2)

In this tapestry the unicorn kneels before a tall white fountain that has a pair of pheasants and a pair of goldfinches perched on its edge. Other animals both exotic and native to Europe lounge about, while twelve hunters in the back of the scene discuss the discovery of their quarry. Flora and fauna play a significant role in the narratives of the Unicorn Tapestries. Plants prescribed in medieval herbals as antidotes to poisoning, such as sage, pot marigolds, and orange, are positioned near the stream, which is being purified by the unicorn's magic horn. Visual cues suggest that this tapestry can be read as an allegory of the Passion of Christ, including the presence of exactly twelve hunters (the apostles) and the prominent rosebush (martyrdom) directly behind the unicorn.

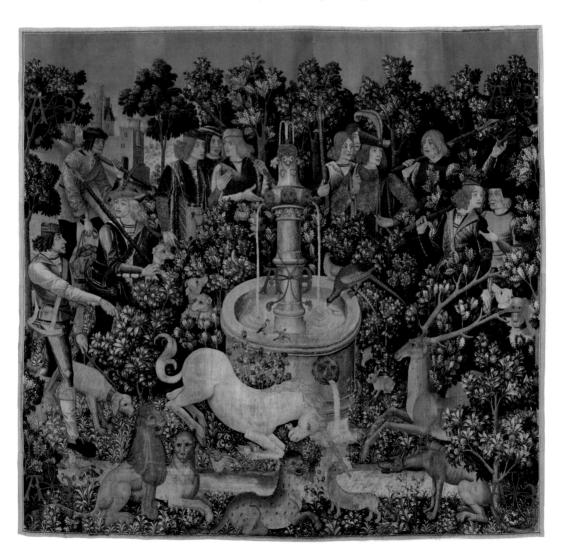

119 | The Unicorn Is Attacked

South Netherlands, 1495–1505 Wool warp with wool, silk, silver, and gilt wefts 12 ft. 1 in. \times 14 ft. (368.3 \times 426.7 cm) Gift of John D. Rockefeller Jr., 1937 (37.80.3)

According to tradition, the unicorn cannot be disturbed while performing a magical act. The attack by the hunters thus presumably begins soon after the action depicted in *The Unicorn Is Found*, and the scene is one filled with chaos and commotion. The ferocity of the battle is conveyed by the converging lances aimed at the animal, the sounding of the hunting horns, and the menacing hounds. Already wounded on his back, the unicorn leaps across a stream in a desperate attempt to escape his encircling enemies.

The use of hounds to scout, chase, and eventually attack the quarry was typical practice in medieval stag hunts, and the palatial buildings in the background might be a further allusion to the hunt as a royal or aristocratic pastime. Unlike *The Hunters Enter the Woods* and *The Unicorn in Captivity*, this and the other hangings are set in realistic landscapes that enhance the drama of the hunt.

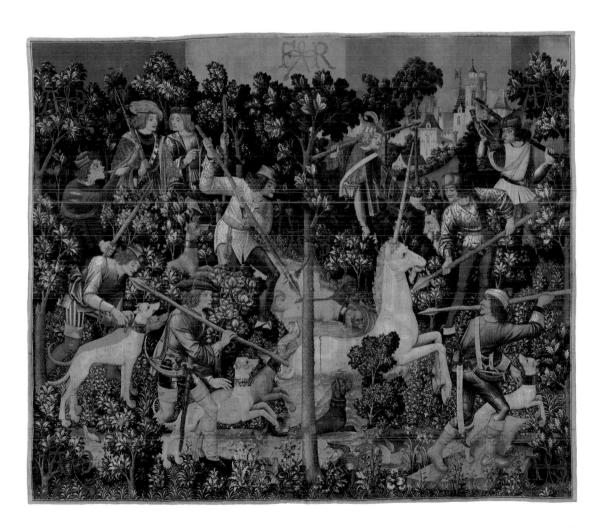

120 | The Unicorn Defends Itself

South Netherlands, 1495–1505 Wool warp with wool, silk, silver, and gilt wefts 12 ft. 1 in. × 13 ft. 2 in. (368.3 × 401.3 cm) Gift of John D. Rockefeller Jr., 1937 (37.80.4) Here the injured unicorn is being held at bay by three hunters ready to pierce him with their lances. The furious animal reacts with a gruesome attack on a greyhound before him, almost tearing the dog's body apart. The horn-blowing hunter at lower left wears a scabbard with the inscription ave regina c[oeli] (Hail, Queen of the Heavens). He is often thought to represent the Archangel Gabriel, who announced to the Virgin Mary that she is to give birth to the Christ Child. The huntsmen and other figures are garbed in the fashions of about the turn of the sixteenth century, including round-toed shoes and fitted bodices, and their headdresses and hairstyles also reflect contemporary tastes. The mastery of the weavers is evident in the convincing representation of different materials and textures in the costumes, such as brocade, velvet, leather, and fur.

In order to make the tapestries, plain wool yarns (the warp) were stretched between two beams of a large loom; a bobbin then brought dyed and metallic threads (the wefts) over and under the warp threads to create the design. Chemical analyses reveal that the dye pigments used in the Unicorn Tapestries came from such plants as weld (yellow), madder (red), and woad (blue), all of which are grown in the Bonnefont Cloister garden (no. 49). With the aid of mordants, substances that help fix the dyes to fabric, these three primary colors were blended to achieve a dazzling spectrum of hues strategically highlighted by the addition of metallic threads.

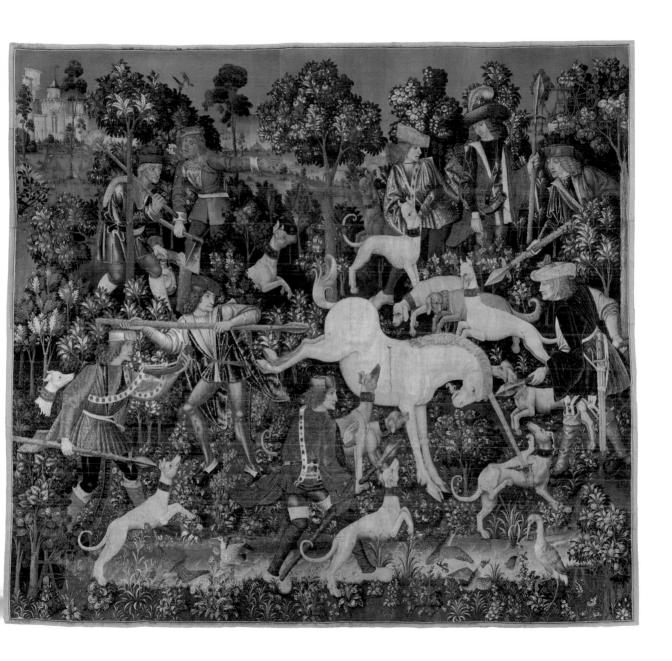

121 | The Mystic Capture of the Unicorn

South Netherlands, 1495–1505 Wool warp with wool, silk, silver, and gilt wefts $66\frac{1}{2} \times 25\frac{1}{2}$ in. (168.9 \times 64.8 cm); $78 \times 25\frac{1}{2}$ in. (198.1 \times 64.8 cm) Gift of John D. Rockefeller Jr., 1938 (38.51.1, .2)

In these two fragments of a single tapestry, the unicorn appears to have been tamed. He seems so docile, in fact, that he is oblivious to the dog licking the wound on his back and stares lovingly at the maiden who must have subdued him. Most of her figure is missing, the result of damage incurred after the tapestries were looted in 1793. The remaining traces include the maiden's right arm, clothed in red velvet and visible between the beard and throat of the unicorn, and her fingers, seen gently caressing the bottom of the animal's mane. She sits in an enclosed garden (*hortus conclusus*), often a metaphor for the purity of a maiden. The more complete female figure may be signaling to the hunter outside the garden, who in turn sounds his horn to summon the others.

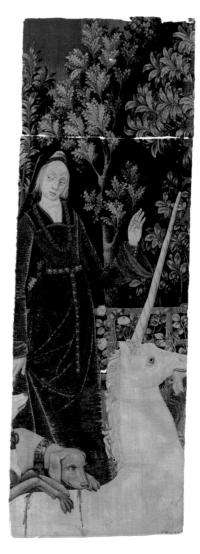

122 | The Unicorn Is Killed and Brought to the Castle

South Netherlands, 1495–1505 Wool warp with wool, silk, silver, and gilt wefts 12 ft. 1 in. × 12 ft. 9 in. (368.3 × 388.6 cm) Gift of John D. Rockefeller Jr., 1937 (37.80.5) Two episodes of the hunt narrative are brought together in this hanging. At left, two hunters drive their lances into the neck and chest of the unicorn, as a third delivers the coup de grâce from the back. It has been suggested that the doomed unicorn is an allegory for Christ dying on the Cross; the large holly tree (often a symbol of the Passion) rising behind his head seems to reinforce this association. In the other episode, at right, a lord and his lady receive the body of the unicorn in front of their castle. They are surrounded by their attendants, with more curious onlookers peering through windows of the turret behind them. The dead animal is slung on the back of a horse, his horn already cut off but still entangled in thorny oak branches—probably symbolizing the Crown of Thorns. The rosary in the hand of the lady and the three other women standing behind the lord encourage a deeper reading of the scene, perhaps as a symbolic Deposition witnessed by the grieving Virgin Mary, John the Baptist, and the Holy Women.

123 | The Unicorn in Captivity

South Netherlands, 1495–1505 Wool warp with wool, silk, silver, and gilt wefts 12 ft. 1 in. \times 99 in. (368 \times 251.5 cm) Gift of John D. Rockefeller Jr., 1937 (37.80.6) One of the most beloved objects at The Cloisters, this tapestry shows the captured unicorn resting in a flowery meadow within the confines of a circular fence. Behind him is a pomegranate tree, some of its fruits bursting with seed. This seemingly simple design belies many layers of possible readings. According to some, the unicorn here symbolizes a happy groom now bonded by marriage (the circular fence) to his love (his collar, a form of the "chain of love"). The red drops on his back can thus be read as the juice of the pomegranate, a fruit considered a fertility symbol in the Middle Ages. Plants such as bistort (by his right knee) and the large European orchid (whose bloom is set against his body) were believed to have medicinal properties that would, respectively, help women conceive and determine the sex of the unborn child. Not all of the plant symbolism is secular, however. Both the Madonna lily and Saint Mary's thistle make reference to the Virgin Mary, while the carnation (to the left of the irises) is thought to symbolize the Passion of Christ.

The brilliant colors, beautiful landscapes, and realistic depictions of flora and fauna in all of the Unicorn Tapestries combine to make these hangings invaluable and cherished works of art. It is the free blending of the secular and the sacred, however, that truly distinguishes this group of seven tapestries as a rich source for the study of medieval art, iconography, and lore.

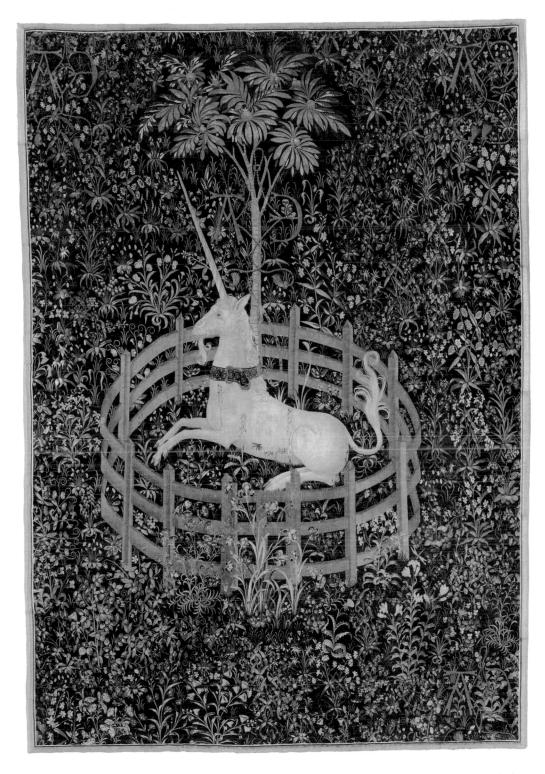

124 | Beaker

Germany, probably Lower Rhineland, early 16th century Pattern-molded potash-lime glass with applied decoration H. 3½ in. (9 cm); Diam. 3¼ in. (8.3 cm) The Cloisters Collection, 1983 (1983.16)

By the beginning of the fifteenth century glass was increasingly the material of choice for drinking vessels, replacing cruder ones of wood and earthenware and sometimes more expensive metal ones. Surviving glass vessels, as well as representations of them in manuscript illuminations, prints, and panel paintings, indicate that glass forms grew more and more sophisticated about 1500. In this especially well-preserved example, the body of the beaker, with its prunted decoration (the applied "blobs" of glass), is surmounted by a wide, flaring lip that has been textured in a mold. The vessel's green color derives from the iron content of river sand, which was the primary ingredient for glass. Northern European forests provided ample supplies of fuel and ash, also required for glassmaking.

125 | Panels with Scenes from the Life and Passion of Christ

France, Normandy (Seine-Maritime), early 16th century Probably from a church at Jumièges Oak $35\frac{1}{2} \times 11\frac{3}{8} \times 1\frac{1}{2}$ in. $(90.2 \times 28.9 \times 3.8 \text{ cm})$ each The Cloisters Collection, 1950 (50.147.1, .2)

Until 1950 these panels lined the Great Hall of Highcliffe Castle in southern England. Constructed in the 1830s for Lord Stuart de Rothesay, the castle was furnished in part with stonework acquired from the ruined royal abbey at Jumièges in Normandy, where the panels might also have originated. In all likelihood they once decorated the backs of choir stalls ordered in 1501 by the abbot of Jumièges.

Carved on The Cloisters' thirty-five oak panels are scenes from the lives of the Virgin and Christ, each set under an elaborate canopy of single or double arches. The exuberant latticework surrounding the arches provides an almost encyclopedic display of pinnacles, crockets, spirals, and other fanciful decorations. The panels shown here open the narrative sequence, with the childless Joachim and

Anne standing inside the Temple, saddened by the refusal of their offering. On the next panel an angel, arching his body, appears to Joachim with the news that he and Anne will have a daughter and that she will be named Mary. As in many late medieval works, the figures are foreshortened within their inhabited surroundings, adding depth and drama to the composition.

126 | Sorgheloos (Carefree) in Poverty

North Lowlands, 1510–20 Colorless glass with silver stain and vitreous paint Diam. 9 in. (23 cm) The Cloisters Collection, 1999 (1999-243) The story of Sorgheloos ("carefree" in Dutch) is one of the most well-known moral lessons of the late medieval period. Like the Prodigal Son of the Christian parable, Sorgheloos led a carefree life, spending at will until he became penniless and friendless. Unlike the Prodigal Son, however, who is received by his forgiving father, Sorgheloos is condemned to the perpetual companionship of Aermoede ("poverty"), who we see gleaning straw in the background of this roundel. Sorgheloos, meanwhile, sits in his impoverished room before a fire, stirring a kettle of boiling herring with a sheath of straw and using a wood tub for a chair. He owns only an empty cupboard and a handful of utensils, his grinding poverty vividly illustrated by the emaciated dog, expiring cat, and dead rat.

Silver-stained roundels were commissioned largely for domestic, civic, or professional settings in northern Europe. In the Lowlands, particularly, moralizing tales taken or adapted from biblical and

secular sources were extremely popular, reflecting the values of the rising middle class. They were made in great quantities, a factor of their small size and the relative ease with which they could be displayed. The final color of the silver stain depended on many variables, including the materials used and the duration of the firing, but only the finest glass painters were able to achieve the warm and luminous shades of gold unique to this type of glass.

127 | Saint Michael

North Spain, Castilla-León (Burgos), probably Burgos, ca. 1530 Wood, paint, and gilding H. 73½ in. (186.7 cm) The Cloisters Collection, 1953 (53.65)

Judging from Saint Michael's leaning posture and the sculpture's large scale, it seems likely that this statue was intended to be seen from below, in a manner

> and high places. Michael, the warrior saint, is represented wearing steel plate armor, and he originally held a lance in his right hand with which he slew the winged devil beneath his feet (now missing its head). Consistent with Saint Michael's role in weighing souls at the Last Judgment, his left hand would have held a scale. No specific attribution for the sculpture has emerged, but it is generally consistent with those produced in Burgos in the early sixteenth century. This sculpture neatly evokes that period, when the elegant spirit of late Gothic art began to blend into the emerging Renaissance style.

GLOSSARY
SUGGESTED READINGS
SELECTED REFERENCES
ACKNOWLEDGMENTS
INDEX

GLOSSARY

Words appearing in *italic* type are defined elsewhere in the glossary.

A | abbot/abbess: head or superior of a monastery.

acanthus: Mediterranean plant whose spiky foliage has served as a decorative motif for architecture and sculpture since classical Greece.

alabaster: dense, transparent form of gypsum; used only for interior sculpture because it is slightly soluble in water.

alloy: metal composed of two or more metals (or a metal and a non-metal) that are combined in the molten state. Bronze, for example, is primarily copper and tin.

Alsace: in the *Middle Ages*, a region of the Holy Roman Empire located west of the Rhine; today part of eastern France.

altar: table (or a fixed or portable table-like structure) used for religious ceremonies; must be consecrated before it is suitable for the celebration of the *Eucharistic sacrament*, or communion.

altar frontal: decorative cover on the front of an *altar*; also called an *antependium*.

altarpiece: decorative structure behind an *altar*, often painted or carved, sometimes consisting of several panels; also called a *retable*.

antependium: see altar frontal.

angel: spiritual being believed to be an intermediary between God and humanity. Angels are ranked in a cosmic hierarchy of nine levels and duties, such as seraphim, *cherubim*, archangel, etc.

Apocalypse: visions of the end of time revealed to Saint John, whose recording of it became the *book of Revelation*, the last book of the New Testament.

apostles: twelve disciples of Christ sent out to spread his teachings.

apse: domed space, often semicircular or polygonal in shape, located usually at the east end of a church.

aquamanile: vessel, often in the form of an animal, used to pour out water for washing hands; served both liturgical and secular functions.

arcade: series of arches, often supported by columns or pilasters.

arch: curved frame or opening for a door or window, often composed of blocks known as *voussoirs*.

archbishop: *bishop* of the highest rank who oversees an *ecclesiastical* province. See *clergy*.

archivolt: moldings framing an arch, often in multiple bands.

B | **barrel vault:** stone or sometimes wooden *vault* that looks like a tunnel or a cutaway barrel.

basilisk: dragon with a serpent's tail, signifying the power to kill.

beaker: drinking vessel without a handle; usually has a wide mouth.

Benedictine order: monastic order whose followers subscribe to the Rule of Saint Benedict, which contains instructions for the structure of the community as well as how time should be spent in prayer, study, and work.

benediction: blessing or invocation of divine favor upon a person or object.

Bible: sacred scripture, divided into the Old and New Testaments. The Old Testament (Hebrew Bible) includes the creation of the world and the history of the Jewish people as well as the writings of the prophets and the Psalms. The New Testament includes the *Gospels*, the *Epistles*, and the *book of Revelation*.

bishop: member of the *clergy* consecrated for the spiritual government and direction of a *diocese*. See *clergy*.

book of hours: book containing prayers to be recited at the eight *canonical hours* of the day. Meant for private use, it is often small enough to be held in one hand and its pages are frequently decorated with fine *illuminations*.

book of Revelation: see Apocalypse, Bible.

boss: convex, circular knob often used in decoration.

boxwood: fine-grained hardwood well suited to intricate carving.

C | **cabochon:** convex, unfaceted polished gemstone.

canonize: to declare by papal authority the sainthood of a deceased person, whose name is then placed on an officially recognized calendar, or canon, of *saints*.

canonical hours: stated times of day (Lauds, Prime, Terce, Sext, None, Vespers, Compline, and Matins) for prayers, the recitation of the book of Psalms, and other readings.

capital: top of a column or pilaster. See column.

Carmelite order: founded in the late twelfth century on Mount

Carmel in modern Israel, the order is characterized by an austere lifestyle and a particular devotion to the Virgin Mary.

Carolingian: refers to the era of Charlemagne (r. as emperor 800–814) and his successors, who reigned over territories comprising modern France, Germany, Switzerland, Austria, and Italy until the early tenth century.

casting: process of creating an object by pouring molten material into a mold and allowing it to solidify.

Catalunya: autonomous region centered in the eastern Pyrenees whose historical territories are today divided between France and Spain.

cathedral: literally, a church where the seat (cathedra) of a *bishop* is located; also the church where the bishop regularly performs the *liturgy*.

censer: container for burning incense; used in the *liturgy*.

chalice: cuplike vessel containing wine consecrated during the *Eucharistic liturgy*, or communion.

champlevé: type of *enameling* in which shallow depressions are carved into a metal base and filled with powdered glass.

chapel: place of worship, often housing its own *altar*; can refer to a space within a large building (church, castle, palace) or an individual building (typically small) without parochial functions.

chapter house: assembly room in a *monastery* where the community meets daily for religious and administrative purposes.

chasing: process of adding fine details to the surface of metal or smoothing roughness from the *casting* process.

chasuble: loose, sleeveless outer garment worn by *bishops* or *priests* during the *Mass*.

cherubim: celestial winged being; one of the nine orders of angels.

choir: in architecture, a term used to describe the space typically east of the *transept* where the *clergy* and singers perform the *liturgy*.

choir screen: screen situated between the *choir* and the *nave* of a church that separates the *clergy* from the congregation.

choir stalls: seats in the *choir*, often arranged in two rows facing each other. Their hinged seats and high backs are often adorned with carvings.

Cistercian order: monastic order, founded in 1098 by Robert of Molesme at Cîteaux in Burgundy, that champions strict adherence to the Rule of Saint Benedict. With its austere spirituality and administrative efficacy, the order rapidly grew in popularity.

clergy: persons consecrated and appointed by the church to perform religious services; generally comprises the orders of *archbishop*, *bishop*, *priest*, and *deacon*.

cloister: in a *monastery*, a square or rectangular open-air courtyard surrounded by covered passageways and situated next to the monastic church; its use is limited to the monks or nuns.

coat of arms: *heraldic* design on a shield, banner, *surcoat*, etc.; also the heraldic shield and surrounding symbols. See *heraldry*.

colonette: small column.

column: in architecture, a vertical member with a cylindrical, sometimes tapering, body. It stands on a base and is topped by a *capital*.

convent: in the *Middle Ages*, a word interchangeable with the term *monastery*. In modern usage, it often refers to a community of women.

corbel: block that projects from a wall to support a roof, ceiling, or sculpture.

cornice: generally, a horizontal molding that crowns a building, often in projection.

corpus (Latin, "body"): often used to refer to the body of the crucified Christ.

credenza: legless sideboard used for storage.

crenellation: defensive parapet wall at the top of a roof with alternating open spaces (crenels) and solid blocks (merlons).

crocket (French *crochet*, "crook"): curved-leaf motif often used in architectural and sculptural decoration, especially in the later *Middle Ages*.

crosier/crozier: staff, shaped like a shepherd's crook, that is carried by *bishops* and *abbots*.

cross: composed of two intersecting bars, a symbol of Christianity evoking the Crucifixion.

crucifix: cross with a depiction of the crucified Christ.

cruciform: cross-shaped.

cruet: small container for wine or water used in the *liturgy*; often found in sets.

Crusades: military campaigns initially launched in 1095 by Pope Urban II aimed at recapturing the Church of the Holy Sepulcher in Jerusalem. Prolonged conflicts between Christians from western Europe, various Muslim powers, and, ultimately, Christians in Byzantium ensued. The crusading presence in the East ended with the fall of the city of Acre (in modern Israel) to Muslim forces in 1291.

D | **deacon:** member of the *clergy,* ranked below *bishop* and *priest.*

diocese: sphere of jurisdiction of a *bishop*.

diptych: pair of hinged panels, usually carved or painted. See triptych.

Dominican order: *Mendicant* order founded by Saint Dominic (1170–1221) in the early thirteenth century. Instead of prayers and manual labor, the Dominicans emphasize learning and preaching, which often brought them out of the seclusion of the *cloister*.

 ${f E} \mid {f earthenware:} \ {\sf low-fired} \ {\sf pottery} \ {\sf that} \ {\sf is} \ {\sf slightly} \ {\sf porous} \ {\sf unless} \ {\sf glazed}.$

ecclesiastic: pertaining to or concerned with affairs of the church.

effigy: generally, the image of a person; in describing medieval tomb sculpture, the representation of the deceased.

embroidery: textile decorated with stitched threads.

enamel: powdered colored glass fused to a metal surface. See *champlevé*.

engraving: process of decorating a metal surface with cut or carved lines.

Epiphany: Christian feast celebrated on January 6 that commemorates Christ's appearance to the Gentiles, represented by the three *Magi*, or wise men.

Epistles: letters by early Christian writers or by the *apostle* Paul. In the context of the *Mass*, the term Epistle refers to the first scriptural passage to be read, customarily followed by the second passage, referred to as the *Gospel*.

Eucharist: central *sacrament* of the church, in which bread and wine are transformed during the *Mass* into the body and blood of Christ; also refers to the consecrated bread and wine.

Evangelists: writers of the four Christian Gospels (Matthew, Mark, Luke, and John) whose writings are believed to have been divinely inspired.

extreme unction: *sacrament* of anointing the sick who are in danger of death.

F | **Flamboyant:** late *Gothic* style characterized in part by the use of *tracery* patterns designed with geometric intricacies to create undulating, often flame-like forms. The style flourished from the fourteenth through the sixteenth century and was widely employed by architects as well as sculptors, painters, and furniture makers.

fleur-de-lis: stylized lily used in art and *heraldry*.

Franciscan order: *Mendicant* order founded by Saint Francis of Assisi (1181/2–1226) in the early thirteenth century that is characterized by a commitment to poverty and teaching.

fresco: painting technique in which *pigments* dissolved in water are applied to a wet plaster surface.

frieze: horizontal band, often decorated, high on a wall or the facade of a building.

friar (Latin *frater*, "brother"): male member of one of the *Mendicant* orders, such as the *Franciscans* and *Dominicans*.

G | **gable:** in architecture, a triangular section atop a facade that conforms to the pitched roof behind; sometimes located above window or door openings for decorative purposes.

gesso: plaster used as a ground for painting or gilding.

gilding: application of gold for decorative purposes.

gisant: tomb *effigy* with the deceased person represented in a recumbent position.

gold leaf: gold beaten into very thin sheets.

Gospel (Old English *gödspel*, "good news"): term that has come to define the first four books of the New Testament (the Gospels according to Matthew, Mark, Luke, and John) and, by extension, Christ's own teachings.

Gothic: predominant style of art and architecture in western Europe from the middle of the twelfth through the fifteenth century. Gothic emerged in the region around Paris in the mid-twelfth century as an architectural style characterized by the use of pointed *arches*, flying buttresses, and *rib vaults*. The Renaissance style developed about 1400 in Florence, but Gothic persisted until the early sixteenth century in much of Europe.

grisaille: painting or decoration in tones of gray.

H | **halo:** circle of celestial light surrounding the head; used in visual representations to indicate power, glory, or divinity.

heraldry: study or use of hereditary designs primarily appearing on the surface of a shield.

Holy Ghost or Holy Spirit: one of the three persons of the *Trinity,* often depicted as a dove.

host: wafer or bread consecrated and consumed at Mass.

Huguenots: French Protestants whose military campaigns against the Catholic Church and the monarchy, beginning in the midsixteenth century, came to be known as the Wars of Religion. Despite repeated persecutions, they quickly gained popularity, particularly in southwestern France.

I | **iconography** (Greek *eikön*, from the verb meaning "to resemble"): study of images and, by extension, the meaning of subjects and stories in art.

illumination: use of paint, often combined with gold, in the decoration of manuscripts.

inlay: decorative technique in which an area of surface is removed and replaced by a new, usually contrasting material.

Instruments of the Passion: objects present at Christ's Crucifixion, including the Holy Cross, Lance, Nails, and Crown of Thorns; also referred to as the Arma Christi.

intarsia: inlay decoration, usually of wood.

ivory: dense, fine-grained white material derived from the teeth of elephants, walrus, and other animals.

- **J** | **jamb:** vertical side of a window or doorway.
- **K** | **knop:** small decorative swelling or knob on the stem of a cup or chalice.
- L | **lancet:** in architecture, a tall narrow window surmounted by a pointed *arch*.

lapis lazuli: semiprecious blue stone ground to manufacture the *pigment* ultramarine.

lectern: stand used to support books for reading or singing during the *liturgy*.

lintel: horizontal member spanning the top of a door or window opening.

liturgical instruments: objects used in the *liturgy*, especially during the *Mass*, such as the *chalice*, *paten*, and *censer*.

liturgy: communal prayers and other rituals prescribed by the church.

Lowlands: historic region corresponding roughly to modern Luxembourg, Belgium, and the Netherlands.

luster: iridescent metallic decoration of ceramics.

M | **Magi** (sing. Magus): the three "wise men" who followed a mysterious star to Bethlehem, where they presented gifts to the Christ Child. See *Epiphany*.

maiolica: Italian term originally describing tin-glazed Islamic ceramics shipped from Spain to Italy and later referring to tinglazed vessels of Italian manufacture.

Man of Sorrows: devotional image depicting the dead Christ, who is usually shown in a frontal position and often flanked by the Virgin Mary or *angels* and the *Instruments of the Passion*.

mandorla (Italian, "almond"): literally an almond shape that in visual representations often surrounds the image of Christ or the Virgin to indicate their holiness.

Mass: principal service of the church, the centerpiece of which is the celebration of the *Eucharist*; also includes scriptural readings and sermons, all of which are offered for the welfare and communion of the living and the dead.

Maundy Thursday: Thursday before Easter Sunday, when the Last Supper attended by Christ and his disciples is commemorated.

meander: a decorative pattern, used since antiquity, consisting of a continuous line formed into interlocking rectangular shapes.

memento mori: visual image that serves as a reminder of the inevitability of death.

Mendicant (Latin, from the verb meaning "to beg"): type of religious order whose members take a vow of poverty and live by begging. Unlike the monastic orders, which seclude themselves from the outside world, Mendicants (such as the Franciscans and Dominicans) are not bound by a promise of confinement.

Middle Ages: in general, the period between the end of the western Roman Empire and the beginning of the Renaissance in Europe.

millefleurs (French, "thousand flowers"): popular decorative motif that uses a dense field of flowers as a background, especially for tapestries.

miter: tall, pointed ceremonial headdress worn by *bishops* (and sometimes *abbots*).

monastery: usually a reclusive community of monks or nuns living under religious vows and according to certain rules.

monasticism: devotional lifestyle of monks or nuns who live, to some degree, in seclusion under religious vows and who are subject to a fixed rule, or code of conduct.

mordant: substance that chemically fixes dyes to textiles.

mortise and tenon: joint in which a hole (mortise) is cut to receive a projecting tenon.

mother-of-pearl: iridescent lining of some shells used for carving and *inlay*.

mullion: vertical stone element within a window frame.

N | **nave:** in a *cruciform* church, the central aisle used by the congregation that intersects the shorter horizontal arm of the *transept*; comparable to the long vertical arm of a *cross*.

niello: black substance composed of powdered silver, lead, copper, and sulfur that is fused by heat to engraved metal surfaces.

O oculus: a round window.

opus anglicanum (Latin, "English work"): luxurious embroideries produced in England between the thirteenth and fifteenth centuries.

P | palmette: decorative motif derived from the form of a palm leaf.

parchment: animal skin that has been prepared for use in the production of manuscripts.

pasteboard: layers of paper pressed together to create a rigid surface.

paten: circular shallow dish used to hold the host.

pigment: coloring agent for paint, dye, etc.

pilaster: vertical architectural member. Unlike the *column*, which is round, the pilaster is often square or rectangular in section.

pilgrimage: journey made to a holy place as an act of religious devotion. The three major pilgrimage destinations in the *Middle Ages* were Rome, Santiago de Compostela, and Jerusalem.

polylobed: design that is ringed with petal-like projections; scalloped.

pope: *bishop* of Rome and head of the western church (today the Roman Catholic Church).

pot-metal: glass with color produced by adding metallic oxides to the molten glass during production.

predella: horizontal zone below the main panels of an *altarpiece* that is often decorated with painting or carving.

priest: member of the *clergy* who has the authority to administer the *sacraments*.

Premonstratensian order: monastic order founded in 1120 by Saint Norbert (ca. 1080–1134) at Prémontré near Laon, in northern France. The order observes the Rule of Saint Augustine, with considerable influence from the *Cistercians*.

pulpit: elevated structure in a church reserved for scriptural readings and preaching.

Q | quatrefoil: four-leaf design.

R | **refectory:** communal dining room in a *monastery*.

relic: any object associated with a *saint*, including bodily remains, regarded as a memorial after his/her death and held in esteem or venerated.

reliquary: receptacle for the preservation and sometimes display of *relics*.

repoussé: surface relief decoration created by hammering the reverse side of a metal object.

retable: see altarpiece.

rib vault: type of masonry *vault* whose surface is articulated by vein-like stone ridges (ribs).

rock crystal: transparent and extremely hard quartz.

Romanesque (French *roman*, "Roman-like"): descriptive term from the early nineteenth century for an architectural style that made prevalent use of the round *arches* found in Roman buildings. In general, Romanesque refers to the architectural and artistic style in western Europe from about 950 to 1150, when monumental art forms such as *fresco* and relief sculpture were revived.

rose window: large, circular *stained-glass* window often filled with intricate *tracery* designs.

S | **sacrament:** religious act that confers divine grace on the participant through the performance of certain rituals, for example, communion, baptism, and matrimony.

saint: in general, a holy person, the meaning and extent of which varied throughout the *Middle Ages*. See *canonize*.

sarcophagus: stone coffin.

shrine: in western Europe, a receptacle for the body or *relics* of *saints*. The term is often applied to spaces made holy by that receptacle, or to a place of worship where devotions are paid to a saint.

silver-stain: application of a silver compound to the back of *stained glass* that produces a yellow color; first used in western Europe in the fourteenth century.

socle: projecting pedestal of a *column*.

spandrel: wall areas between arches.

stained glass: colored and painted glass pieces assembled with lead channels to form a decorative panel or window.

stigmata: marks replicating the wounds of Christ from the Crucifixion.

surcoat: short tunic worn over armor.

T | **tang:** connecting element that holds together the vertical and horizontal elements of a *cross*.

tapestry: hangings woven on a loom with warp and weft threads.

tempera: generally refers to egg tempera, a paint made using egg yolk to bind *pigments*.

terracotta (Italian, "baked earth"): fired clay.

tonsure: shaved crown of the head of a *priest* or monk.

tracery: stone elements, often arranged in a decorative pattern, that hold glass in place (as in a stained-glass window). Tracery first emerged in the late twelfth century and became a prominent feature of Gothic architecture. Tracery patterns were also employed by artists working in a variety of other media, from wood sculpture and metalwork to furniture.

transept: in a *cruciform* church, a corridorlike space near the sanctuary that transverses the *nave*.

treasury: in a church or *monastery*, a storage room for precious objects (most of which are liturgical or devotional in nature).

trefoil: three-leaf design.

Trinity: theological concept of the existence of one God in three persons: God the Father, God the Son, and the *Holy Ghost* or *Holy Spirit*.

triptych: three hinged panels, carved or painted. See diptych.

True Cross: *cross* reputedly discovered in the fourth century by Helena, mother of Constantine the Great, that was thought to be the cross on which Christ was crucified.

tympanum: flat field above a doorway between the *lintel* and the *archivolt*, often decorated with carvings.

typology: method of associating the Old and New Testaments in which episodes and figures in the Old Testament are seen to prefigure those of the New Testament.

U | **unicorn:** mythological animal with the body of a horse (or kid) and a single horn on its forehead. In the *Middle Ages*, it was often considered a symbol of Christ, and its horn was believed to possess therapeutic and magical powers.

V | **vault:** in general, a concave ceiling often constructed of masonry; variations include *barrel vault* and *rib vault*.

vellum: high-quality parchment.

velvet: woven textile with a raised pile.

vermiculé: scroll-like decorative design that imitates the patterns of worm-eaten wood.

vestment: liturgical garment worn by those performing the *Mass*. **voussoir:** wedge-shaped stone blocks of which an *arch* is composed.

W | **warp:** in *tapestry* weaving, often undyed threads stretched across a loom to form the base structure of a hanging.

wattle: panels made of tree branches and twigs interwoven with stakes or rods; used as material for constructing fences, walls, or sometimes roofs.

weft: in *tapestry* weaving, dyed or metallic threads that run above and below the *warp* threads to form the design of a hanging.

SUGGESTED READINGS

The following titles are recommended for those interested in medieval art in general and The Cloisters collection in particular. It was prepared with the general reader in mind, with preference given to recent, accessible publications in English.

Primary Sources

Davis-Weyer, Caecilia, comp. *Early Medieval Art*, 300–1150: *Sources and Documents*. Englewood Cliffs, N.J., 1971.

Frisch, Teresa G. *Gothic Art, 1140–c. 1450: Sources and Documents.* Englewood Cliffs, N.J., 1971; reprint, Toronto, 1987.

The Holy Bible, translated from the Latin Vulgate (Douay Version).... Rockford, Ill., 1989.

Jacobus de Voragine. *The Golden Legend: Readings on the Saints.* Translated by William Granger Ryan. Princeton, 1993.

Saint Benedict. *Rule for Monasteries*. Translated by Leonard J. Doyle. Collegeville, Minn., 1948.

Theophilus. *On Divers Arts*. Translated by John G. Hawthorne and Cyril Stanley Smith. Chicago, 1963.

The Cloisters' History and Collection

Bayard, Tania. Sweet Herbs and Sundry Flowers: Medieval Gardens and the Gardens of The Cloisters. New York, 1985; reprint, 1997.

Cavallo, Adolfo Salvatore. The Unicorn Tapestries at The Metropolitan Museum of Art. New York, 1998.

Freeman, Margaret B. *The Unicorn Tapestries*. New York, 1976; reprint, 1983.

Leuchak, Mary Rebecca. "Old World for the New': Developing the Design for The Cloisters." *The Metropolitan Museum Journal* 23 (1988), pp. 257–77.

Mumford, Lewis. "Pax in Urbe." *The New Yorker*, May 21, 1938. Reprinted in *Sidewalk Critic: Lewis Mumford's Writings on New York*, edited by Robert Wojtowicz, pp. 213–16. New York, 1998.

Parker, Elizabeth C., and Charles T. Little. *The Cloisters Cross: Its Art and Meaning*. New York, 1994.

Parker, Elizabeth C., ed., with the assistance of Mary B. Shepard. *The Cloisters: Studies in Honor of the Fiftieth Anniversary*. New York, 1992. A volume with more than twenty essays contributed by leading scholars on the history and major works of art of The Cloisters.

Rorimer, James J. The Cloisters: The Building and the Collection of Mediaeval Art in Fort Tryon Park. New York, 1938; reprint, 1963.

———. Medieval Monuments at The Cloisters as They Were and as They Are. Rev. ed. New York, 1972.

Schrader, J. L. "George Grey Barnard: The Cloisters and The Abbaye." *The Metropolitan Museum of Art Bulletin* 37, no. 1 (Summer 1979), pp. 1–52.

——. "A Medieval Bestiary." The Metropolitan Museum of Art Bulletin 44, no. 1 (Summer 1986), pp. 3–56.

Smith, Elizabeth Bradford. "George Grey Barnard: Artist/Collector/Dealer/Curator." *Medieval Art in America: Patterns of Collecting*, 1800–1940. Exh. cat. University Park, Pa., Palmer Museum of Art. University Park, Pa., 1996.

Tomkins, Calvin. Merchants and Masterpieces: The Story of The Metropolitan Museum of Art. New York, 1970; reprint, 1989. See chapter 19.

Wixom, William D. "Medicval Sculpture at The Cloisters." *The Metropolitan Museum of Art Bulletin* 46, no. 3 (Winter 1988–89), pp. 3–64.

— — , ed. *Mirror of the Medieval World*. Exh. cat. New York, The Metropolitan Museum of Art. New York, 1999.

———, and Margaret Lawson. "Picturing the Apocalypse: Illustrated Leaves from a Medicval Spanish Manuscript." *The Metropolitan Museum of Art Bulletin* 59, no. 3 (Winter 2002), pp. 1–56.

Young, Bonnie. A Walk Through The Cloisters. New York, 1979; reprint, 1988.

Studies on The Cloisters' collection appear frequently in The Metropolitan Museum of Art Bulletin (1905–) and The Metropolitan Museum Journal (1968–), both easily searched using the Museum's online library catalogue, Watsonline, accessible through the Metropolitan's website, www.metmuseum.org. The website also contains pages devoted to highlights of the collection, special features on selected works at The Cloisters, and thematic discussions of medieval art in the Timeline of Art History.

Medieval Art at the Metropolitan Museum

Ainsworth, Maryan W., and Keith Christiansen, eds. *From Van Eyck to Bruegel: Early Netherlandish Paintings in The Metropolitan Museum of Art.* Exh. cat. New York, The Metropolitan Museum of Art. New York, 1998.

Boehm, Barbara Drake. *Enamels of Limoges* 1100–1350. Exh. cat. New York, The Metropolitan Museum of Art. New York, 1996.

———. *Prague: The Crown of Bohemia*, 1347–1437. Exh. cat. New York, The Metropolitan Museum of Art; Prague Castle. New York, 2005.

Cavallo, Adolfo Salvatore. *Medieval Tapestries in The Metropolitan Museum of Art.* New York, 1993.

Chapuis, Julien, et al. *Tilman Riemenschneider: Master Sculptor of the Late Middle Ages.* Exh. cat. New York, The Metropolitan Museum of Art. New Haven, 1999.

Gómez-Moreno, Carmen. *Medieval Art from Private Collections*. Exh. cat. New York, The Metropolitan Museum of Art. New York, 1968.

Hayward, Jane. English and French Medieval Stained Glass in the Collection of The Metropolitan Museum of Art. Revised and edited by Mary B. Shepard and Cynthia Clark. 2 vols. New York, 2003.

Husband, Timothy B. *The Luminous Image: Painted Glass Roundels in the Lowlands, 1480–1560*. Exh. cat. New York, The Metropolitan Museum of Art. New York, 1995.

———, and Jane Hayward. *The Secular Spirit: Life and Art at the End of the Middle Ages.* Exh. cat. New York, The Metropolitan Museum of Art. New York, 1975.

———, with the assistance of Gloria Gilmore-House. *The Wild Man: Medieval Myth and Symbolism*. Exh. cat. New York, The Metropolitan Museum of Art. New York, 1980.

Little, Charles T., ed. *The Art of Medieval Spain, A.D.* 500–1200. Exh. cat. New York, The Metropolitan Museum of Art. New York, 1993.

The Metropolitan Museum of Art. Europe in the Middle Ages. Introductions by Charles T. Little and Timothy B. Husband. New York, 1987.

———. *Gothic and Renaissance Art in Nuremberg,* 1300–1550. Exh. cat. New York, The Metropolitan Museum of Art; Nuremberg, Germanisches Nationalmuseum. New York, 1986.

Ostoia, Vera K. *The Middle Ages: Treasures from The Cloisters and The Metropolitan Museum of Art.* Exh. cat. Los Angeles County Museum of Art. Los Angeles, 1969.

Medieval Art and Architecture in General

Alexander, Jonathan J. G. Medieval Illuminators and Their Methods of Work. New Haven, 1992.

Barnet, Peter, ed. *Images in Ivory: Precious Objects of the Gothic Age.* Exh. cat. Detroit Institute of Arts; Baltimore, Walters Art Gallery. Detroit, 1997.

Baxandall, Michael. The Limewood Sculptors of Renaissance Germany. New Haven, 1980.

Camille, Michael. Gothic Art: Glorious Visions. New York, 1996.

Coldstream, Nicola. Medieval Architecture. New York, 2002.

Cross, F. L., ed. *The Oxford Dictionary of the Christian Church.* 3d ed. New York, 1997.

De Hamel, Christopher. A History of Illuminated Manuscripts. 2d ed., rev. and enl. London, 1994.

Duby, Georges. *The Age of the Cathedrals: Art and Society, 980–1420*. Translated by Eleanor Levieux and Barbara Thompson. Chicago, 1981.

Erlande-Brandenburg, Alain. Cathedrals and Castles: Building in the Middle Ages. Translated by Rosemary Stonehewer. New York, 1995.

Frankl, Paul. Gothic Architecture. Revised by Paul Crossley. New Haven, 2000.

Freeman, Margaret B. Herhs for the Mediaeval Household: For Cooking, Healing and Divers Uses. 2d ed. New York, 1997.

Gerli, E. Michael, ed. Medieval Iberia: An Encyclopedia. New York, 2003.

Gesta (1963–). A scholarly journal devoted exclusively to the study of medieval art. Of interest are special issues such as "The Renaissance of the Twelfth Century" (1970/2), "Paradisus Claustralis" (1973/1–2), and occasional publications of medieval objects at The Metropolitan Museum of Art.

Hearn, M. F. Romanesque Sculpture: The Revival of Monumentul Stone Sculpture in the Eleventh and Twelfth Centuries. Ithaca, N.Y., 1981.

Jeep, John M., ed. Medieval Germany: An Encyclopedia. New York, 2001.

Kibler, William W., et al., eds. *Medieval France: An Encyclopedia*. New York, 1995.

Medieval Craftsmen Series

Binski, Paul. Painters. London, 1991.

Brown, Sarah, and David O'Connor. Glass-Painters. London, 1991.

Cherry, John. Goldsmiths. London, 1992.

Coldstream, Nicola. Masons and Sculptors. Toronto, 1991.

De Hamel, Christopher. Scribes and Illuminators. Toronto, 1992.

Pfaffenbichler, Matthias. Armourers. Toronto, 1992.

Staniland, Kay. Embroiderers. London, 1991.

Nees, Lawrence. *Early Medieval Art*. Oxford History of Art series. Oxford. 2002.

Raguin, Virginia Chieffo, with Mary Clerkin Higgins. *Stained Glass: From Its Origins to the Present*. New York, 2003.

Sauerländer, Willibald. *Gothic Sculpture in France:* 1140–1270. Translated by Janet Sondheimer. New York, 1972.

Schapiro, Meyer. Romanesque Art. New York, 1977.

Sears, Elizabeth, and Thelma K. Thomas, eds. Reading Medieval Images: The Art Historian and the Object. Ann Arbor, 2002.

Snyder, James. *Medieval Art: Painting–Sculpture–Architecture*, 4th–14th Century. New York, 1989.

Stalley, Roger. *Early Medieval Architecture*. Oxford History of Art series. Oxford, 1999.

Stokstad, Marilyn. Medieval Art. 2d ed. Boulder, 2004.

Strayer, Joseph R., ed. *Dictionary of the Middle Ages*. 14 vols. New York, 1982–2004.

Szarmach, Paul E., et al., eds. *Medieval England: An Encyclopedia*. New York, 1998.

Williamson, Paul. Gothic Sculpture: 1140–1300. New Haven, 1995.

SELECTED REFERENCES

References are arranged numerically by object number and listed in chronological order within each entry. Omitted works of art do not have accompanying references. Frequently cited references have been abbreviated below; full bibliographic data for these is provided at the end of the list.

- Plaque with Saint John the Evangelist (1977.421)
 Wixom 1999.
- 2 | Plaque with Scenes at Emmaus (1970.324.1)

Hermann Schnitzlet, "Eine Metzer Emmaustafel," Wallraf-Richartz-Jahrbuch 20 (1958), pp. 41–54; Victor H. Elbern, "Vier karolingische Elfenbeinkästen: Historische, symbolische und liturgische elemente in der spätkarolingischen Bildkunst," Zeitschrift des deutschen Vereins für Kunstwissenschaft 20, nos. 1–2 (1966), pp. 1–16.

- 3 | Bursa Reliquary (53.19.2)
 Hermann Fillitz and Martina Pippal,
 Schatzkunst: Die Goldschmiede- und
 Elfenbeinarbeiten aus österreichischen
 Schatzkammern des Hochmittelalters
 (Salzburg, 1987).
- 4 Three Holy Women at the Holy Sepulcher (1993.19)
 Wixom 1999.
- 5 | Plaque with Saint Aemilian (1987.89) Little 1993; Wixom 1999.
- 6 | Cloister from Saint-Michel-de-Cuxa (25.120.398, .399, .452, .547–.589, .591–.607, .609–.638, .640–.666, .835–.837, .872c, d, .948, .953, .954) Rorimer 1972; Thomas E. A. Dale, "Monsters, Corporeal Deformities, and Phantasms in the Cloister of St-Michel-de-Cuxa," *Art Bulletin* 83, no. 3 (September 2001), pp. 402–36.
- 7 | Narbonne Arch (22.58.1a)
 J. L. Schrader, "A Medieval Bestiary,"
 The Metropolitan Museum of Art
 Bulletin 44, no. 1 (Summer 1986),
 pp. 3–56; Little 1987a.

- 8 | Angel from Saint-Lazare at Autun (47.101.16)
 Denis Grivot and George Zarnecki, Gislebertus, Sculptor of Autun (New York, 1961); Little 1987b.
- 9 | Enthroned Virgin and Child (47.101.15) Forsyth 1982; Little 1987b.
- 10 Enthroned Virgin and Child (67.153) Forsyth 1982; Little 1987b.
- 11 | Apse from San Martín at Fuentidueña (L.58.86)

 James J. Rorimer, Carmen GómezMoreno, and Margaret B. Freeman,
 "The Apse from San Martín at Fuentidueña," The Metropolitan Museum
 of Art Rulletin 19, no. 10 (June 1961),
 pp. 265–96; David L. Simon,
 "Romanesque Art in American
 Collections, XXI. The Metropolitan
 Museum of Art. Part 1: Spain,"
 Gesta 23, no. 2 (1984), pp. 145–59.
- 12 | Crucifix (35.36a, b) Little 1993.
- 13 | The Virgin and Child in Majesty and the Adoration of the Magi (50.180a-c) James J. Rorimer, "A XII Century Fresco from the Pyrenees," *The Metropolitan Museum of Art Bulletin* 13, no. 6 (February 1955), pp. 185–92; Rorimer 1972.
- 14 | The Adoration of the Magi (30.77.6-.9) Rorimer 1972; Elizabeth Valdez del Álamo, "The Epiphany Relief from Cerezo de Riotirón," in Parker 1992,

pp. 110-45.

15 Commentary on the Apocalypse of Saint John (1991.232.1-.14)

William D. Wixom and Margaret Lawson, "Picturing the Apocalypse: Illustrated Leaves from a Medieval Spanish Manuscript," *The Metropolitan Museum of Art Bulletin* 59, no. 3 (Winter 2002), pp. 1–56.

16 Doorway from San Leonardo al Frigido (62.189)

Rorimer 1972; Dorothy F. Glass, "Then the Eyes of the Blind Shall Be Opened': A Lintel from San Cassiano a Settimo," in *Reading Medieval Images: The Art Historian and the Object*, edited by Elizabeth Sears and Thelma K. Thomas, pp. 143–50 (Ann Arbor, 2002).

17 Game Piece with Hercules Slaying the Three-Headed Geryon (1970.324.4)

Vivian B. Mann, "Samson vs. Hercules: A Carved Cycle of the Twelfth Century, in the High Middle Ages," *ACTA* 7 (1980), pp. 1–38.

18 Plaque with the Pentecost (65.105) Peter Lasko, Ars Sacra, 800–1200, 2d ed. (New Haven, 1994).

20 Chapel from Notre-Dame-du-Bourg at Langon (34.115.1–.269)

Rorimer 1972; Jacques Gardelles, "Notre-Dame-du-Bourg à Langon: État des questions," *Cahiers du Bazadais* 17 (1977), pp. 27–42.

21 | Chapter House from Notre-Damede-Pontaut (35.50) Rorimer 1972.

22 Cross (63.12)

Elizabeth C. Parker and Charles T. Little, *The Cloisters Cross: Its Art and Meaning* (New York, 1994).

23 Martyrdom of Saint Lawrence (1984.232)

Hayward 2003.

24 Initial V from a Bible (1999.364.2)

Walter Cahn, Romanesque Manuscripts: The Twelfth Century (London, 1996); "Recent Acquisitions, A Selection: 1999–2000," The Metropolitan Museum of Art Bulletin 58, no. 2 (Fall 2000), p. 17.

25 Plaque with Censing Angels (2001.634)

"Recent Acquisitions, A Selection: 2001–2002," *The Metropolitan Museum of Art Bulletin* 60, no. 2 (Fall 2002), p. 11.

26 Reliquary Cross (2002.18)

"Recent Acquisitions, A Selection: 2001–2002," The Metropolitan Museum of Art Bulletin 60, no. 2 (Fall 2002), p. 12; Pete Dandridge, "Reconsidering a Romanesque Reliquary Cross," Met Objectives: Treatment and Research Notes 4, no. 1 (Fall 2002), pp. 5–7.

27 Cloister from Saint-Guilhem-le-Désert (25.120.1-.134)

Rorimer 1972; Robert Saint-Jean, Saint-Guilhem-le-Désert: La sculpture du cloître de l'abbaye de Gellone (Montpellier, 1990); Daniel Kletke, The Cloister of St.-Guilhem-le-Désert at The Cloisters in New York City (Berlin, 1997).

28 Corbel (34.21.2)

Walter Cahn, ed., Romanesque Sculpture in American Collections, vol. 2, New York and New Jersey, Middle and South Atlantic States, the Midwest, Western and Pacific States (Turnhout, 1999); Christian Bougoux, L'imagerie romane figurée de la Sauve-Majeure: L'iconographie romane au risque de la sémantique (Bordeaux, 2002).

29 Torso of Christ from a Deposition (25.120.221)

Little 1987b; François Avril et al., *La France romane au temps des premiers Capétiens*, 987–1152, exh. cat., Paris, Musée du Louvre (Paris, 2005).

30 Altar Frontal (25.120.256)

Walter W. S. Cook, "The Stucco Altar-Frontals of Catalonia," Art Studies 2 (1924), pp. 41–81.

31 | Segment of a Crosier Shaft (1981.1)

Wixom 1999; Charles T. Little, "Along the Pilgrimage Road: Ivories and the Role of Compostela," in Patrimonio artístico de Galicia y otros estudios: Homenaje al Prof. Dr. Serafin Moralejo Álvarez, edited by Ángela Franco Mata, vol. 3, pp. 159–66 (Santiago de Compostela, 2004).

32 Bowl of a Drinking Cup (47.101.31)

George Zarnecki, Janet Holt, and Tristram Holland, eds., *English Romanesque Art*, 1066–1200, exh. cat., London, Hayward Gallery (London, 1984).

33 Clasp (47.101.48)

Herbert Broderick, "Solomon and Sheba Revisited," *Gesta* 16, no. 1 (1977), pp. 45–48.

34 | Relief with the Annunciation (60.140) Rorimer 1972; Lisbeth Castelnuovo-Tedesco, "Romanesque Sculpture in North American Collections. XXII. The Metropolitan Museum of Art. Part II: Italy (I)," Gesta 24, no. I

35 Lion Passant (31.38.1a, b) Rorimer 1972; Walter Cahn, "The Frescoes of San Pedro de Arlanza," in Parker 1992, pp. 86–109.

(1985), pp. 61-76.

- 36 Doorway from Notre-Dame at Reugny (34.120.1–.120) Rorimer 1972; Anne Courtillé, Auvergne et Bourbonnais gothiques, les débuts (Nonette, 1990).
- 37 Doorway from Moutiers-Saint-Jean (32.147) (40.51.1)
 Rorimer 1972; Neil Stratford, "The Moutiers-Saint-Jean Portal in The Cloisters," in Parker 1992, pp. 260–81.
- 38 | Theodosius Arrives at Ephesus (1980.263.4) Michael Cothren, "The Seven Sleepers and the Seven Kneelers: Prolegomena to a Study of the 'Belles Verrières' of the Cathedral of Rouen," *Gesta* 25 (1986), pp. 203–26; Hayward 2003.
- 39 Scenes from the Life of Saint
 Nicholas (1980.263.2, .3)
 Suse Childs, "Two Decrea from the
 Life of St. Nicholas and Their Relationship to the Glazing Program of
 the Chevet Chapels at Soissons
 Cathedral," in Caviness and Husband
 1985, pp. 25–33; Hayward 2003.
- 40 | Chalice (47.101.30) McLachlan 2001; Didier and Toussaint 2003.
- 41 Arm Reliquary (47.101.33)
 Cynthia Hahn, "The Voices of the Saints: Speaking Reliquaries,"
 Gesta 36, no. 1 (1997), pp. 20–31;
 Didier and Toussaint 2003.
- 42 Chalice, Paten, and Straw (47.101.26–.29)
 McLachlan 2001.
- 43 | Virgin (47.101.11)

 Rorimer 1972; Iconoclasme: Vie et mort de l'image médiévale, exh. cat.,

 Berne, Musée d'Histoire; Strasbourg,

 Musée de l'Oeuvre Notre-Dame
 (Paris, 2001).

44 | Head (1990.132) Wixom 1999.

- 45 Two Scenes from the Legend of Saint Germain of Paris (1973.262.1, .2) Mary B. Shepard, "The St. Germain Windows from the Thirteenth-Century Lady Chapel at Saint-Germain-des-Prés," in Parker 1992, pp. 282–301; Hayward 2003.
- 46 Enthroned Virgin and Child (1999.208)

Richard H. Randall, Jr., The Golden Age of Ivory: Gothic Carvings in North American Collections (New York, 1993); Charles T. Little, "L'art de l'ivoire au temps de Philippe le Bel: Renouveau et tradition," in 1300—L'art au temps de Philippe le Bel: Actes du colloque international, Galeries Nationales du Grand Palais, 24 et 25 juin 1998, edited by Danielle Gaborit-Chopin and François Avril, pp. 75–88 (Paris, 2001).

- 47 Diptych with the Coronation of the Virgin and the Last Judgment (1970.324.7a, b)
 Barnet 1997.
- 48 Enthroned Virgin and Child (1979.402) Wixom 1999.
- 49 Cloister from Bonnefont-en-Comminges (25.120.778) Rorimer 1972.
- 51 Tomb Effigy of Jean d'Alluye (25.120.201) Rotimer 1972; Helmut Nickel, "A Crusader's Sword: Concerning the Effigy of Jean d'Alluye," *The Met*ropolitan Museum Journal 26 (1991), pp. 123–28.
- 52 | Sepulchral Monument of Ermengol VII, Count of Urgell (28.95) Rorimer 1972; Timothy B. Husband, "Sancti Nicolai de fontibus amoenis' or 'Sti. Nicolai et Fontium Amenorum': The Making of Monastic History," in Parker 1992, pp. 354–83.
- 53 Stained Glass with Emperor Henry II and Queen Kunigunde (65.96.3—.4) Eva Frodl-Kraft, "Problems of Gothic Workshop Practices in Light of a Group of Mid-Fourteenth-Century Austrian Stained-Glass Panels," in Caviness and Husband 1985, pp. 107–23.

54 Stained Glass with the Baptism of Christ and the Agony in the Garden (1986.285.4, .5)

Eva Frodl-Kraft, "The Stained Glass from Ebreichsdorf and the Austrian 'Ducal Workshop,'" in Parker 1992, pp. 384–407.

- 55 Diptych with Scenes of the Life of Christ and the Virgin, Saint Michael, John the Baptist, Thomas Becket, and the Trinity (1970.324.8a, b) Barnet 1997.
- 56 Grisaille Lancet (48.183.2) (1984.199.1-.11) Hayward 2003.
- 57 Pair of Altar Angels (52.33.1, .2) Françoise Baron, L'art au temps des rois maudits: Philippe le Bel et ses fils, 1285–1328, exh. cat., Paris, Grand Palais (Paris, 1998).
- 58 Standing Virgin and Child (37.159) Wixom 1988–89.
- 59 Mirror Case with Scenes of the Attack on the Castle of Love (2003.131.1) Barnet 1997; "Recent Acquisitions, A Selection: 2002–2003," The Metropolitan Museum of Art Bulletin 61, no. 2 (Fall 2003), p. 12.
- 60 Panel with Hunting Scenes (2003.131.2)

Barnet 1997; "Recent Acquisitions, A Selection: 2002–2003," *The Metropolitan Museum of Art Bulletin* 61, no. 2 (Fall 2003), pp. 12, 13.

61 | Support Figure of a Seated Cleric or Friar (1991.252)

William D. Wixom, "A Thirteenth-Century Support Figure of a Seated Friar," Wiener Jahrbuch für Kunstgeschichte 46–47 (1993–94), pp. 797–802; Wixom 1999.

62 The Hours of Jeanne d'Evreux, Queen of France (54.1.2)

Barbara Drake Boehm, The Hours of Jeanne d'Evreux: Prayer Book for a Queen (CD-ROM; New York, 1999); Das Stundenbuch der Jeanne d'Evreux / The Hours of Jeanne d'Evreux / Le livre d'heures de Jeanne d'Evreux, facsimile, with commentary by Barbara Drake Boehm, Abigail Quandt, and William D. Wixom (Lucerne, 2000).

63 | Reliquary Shrine (62.96)

Danielle Gaborit-Chopin, "The Reliquary of Elizabeth of Hungary at
The Cloisters," in Parker 1992,
pp. 326–53; Bochm 2005.

- 64 | Double Cup (1983.125a, b) Wixom 1999.
- 65 | Covered Beaker (1989.293) Wixom 1999.
- 66 Enthroned Virgin (1998.214)
 Wixom 1999.
- 67 Relief with Saint Peter Martyr and Three Donors (2001.221) "Recent Acquisitions, A Selection: 2000–2001," The Metropolitan Museum of Art Bulletin 59, no. 2 (Fall 2001), pp. 18, 19.
- 68 | The Crucifixion and the Lamentation (61.200.1, .2)
 Laurence B. Kanter et al., Painting and Illumination in Early Renaissance Florence 1300–1450, exh. cat., New York, The Metropolitan Museum of Art (New York, 1994).
- 69 | The Adoration of the Shepherds (25.120.288) Keith Christiansen, "Fourteenth-Century Italian Altarpieces," The Metropolitan Museum of Art Bulletin 40, no. 1 (Summer 1982), pp. 38, 39, 41.
- 70 | Chalice (1988.67) Wixom 1999.
- 71 Aquamanile in the Form of a Dragon (47.101.51)Barnet and Dandridge 2006.
- 72 Aquamanile in the Form of a Cock (1989.292) Barnet and Dandridge 2006.
- 73 Aquamanile in the Form of a Lion (1994.244) Barnet and Dandridge 2006.
- 74 | Brooch (1986.386) Wixom 1999.
- 75 Altar Cruet (1986.284) Wixom 1999.
- 76 The Bishop of Assisi Giving a Palm to Saint Clare (1984.343) Nuremberg 1986; Wixom 1999.
- 77 Embroidered Hanging (69.106) Bonnie Young, "Needlework by Nuns: A Medieval Religious Embroidery," The Metropolitan Museum of Art Bulletin 28, no. 6 (February 1970), pp. 262–77; Kay Staniland, Embroiderers, Medieval Craftsmen series (London, 1991).

78 Pietà (Vesperbild) (2001.78)

"Recent Acquisitions, A Selection: 2000–2001," The Metropolitan Museum of Art Bulletin 59, no. 2 (Fall 2001), p. 20; Boehm 2005.

79 Credenza (53.95)

Luisa Bandera, Il mobile emiliano (Milan, 1972); Graziano Manni, Mobili in Emilia: Con una indagine sulla civiltà dell'arredo alla corte degli Estensi (Modena, 1986).

80 Plate with the Arms of Blanche of Navarre (56.171.148)

Timothy B. Husband, "Valencian Lustreware of the Fifteenth Century: Notes and Documents," *The Metropolitan Museum of Art Bulletin* 29, no. 1 (Summer 1970), pp. 11–19; Timothy B. Husband, "Valencian Lustreware of the Fifteenth Century: An Exhibition at The Cloisters," *The Metropolitan Museum of Art Bulletin* 29, no. 1 (Summer 1970), pp. 20–32.

81 | Julius Caesar and Attendants, from the Nine Heroes Tapestries (47.101.3) Cavallo 1993.

82 The Belles Heures of Jean de France, Duc de Berry (54.1.1)

Millard Meiss, with Sharon Off Dunlap Smith and Elizabeth Home Beatson, French Painting in the Time of Jean de Berry: The Limbourgs and Their Contemporaries, 2 vols. (New York, 1974): John Plummcr, "The Beginnings of the Belles Heures," in Parker 1992, pp. 420–39; Paris 1400: Les arts sous Charles VI, exh. cat., Paris, Musée du Louvre (Paris, 2004).

83 Beaker with Apes (52.50)

The Secular Spirit: Life and Art at the End of the Middle Ages, exh. cat., New York: The Metropolitan Museum of Art, The Cloisters (New York, 1975); Reinhold Baumstark, ed., Schatzkamerstücke aus der Herbstzeit des Mittelalters: Das Regensburger Emailkästchen und sein Umkreis, exh. cat., Munich, Bayerisches Nationalmuseum (Munich, 1992).

84 The Intercession of Christ and the Virgin (53.37)

Millard Meiss, "An Early Altarpiece from the Cathedral of Florence," The Metropolitan Museum of Art Bulletin 12, no. 10 (June 1954), pp. 302–17; Federico Zeri, with Elizabeth E. Gardner, Italian Paintings: A Catalogue of the Collection of The Metropolitan

Museum of Art, vol. 1, Florentine School (New York, 1971); Charlotte Hale, "The Technique and Materials of the 'Intercession of Christ and the Virgin' Attributed to Lorenzo Monaco," in The Fabric of Images: European Paintings on Textile Supports in the Fourteenth and Fifteenth Centuries, edited by Caroline Villers, pp. 31–41 (London, 2000).

85 Retable with Christ, Saint John the Baptist, and Saint Margaret (62.128a-h)

Lisbeth Castelnuovo-Tedesco, "A Late Gothic Sculpture from Italy: The Savona Altarpiece in The Cloisters," in Parker 1992, pp. 440–59.

86 | Fragment of a Tapestry Hanging (1990.211)

Cavallo 1993; Wixom 1999.

87 Altar Frontal with Man of Sorrows and Saints (1991.156)Nuremberg 1986; Wixom 1999.

88 Retable with Scenes from the Life of Saint Andrew (06.1211.1-.9)

Charles D. Cuttler, Northern Painting from Pucelle to Bruegel, rev. and updated ed. (Fort Worth, 1991).

89 The Annunciation Triptych (Mérode Triptych) (56.70)

Stephan Kemperdick, Der Meister von Flémalle: Die Werkstatt Robert Campins und Rogier van der Weyden (Turnhout, 1997); Maryan W. Ainsworth and Keith Christiansen, eds., From Van Fyck to Bruegel: Early Netherlandish Paintings in the Metropolitan Museum of Art, exh. cat., New York, The Metropolitan Museum of Art (New York, 1998); Felix Thürlemann, Robert Campin: A Monographic Study with Critical Catalogue (Munich, 2002).

90 Kneeling Angel (65.215.3)

Timothy B. Husband, "Tilman Riemenschneider and the Tradition of Alabaster Carving," in *Tilman Riemenschneider*, c. 1460–1531, edited by Julien Chapuis, pp. 64–81 (New Haven, 2004).

91 The Virgin Mary and Five Standing Saints Above Predella Panels (37.52.1–.6)

Jane Hayward, "Stained-Glass Windows from the Carmelite Church at Boppard-am-Rhein: A Reconstruction of the Glazing Program of the

North Nave," *The Metropolitan Museum Journal* 2 (1969), pp. 75–114;
Rorimer 1972.

- 92 | Paschal Candlestick (44.63.1a, b) Margaret B. Freeman, "Lighting the Paschal Candlestick," *The Metropolitan Museum of Art Bulletin* 3, no. 8 (April 1945), pp. 194–200.
- 93 | Altar Predella and Socle of Archbishop Don Dalmau de Mur y
 Cervelló (09.146) (14.101.1, .2) (16.79)
 R. Steven Janke, "The Retable of Don Dalmau de Mur y Cervelló from the Archbishop's Palace at Saragossa: A
 Documented Work by Francí Gomar and Tomás Giner," The Metropolitan
 Museum Journal 18 (1983), pp. 65–80.
- 94 Saint James the Greater (69.88)
 María Jesús Gómez Barcena,
 Escultura gótica funeraria en Burgos
 (Burgos, 1988); Jay A. Levenson, ed.,
 Circa 1492: Art in the Age of Exploration, exh. cat., Washington, D.C.,
 National Gallery of Art (Washington,
 D.C., 1991).
- 95 Standing Virgin and Child (1996.14) Chapuis 1999; Wixom 1999.
- 96 Saint Barbara (55.166)
 Eva Zimmermann, "Zur Rekonstruktion des ehemaligen Hochaltares der Kippenheimer St. Mauritiuskirche," in Festschrift für Peter Bloch zum 11. Juli 1990, edited by Hartmut Krohm and Christian Theuerkauff, pp. 121–33 (Mainz am Rhein, 1990).
- 97 The Death of the Virgin (The Dormition) (1973.348) Wixom 1988-89.
- 98 | The Lamentation (55.85)

 Theodor Müller, Sculpture in the Netherlands, Germany, France, and Spain: 1400 to 1500 (Baltimore, 1966); Mojmír Frinta, "Identified Shutters of a Sculptured Shrine at The Cloisters," Gesta 6 (January 1967), pp. 40–45.
- 99 Set of Fifty-two Playing Cards (1983.515.1-.52) Wixom 1999.
- 100 | Tau Cross (1990.283a, b)
 Timothy B. Husband, "The Winteringham Tau Cross and Ignis Sacer,"
 The Metropolitan Museum Journal 27
 (1992), pp. 19–35; Wixom 1999.

- 101 | Armorial Bearings and Badges of John, Lord Dynham (60.127.1)
 Cavallo 1993; Richard Marks and Paul Williamson, eds., Gothic: Art for England 1400–1547, exh. cat., London, Victoria and Albert Museum (London, 2003).
- 102 | Fragment of a Chasuble (1982.432) Wixom 1999.
- 103 | Seated Bishop (1970.137.1) Chapuis 1999.
- 104 | Three Kings from an Adoration Group (52.83.1-.3)
 Spätgotik am Oberrhein: Meisterwerke der Plastik und des Kunsthandwerks, 1450-1530, exh. cat., Badisches
 Landesmuseum (Karlsruhe, 1970);
 Wixom 1988-89.
- 105 | Saint Anthony Abbot (1988.159) Wixom 1999.
- 106 | Covered Beaker (1994.270a, b) Heinrich Kohlhaussen, Nürnberger Goldschmiedekunst des Mittelalters und der Dürerzeit 1240 bis 1540 (Berlin, 1968); Wixom 1999.
- 107 | Covered Chalice (58.39a, b) José Manuel Cruz Valdovinos, Platería en la época de los Reyes Católicos, exh. cat., Madrid, Fundación Central Hispano (Madrid, 1992).
- 108 Triptych with Scenes from the Passion of Christ (69.226) Johannes Neuhardt, ed., Gold + Silber: Kostbarkeiten aus Salzburg, exh. cat., Dommuseum zu Salzburg (Salzburg, 1984).
- 109 Cloister from Trie-en-Bigorre (25.120.177) Rorimer 1972.
- (13.138.1)
 Rorimer 1972; Pantxika Béguerie-De
 Paepe, La sculpture picarde à Abbeville
 vers 1500 (Tournai, 2001).

110 Doorway and Staircase Enclosure

- 111 One of a Pair of Ewers (53.20.2)
 Timothy B. Husband, *The Wild Man: Medieval Myth and Symbolism*, exh. cat., New York, The Metropolitan Museum of Art, The Cloisters (New York, 1980); Nuremberg 1986.
- 112 Lectern in the Form of an Eagle (68.8) Jan Crab, "The Great Copper Pelican in the Choir: The Lectern from the Church of St. Peter in Louvain," The Metropolitan Museum of Art Bulletin 26, no. 10 (June 1968), pp. 401–9.

113 | Man of Sorrows (1999.227)

Peter Barnet, "An Ivory Relief of the 'Man of Sorrows' in New York," *The Sculpture Journal* 4 (2000), pp. 1–6.

114 | Memento Mori (Dives in Hell) (1985.136)

Wixom 1999.

115 | The Mater Dolorosa (1998.215b) Wixom 1999.

116 | Quatrefoil Panel with Secular Scenes (11.120.2) Nuremberg 1986.

117- The Unicorn Tapestries

123 (37.80.1-.6, 38.51.1, .2)

Cavallo 1993; Adolfo Salvatore Cavallo, The Unicorn Tapestries at The Metropolitan Museum of Art (New York, 1998).

124 Beaker (1983.16)

Wixom 1999.

Panels with Scenes from the Life and Passion of Christ (50.147.1, .2)

Margaret B. Freeman, "Late Gothic Woodcarvings from Normandy," *The Metropolitan Museum of Art Bulletin* 9, no. 10 (June 1951), pp. 260–69.

126 | Sorgheloos (Carefree) in Poverty (1999.243)

Timothy B. Husband, *The Luminous Image: Painted Glass Roundels in the Lowlands*, 1480–1560, exh. cat., New York, The Metropolitan Museum of Art (New York, 1995).

127 Saint Michael (53.65)

Suzanne L. Stratton, ed., Spanish Polychrome Sculpture, 1500–1800, in United States Collections, exh. cat., New York, The Spanish Institute; Dallas, Meadows Museum, Southern Methodist University; and Los Angeles County Museum of Δrt (New York, 1993).

Barnet and Dandridge 2006. Peter Barnet and Pete Dandridge. Lions, Dragons, and Other Beasts. Aquamanilia of the Middle Ages: Vessels for Church and Table. Exh. cat. New York, Bard Graduate Center, 2006.

Barnet 1997. Peter Barnet, ed. *Images in Ivory: Precious Objects of the Gothic Age.* Exh. cat. Detroit Institute of Arts; Baltimore, Walters Art Gallery. Detroit, 1997.

Boehm 2005. Barbara Drake Boehm. Prague: The Crown of Bohemia, 1347–1437. Exh. cat. New York, The Metropolitan Museum of Art; Prague Castle. New York, 2005.

Cavallo 1993. Adolfo Salvatore Cavallo. Medieval Tapestries in The Metropolitan Museum of Art. New York, 1993.

Caviness and Husband 1985. Madeline H. Caviness and Timothy B. Husband, eds. Corpus Vitrearum: Selected Papers from the XIth International Colloquium of the Corpus Vitrearum, New York, 1–6 June 1982. New York, 1985.

Chapuis 1999. Julien Chapuis, et al. Tilman Riemenschneider: Master Sculptor of the Late Middle Ages. Exh. cat. New York, The Metropolitan Museum of Art. New Haven, 1999.

Didier and Toussaint 2003. Robert Didier and Jacques Toussaint, eds. *Autour de Hugo d'Oignies*. Exh. cat. Namur, Musée des Arts Ancients du Namurois. Namur, 2003.

Forsyth 1982. Ilene H. Forsyth. Throne of Wisdom: Wood Sculptures of the Madonna in Romanesque France. Princeton, 1982.

Hayward 2003. Jane Hayward. *English and French Medieval Stained Glass in the Collection of The Metropolitan Museum of Art.* Revised and edited by Mary B. Shepard and Cynthia Clark. 2 vols. New York, 2003.

Little 1987a. Charles T. Little, with David L. Simon and Leslie Bussis. "Romanesque Sculpture in North American Collections. XXV. The Metropolitan Museum of Art, Part V. Southwestern France." Gesta 26, no. 1 (1987), pp. 61–76.

Little 1987b. Charles T. Little. "Romanesque Sculpture in North American Collections. XXVI. The Metropolitan Museum of Art. Part VI. Auvergne, Burgundy, Central France, Meuse Valley, Germany." Gesta 26, no. 2 (1987), pp. 153–68.

Little 1993. Charles T. Little, ed. *The Art of Medieval Spain, A.D.* 500–1200. Exh. cat. New York, The Metropolitan Museum of Art. New York, 1993.

McLachlan 2001. Elizabeth Parker McLachlan. "Liturgical Vessels and Implements." In *The Liturgy of the Medieval Church*, edited by Thomas J. Heffernan and E. Ann Matter, pp. 369–429. Kalamazoo, Mich., 2001.

Nuremberg 1986. Gothic and Renaissance Art in Nuremberg, 1300–1550. Exh. cat. New York, The Metropolitan Museum of Art; Nuremberg, Germanisches Nationalmuseum. New York, 1986.

Parker 1992. Elizabeth C. Parker, ed., with the assistance of Mary B. Shepard. The Cloisters: Studies in Honor of the Fiftieth Anniversary. New York, 1992.

Rorimer 1972. James J. Rorimer. Medieval Monuments at The Cloisters as They Were and as They Are. Rev. ed. New York, 1972.

Wixom 1988–89. William D. Wixom. "Medieval Sculpture at The Cloisters." *The Metropolitan Museum of Art Bulletin* 46, no. 3 (Winter 1988–89), pp. 3–64.

Wixom 1999. William Wixom, ed. Mirror of the Medieval World. Exh. cat. New York, The Metropolitan Museum of Art. New York, 1999.

ACKNOWLEDGMENTS

his book is the result of the cooperation and encouragement of many. We owe an enormous debt to our fellow curators and educators in the Department of Medieval Art and The Cloisters who tirelessly read drafts of the text and made many helpful suggestions. They are: Barbara Drake Boehm, Julien Chapuis, Helen C. Evans, Meredith Fluke, Melanie Holcomb, Timothy Husband, Charles T. Little, and Leslie Bussis Tait. Many other staff members and friends made valuable contributions. We are especially grateful to Christina Alphonso, Drew Anderson, Sylvan Barnet, Christine Brennan, Michael Carter, Lisbeth Castelnuovo-Tedesco, Dorothy Glass, Keith Glutting, Sigrid Goldiner, Lucretia Kargère, Deirdre Larkin, Marlene Lieu, Theo Margelony, Susan Moody, Thom Morin, Nadine Orenstein, José Ortiz, Xavier Seubert, Tom Vinton, Ann Webster, and Emma Wegner. Lisa Skogh was research assistant for the project and provided valuable assistance coordinating the guide in its early stages and assembling the glossary. Subsequently, Tiffany Sprague, research associate, saw the project through the editing and design process with admirable skill and diplomacy. Barbara Bridgers and Museum photographers Oi-Cheong Lee and Joe Coscia, with the assistance of Teresa Christiansen, labored under sometimes difficult conditions to produce the magnificent new photographs used throughout. Doralynn Pines, associate director for administration, was enthusiastic about the project from the start. John P. O'Neill, editor in chief, and his staff are responsible for the high standards of editing, design, and production, expertly overseen by our editor, Dale Tucker. Tony Drobinski created the handsome design of the book, and John Papasian was responsible for the isometric drawings of The Cloisters. Finally, we are grateful to Philippe de Montebello for his leadership and support. .

INDEX

Page numbers in italic refer to illustrations.

Aachen, ivory plaque from, 24, 24-25

from, 152, 152, 153

Abbeville, doorway and staircase enclosure

Adoration of the Magi: fresco from Tredós

with, 40, 40; stone carving from Cerezo de Riotirón, 41, 41, 42; stained glass from Ebreichsdorf with, 90; wood statues from Lichtenthal, 143, 143 Adoration of the Shepherds, panel by Bartolo di Fredi, 105, 105-6 Aemilian, Saint, ivory plaque with, 28, 28-29 Agony in the Garden, stained glass from Ebreichsdorf with, 90, 90, 91 altar angels, French pair of, 94, 94 altar frontals: tapestry, from Nuremberg, 123, 123; wood, from Ginestarre de Cardós, 63, 63 altar predella and socle of Archbishop don Dalmau de Mur y Cervelló, 131, 131-32, Andrea da Giona (active mid-15th century). Andrew, Saint, retable with, 123-24, 124 angels: altar, French pair of, 94, 94; censing, Limoges enamel plaque with, 56, 56-57; kneeling alabaster, from Burgundian Lowlands or Rhineland, 127, 127; limestone, from Autun, 33, 33, 34 Annunciation: Mérode Triptych by Robert Campin, 18, 125, 125-26, 126; stone relief from Florence, 66, 66-67 Anthony Abbot, Saint, sculpture of, 144, 144 Apocalypse of Saint John, 42 apse, from San Martín at Fuentidueña, 18, 18-19, 36-38, 36-38, 40 aquamaniles, zoomorphic, 107–8, 107–9 arch, from Narbonne, 32, 32 architecture and architectural sculpture: apse from San Martín at Fuentidueña. 18, 18-19, 36-38, 36-38, 40; arch from Narbonne, 32, 32; chapel from Notre-Dame-du-Bourg at Langon, 15, 47, 47-48, 48; chapter house from Notre-Dame-de-Pontaut, 15, 49-50, 49-51;

61, 68, 68-71, 70, 84, 84-86, 86, 148-52, 148-53; Italian, 43, 43-44, 66, 66-67; Spanish, 18, 18-19, 36-38, 36-38, 41, 41, 46, 46, 131, 131-32, 132. See also capitals; cloisters; doors and doorways; stone reliefs; specific sites Arhardt, Jean-Jacques (active 17th century), 79 arm reliquary, Mosan, 76, 76 arms. See heraldic motifs Astudillo, wood crucifix from, 39, 39 Austria: bursa reliquary from, 26, 26; silver triptych from, 146-48, 147; mounts for covered beaker from, 101, 101; stained glass from, 89-90, 89-91; Standing Virgin and Child from, 134, 134 Autun: angel from Saint-Lazare at, 33, 33, 34; Enthroned Virgin and Child from, 34, 34-35 Baptism of Christ, stained glass from Ebreichsdorf with, 90, 90, 91 Barbara, Saint, sculpture of, 135, 135 Barnard, George Grey, 9-11, 15, 58, 62, 84, Bartolo di Fredi (active by 1353-d. 1410), 105, 105-6 Basel, tapestry fragment from, 122, 122 beakers: with apes, from South Lowlands, 119, 119; covered, attributed to workshop of Sebastian Lindenast the Elder, 145, 145; covered, rock crystal, 101, 101; glass, from Germany, 170, 170 Beatus of Liébana, 42 "Beautiful Style" (Schöne Stil), 113 Becket, Thomas, Saint, 55, 56; German ivory with Martyrdom of, 92, 92 Belles Heures of Jean de France, duc de Berry, 117-18, 118 Benkendorff-Schouvaloff, countess, 43 Bernard of Clairvaux, Saint, 31 Bertinus, 75 Bible from Pontigny, initial V from, 55, 55-56

French, 11, 11, 13, 14, 15-18, 16, 17, 19,

29-33, 29-33, 46-50, 46-51, 58, 58-61,

Charles the Bald, king of the West Franks, Biduino, Master, 43, 43-44 Bishop of Assisi Giving a Palm to Saint chasuble fragment, from England, 141, 141 Clare, panel from Nuremberg with, 110, Clare, Saint, panel painting with, 110, 111 clasp, from Meuse valley, 65, 65-66 Blanche of Navarre, queen, plate from cloisters: from Bonnefont-en-Comminges, Manises with arms of, 115, 115 15-18, 17, 84, 84, 85; from Saint-Guilhem-Blumenthal, George, 68 le-Désert, 14, 19, 58, 58-60, 68; from Bohemia: double cup with Three Magi Saint-Michel-de-Cuxa, 11, 11, 13, 15-16, from, 100, 100; Pietà (Vesperbild) from, 16, 29-31, 29-31; from Trie-en-Bigorre. II3, 113 15-16, 18, 148-51, 148-51 bone carving: bursa reliquary, 26, 26. See Clothar, Frankish king, 70 also ivories Clovis, Frankish king, 70 Bonnefont-en-Comminges, cloister from, cock, aquamanile in form of, 108, 108 15-18, 17, 84, 84, 85 Boppard-am-Rhein, stained glass from, 128, Collens, Charles, 13, 15 Cologne: ivory diptych from, 92, 92-93; 128-29, 129 ivory game piece from, 44, 44; wood Breck, Joseph, 13, 15, 16 relief of Dormition from, 136, 136 brooch in shape of letter E, 109, 109 Commentary on the Apocalypse of Saint Brummer, Joseph, 84 Brunn, Isaac (ca. 1590-after 1657), 78 John, 42, 42 Burgundy and Burgundian territories: Constance, stained glass from, 158, 158 corbel, from Notre-Dame-de-la-Grandebeaker with apes from, 119, 119; initial V from Bible from, 55, 55-56; kneeling Sauve, 61, 61 Coronation of the Virgin: doorway from angel from, 127, 127; playing cards from, Moutiers-Saint-Jean, 70, 70, 71; ivory 138, 138. See also Autun from Paris, 82, 82 bursa reliquary, 26, 26 credenza, attributed to Lorenzo and Cristo-Bury St. Edmunds, ivory cross from, 19, 52, foro Canozi, 114, 114 52-53, 53 crosier shaft, ivory segment of, 64, 64 Byzantine, 40, 57 crosses: ivory, from Bury St. Edmunds, 19, 52, 52-53, 53; reliquary, from Limoges, 57, 57; tau, 139, 139 Campin, Robert (ca. 1375-1444), 125, 125-26, crucifix, wood, from Astudillo, 39, 39 Crucifixion, by Master of the Codex of Saint candlestick, paschal, 130, 130 George, 104, 104 Canozi, Lorenzo (1425-1477) and Cristoforo cruet, altar, from Central Europe, 110, 110 (ca. 1426-1491), 114, 114 cups: double, with Three Magi, 100, 100; Canterbury, stained glass from, 54-55, 55 bowl of, with nude male figures and capitals: from Bonnefont-en-Comminges, dragons, 65, 65 84, 84, 85; from Langon, 47, 47-48, 48; from Notre-Dame-de-Pontaut, 49-50, Cuxa. See Saint-Michel-de-Cuxa 49-51; from Saint-Guilhem-le-Désert, 14, 58, 58-60; from Saint-Michel-de-Cuxa, Dalmau de Mur y Cervelló, archbishop, 11, 11, 13, 29-31, 29-31; from Trie-enaltar predella and socle of, 131, 131-32, 132 Bigorre, 148-51, 148-51 Death of the Virgin, by workshop of Master Carolingian period, ivories from, 24-25 Tilman, 136, 136 Catalunva: altar frontal from Ginestarre de Deposition fragment, from Lavaudieu, 62, 62 Cardós in, 63, 63; fresco from Tredós in, 40, 40; retable with Saint Andrew from, diptychs: ivory, from Cologne, 92, 92-93; 123-24, 124; sepulchral monument of ivory, from Paris, 82, 82 Ermengol VII from, 88, 88-89 doors and doorways: from Abbeville, 152, Cerezo de Riotirón, Adoration of the Magi 152, 153; from Moutiers-Saint-Jean, 70, 70, 71; from Notre-Dame at Reugny, 68, from, 41, 41, 42 68, 69; from the Pyrenees, with ironchalices: covered, from Spain, 146, 146; work, 46, 46; from San Leonardo al from Meuse valley, 75, 75; from Saint Trudpert at Münsterthal, 77, 77; from Frigido, 43, 43-44 Dormition, by workshop of Master Tilman, Siena, 106, 106-7 136, 136 chapel, from Notre-Dame-du-Bourg at dragon: aquamanile in form of, 107, 107; Langon, 47, 47-48, 48 ewer with handle in form of, 154, 154 chapter house, from Notre-Dame-de-Pontaul, Dynham, Lord John, armorial bearings and 15, 49-50, 49-51

badges of, 139-40, 140

Charlemagne, king of the Franks, 24

Ε earthenware plate, tin-glazed, 115, 115 Ebreichsdorf, stained glass from, 90, 90, 91 effigies: of Ermengol VII, count of Urgell, 88, 88-89; of Jean d'Alluye, 87, 87 Eleanor of Aquitaine, queen, 47-48, 48 Elizabeth, queen of Hungary, 99 embroidered hanging, from Lower Saxony, 112, 112-13 Emmaus, ivory plaque with scenes at, 25, 25 enamels: French, 56, 56-57, 99, 99; Italian, 106, 106-7; Mosan, 45, 45; painted, from South Lowlands, 119, 119 Engelbrecht, Peter, 125 Engelram, Master, 28, 28-29 England: bowl of drinking cup from, 65, 65; chasuble fragment from, 141, 141; ivories from, 52, 52-53, 53, 83, 83; stained glass with Martyrdom of Saint Lawrence from, 54-55, 55; tau cross from, 139, 139

Enthroned Virgin, terracotta from Tuscany, 102, 102

Enthroned Virgin and Child: altar frontal from Ginestarre de Cardós, 63, 63; ivory from England, 83, 83; ivory from Paris, 81, 81; wood carving from Autun, 34, 34–35; wood carving from Saint-Victor at Montvianeix, 35, 35–36

Ermengol VII, count of Urgell, sepulchral monument of, 88, 88–89 ewer, silver, from Nuremberg, 154, 154

F

Flamboyant style, 152 Florence: painting with Intercession of Christ and Virgin from, 120; relief with Annunciation from, 66, 66-67 France: architecture and architectural sculpture from, 11, 11, 13, 14, 15-18, 16. 17, 19, 29-33, 29-33, 46-50, 46-51, 58, 58-61, 61, 68, 68-71, 70, 84, 84-86, 86, 148-52, 148-53; copper alloy sculpture from, 97, 97; enamels from, 56, 56-57, 99, 99; illuminated manuscripts from, 55, 55-56, 98, 98, 117-18, 118; ivories from, 25, 25, 81, 81, 82, 82, 96, 96, 97, 97; metalwork from, 57, 57, 99, 99; stained glass from, 72-74, 72-74, 80, 80-81, 93, 93; stone sculptures from,

from, 34, 34–36, 35, 62, 62, 94, 94, 170–72, 171. See also Burgundy and Burgundian territories; Paris French Revolution, 9, 48, 51, 56, 58, 70, 84,

79, 79, 87, 87, 95, 95; wood carvings

frescoes: from San Pedro de Arlanza, *67*, 67–68; from Tredós, 40, 40 Froville, arcade from, *9*, 15 Fuentidueña, apse from, *18*, 18–19, 36–38, 36–38, 40 G

game piece with Hercules Slaying the Three-Headed Geryon, 44, 44 Gerhaert von Leiden, Nikolaus (active 1460-73?), 134, 134, 135 Germain of Paris, Saint, stained glass with. 80.80-81 Germany: embroidered hanging from, 112, 112-13; ivories from, 24, 24-25, 44, 44, 92, 92-93, 156, 156-57; metalwork from. 77, 77, 100, 100, 107–9, 107–9, 145, 145, 154, 154; stained glass from, 128, 128-29. 129, 158, 158, 159, 159; textiles from, 112, 112-13, 123, 123; wood carvings from. 135, 135, 136, 136, 144, 144. See also Cologne; Nuremberg Giner, Tomás (active 1458-80), 132 Ginestarre de Cardós, altar frontal from, 63, 63 Giovanni di Balduccio (active 1318-49), 102-3, 103

102–3, 103 gisant, 87, 87 gold. See metalwork Gomar, Francí (active 1143–ca. 1493), 131, 131–32, 132 González, Fernán, count of Castile, 66 Gouvert, Paul, 50 grisaille lancet, from Rouen, 93, 93 Guilhem, Saint, duke of Aquitaine and

count of Toulouse, 58. See also Saint-

Guilhem-le-Désert

н

head, limestone, from Paris, 79, 79
Hemmel von Andlau, Peter, 158, 158
Henry II, Holy Roman Emperor, stained glass with, 89, 89–90
Henry II, king of England, 48, 48, 56
heraldic motifs: of Blanche of Navarre, plate with, 115, 115; on capitals from
Trie-en-Bigorre, 148, 148; of John, Lord
Dynham, tapestry with, 139–40, 140; of
Holy Roman Empire, quatrefoil roundel with, 159, 159
Hercules Slaving the Three-Headed

Geryon, ivory game piece with, 44, 44
Highcliffe Castle, 170
Hours of Jeanne d'Evreux, 19, 97, 98, 98.
See also Belles Heures of Jeanne de
France, duc de Berry
Huguenots, 50, 151
hunting scenes: enameled beaker with

apes, 119, 119; ivory panel from Paris, 97, 97; Unicorn Tapestries, 18, 19, 160–68, 161–69

1

illuminated manuscripts: French, 55, 55–56, 98, 98, 117–18, 118; Spanish, 42, 42 initial V, from Bible from Pontigny, 55, 55–56

attributed to Lorenzo Monaco, 120, 120 Limoges: enamel with censing angels from, 56, 56-57; reliquary cross from, International Gothic, 127 ironwork, doors from Pyrenees with, 46, 46 57, 57 Isabella of Portugal, queen, 133 Lindenast, Sebastian, the Elder, 145, 145 lion, aquamanile in form of, 108, 109 Italy: bursa reliquary from, 26, 26; credenza Longuyon, Jacques de, 117 from, 114, 114; ivory from, 27, 27; metalwork from, 106, 106-7; paintings from, Lorenzo Monaco (Piero di Giovanni) (active 104, 104-6, 105, 120, 120; rock crystal 1390-1423), 120, 120 beaker from, 101, 101; stone reliefs from, Louis IX, king of France, 81, 82 Louvain, lectern in form of eagle from, 155, 43, 43-44, 66, 66-67, 102-3, 103, 121, 121; terracotta sculpture from, 102, 102 ivories: English, 52, 52-53, 53, 83, 83; Lower Rhineland: glass beaker from, 170, 170; memento mori from, 157, 157 French, 25, 25, 81, 81, 82, 82, 96, 96, 97, 97; German, 24, 24-25, 44, 44, 92, 92-Lower Saxony, embroidered hanging from, 93, 156, 156-57; Italian, 27, 27; Spanish, 112 112-13 28, 28-29, 64, 64. See also bone carving M maiolica, 115 James the Greater, Saint, sculpture of, 133, 133 Manises, tin-glazed earthenware from, 115, Jean d'Alluye, tomb effigy of, 87, 87 Jean de France, duc de Berry, Belles Heures Man of Sorrows: altar frontal from Nuremof. 117-18, 118 berg, 123, 123; ivory plaque from South Germany, 156, 156-57; retable from Jean de Touyl (d. 1349/50), 99, 99 Jeanne d'Evreux, queen of France, 95; Catalunya, 124, 124 Margaret, Saint, retable from Savona with, Hours of, 19, 97, 98, 98 John II of Aragon, king, 115 121, 121 John of Réome, Saint, 70 Margarethe, abbess of Lichtenthal, 143 John the Baptist, Saint, ivory diptych from Maria of Castile, 115 Martin of Tours, Saint, 36, 131-32, 132 Cologne with, 92, 92; retable from Master of Pedret, 40, 40 Savona with, 121, 121 John the Evangelist, Saint, 155; Commentary Master of Roussillon, 123-24, 124 on Apocalypse of, 42, 42; ivory plaque Master of the Codex of Saint George (active with, 24, 24-25 ca. 1325-50), 104, 104 Mater Dolorosa, by circle of Peter Hemmel Juan II of Castile, king, 133 Judaism, object associated with, 100, 100 von Andlau, 158, 158 Iulius Caesar and Attendants, from Nine memento mori (Dives in hell), 157, 157 Mérode Triptych, 18, 125, 125-26, 126 Heroes Tapostries, 116, 117 metalwork: Austrian, 101, 101, 146-48, 147; Jumièges, carved oak panels from, 170-72, Bohemian, 100, 100; Central European, 171 110, 110; English, 65, 65, 139, 139; French, 57, 57, 97, 97, 99, 99; German, 77, 77, 100, 100, 107-9, 107-9, 145, 145, Keutzl, Rupert, abbot, 148 154, 154; Italian, 106, 106-7; Mosan, 65, Kropf, Heinrich and Kunigunde, 90 Kunigunde, queen, stained glass with, 89, 65 66, 75, 75, 76, 76; from the Pyrenees, 46, 46; Scandinavian, 65, 65; from 89-90 South Lowlands, 155, 155-56; Spanish, 146, 146. See also enamels La Clarté-Dieu, tomb effigy from, 87, 87 Metz, ivory with scenes at Emmaus from, Lamentation, by Master of the Codex of Saint George, 104, 104 Meuse, valley of: arm reliquary from, 76, 76; enamel plaque with Pentecost from, Langon, chapel from, 15, 47, 47-48, 48 45, 45; gilt copper clasp from, 65, La Rochefoucauld, François VI de, 160 Last Judgment, Parisian ivory with, 82, 82 65-66; silver chalice from, 75, 75 La Tricherie, window from, 86, 86 Michael, Saint, ivory diptych from Cologne Lautenbach Master, 158, 158 with, 92, 92; wood sculpture of, 173, 173 Lavanttal, stained glass from, 88-89, 89 Milan, relief by Giovanni di Balduccio Lavaudieu, torso of Christ from, 62, 62 from, 102-3, 103 Lawrence, Saint, stained glass with Martyr-Miraflores, statuette of Saint James the dom of, 54, 54-55 Greater from, 133, 133 lectern in form of eagle, 155, 155-56 mirror case, ivory, from Paris, 96, 96

Lichtenthal, Adoration Group from, 143, 143

Intercession of Christ and the Virgin,

Montvianeix, Enthroned Virgin and Child from, 35, 35–36 Morgan, J. P., 84 Moutiers-Saint-Jean, doorway from, 70, 70, 71 Münsterthal, chalice, paten, and straw from, 77, 77

N

Narbonne, arch from, 32, 32
Nativity, on capital from Trie-en-Bigorre, 151
Netherlandish painting, 136, 137
Nicholas, Saint, stained glass with, 73, 73–
74, 74
Niclaus of Haguenau (ca. 1445–1538), 144,
144
Nine Heroes Tapestries, 18, 116, 117
North Lowlands: memento mori from, 157,
157; roundel of Sorgheloos (Carefree) in
Poverty from, 172, 172–73
Notre-Dame-de-la-Grande-Sauve, corbel

Nuremberg: aquamanile in form of lion from, 108, 109; covered beaker from, 145, 145; ewer with figure of wild man from, 154, 154; panel with Saint Clare from, 110, 111; quatrefoil panel with secular scenes from, 159, 159; tapestry altar frontal from, 123, 123

0

opus anglicanum, 154

P

paintings: German, 110, 111; Italian, 104, 104–6, 105, 120, 120; Annunciation (Mérode Triptych), by Robert Campin, 18, 125, 125–26, 126; on playing cards from South Lowlands, 138, 138; Spanish, 123–24, 124, 137, 137. See also frescoes; illuminated manuscripts

Paris: Hours of Jeanne d'Evreux from, 98, 98; ivories from, 81, 81, 82, 82, 96, 96, 97, 97; limestone head from, 79, 79; reliquary shrine from, 99, 99; stained glass from Saint-Germain-des-Prés in, 80, 80–81; Standing Virgin and Child from, 95, 95

Passion of Christ: oak panels from Jumièges, 170–72, 171; triptych from Salzburg, 146–48, 147

paten, from Saint Trudpert at Münsterthal, 77, 77

Pentecost, enamel plaque with, 45, 45 Pertoldus, Master (Berthold Schauer?),

146–48, 147

Pessler, Martin, 123

Peter Martyr, Saint, relief with, 102–3, 103 Pietà (Vesperbild), from Bohemia, 113, 113 plate, with arms of Blanche of Navarre, 115,

115

playing cards, from South Lowlands, 138, 138 polyptychs: enamel reliquary shrine from Paris, 99, 99; by Master of the Codex of Saint George, 104, 104 Pontaut, chapter house from, 15, 49–50,

49–51
Pontigny, initial *V* from Bible from, 55.

pontigny, initial v from Bible from, 55, 55–56
Prague: double cup from, 100, 100; Pietà

(Vesperbild) from, 113, 113
Pucelle, Jean (active ca. 1319–ca. 1334), 98,

98
Pugin, A. W. N. (1812–1852), 156
Pyrenees: cloister from Bonnefont-enComminges, 15–18, 17, 84, 84, 85; cloister from Saint-Michel-de-Cuxa, 11, 11, 13, 15–16, 16, 29–31, 29–31; cloister from Trie-en-Bigorre, 15–16, 18, 148–51, 148–51; doors with ironwork from, 46, 46. See also Catalunya

0

quatrefoil panel with secular scenes, 159, 159

F

Reims Cathedral, 94, 97 reliefs: altar frontal from Ginestarre de Cardós, 63, 63; Death of the Virgin from workshop of Master Tilman, 136, 136. See also ivories; stone reliefs

reliquaries, 36; arm, Mosan, 76, 76; bursa, 26, 26; of Saint Aemilian, plaque from, 28, 28–29; shrine attributed to Jean de Touyl, 99, 99; silver cross from Limoges, 57, 57

retables: with Lamentation, from Sopetrán, 137, 137; marble, from Savona, 121, 121; with Saint Andrew, from Catalunya, 123–24, 124

Reugny, doorway from, 68, 68, 69 Riemenschneider, Tilman (1460–1531), 141–42, 142

Riguardi, Andrea (active 1308–ca. 1338), 106, 106–7

Rimini-Covignano, retable from, 127 Rockefeller, John D., Jr., 11–13, 18 Rorimer, James J., 13, 15, 16

Rorimer, James J., 13, 15, 16 Rothesay, Lord Stuart de, 170

Rouen: grisaille lancet from Saint-Ouen at, 93, 93; stained glass from Notre-Dame at, 72, 72

S

Saint-Guilhem-le-Désert, cloister from, *14*, 19, 58, 58–60, 68
Saint-Michel-de-Cuxa, cloister from, II, *11*, 13, 15–16, *16*, 29–31, 29–31
Salzburg: bursa reliquary from, 26, *26*; silver triptych from, 146–48, *147*San Gimignano, Adoration of the Sheplerds from, *10*5, 105–6

43-44 San Millán de la Cogolla, ivory plaque Standing Virgin and Child: boxwood from, 28, 28-29 statuette from Austria, 134, 134; stone San Pedro de Arlanza, fresco from, 67, sculpture in Parisian style, 95, 95 67-68 Stockheim, Hartmann von, 154 San Pedro de Cardeña, Commentary on stone reliefs: French, 32, 32, 33, 33; Italian, 43, 43-44, 66, 66-67, 102-3, 103, 121, the Apocalypse of Saint John from, 42, 121; Spanish, 131, 131-32, 132. See also Santa María de Bellpuig de les Avellanes, architecture and architectural sculpture stone sculptures: Bohemian, 113, 113; from sepulchral monument from, 88, 88-89 Saragossa, altar predella and socle from, Burgundian Lowlands or Rhineland, 131, 131-32, 132 127, 127; French, 79, 79, 87, 87, 95, 95; Savona, marble retable from, 121, 121 Spanish, 41, 41, 88, 88-89, 133, 133. Scandinavia, bowl of drinking cup from, See also architecture and architectural 65.65 sculpture Strasbourg: Virgin from choir screen at Schöne Stil ("Beautiful Style"), 113 Schongauer, Martin (ca. 1430-1491), 156 cathedral of, 78, 78, 79; wood sculpseated bishop, sculpture by Tilman ture of Saint Anthony Abbot from, Riemenschneider, 141-42, 142 144, 144 Sens, windows from, 9 straw, from Saint Trudpert at Münsterthal, sepulchral monument of Ermengol VII, count of Urgell, 88, 88-89 support figure of seated cleric or friar, 97, Seven Sleepers, stained glass with, 72, 72 97, 98 Siena: chalice from, 106, 106-7; painting by Bartolo di Fredi from, 105, 105-6 Talbot, John, earl of Shrewsbury, 156 Siloe, Gil de (active 1475-1505), 133, 133 silver. See metalwork tapestries: altar frontal from Nuremberg, Soissons, stained glass from, 73, 73-74, 74 123, 123; with armorial bearings and Sopetrán, Lamentation from, 137, 137 badges of John, Lord Dynham, 139-40, Sorgheloos (Carefree) in Poverty, roundel 140; fragment from hanging made in with, 172, 172-73 Basel, 122, 122; Nine Heroes, 18, 116, 117; South Lowlands: Annunciation (Mérode Unicorn, 18, 19, 160-68, 161-69 Triptych) from, 18, 125, 125-26, 126; tau cross, 139, 139 beaker with apes from, 119, 119; lectern Taylor, Baron I. J. (1789-1879), 13 in form of eagle from, 155, 155-56; Nine terracotta sculpture, Italian, 102, 102 Heroes Tapestries from, 116, 117; playing Terret, Victor, abbot, 34 cards from, 138, 138; tapestry fragment Teutonic Knights, Order of, 154 with heraldic motifs from, 139-40, 140. textiles: chasuble fragment from England, See also Meuse, valley of 141, 141; embroidered hanging from South Netherlands, Unicorn Tapestries Germany, 112, 112-13. See also tapestries from, 18, 19, 160-68, 161-69 Theodosius Arrives at Ephesus, stained Spain: architecture and architectural sculpglass from Rouen with, 72, 72 ture from, 18, 18-19, 36-38, 36-38, 41, Theophilus, 26 41, 46, 46, 131, 131-32, 132; Commentary Three Holy Women at the Holy Sepulcher, on the Apocalypse of Saint John from, ivory from Italy with, 27, 27 Three Kings. See Adoration of the Magi 42, 42; covered chalice from, 146, 146; fresco of lion from, 67, 67-68; ivories Throne of Wisdom, 35 from, 28, 28-29, 64, 64; Lamentation Tilman, Master, workshop of, 136, 136 shrine from, 137, 137; paschal candle-Tondino di Guerrino (active 1308-ca. 1338), 106, 106-7 stick from, 130, 130; stone sculptures from, 41, 41, 88, 88-89, 133, 133; tin-Toppler, Margarete, 123 glazed earthenware plate from, 115, 115; torso of Christ from Deposition, found wood carvings from, 39, 39, 130, 130, near Lavaudieu, 62, 62 Tournai, Annunciation (Mérode Triptych) 173, 173. See also Catalunya stained glass: Austrian, 89-90, 89-91; from, 18, 125, 125-26, 126 Tredós, fresco from, 40, 40 English, 54, 54-55; French, 72-74, 72-74, 80, 80-81, 93, 93; German, 128, Tricht, Aert van, the Elder, 155, 155-56 128-29, 129, 158, 158, 159, 159; from Trie-en-Bigorre, cloister from, 15-16, 18, North Lowlands, 172, 172-73 148-51, 148-51

stairway enclosure from Abbeville, 152, 152,

San Leonardo al Frigido, doorway from, 43,

triptychs: Annunciation (Mérode Triptych), 18, 125, 125–26, 126; with scenes from Passion of Christ, 146–48, 147 Tuscany: terracotta of Enthroned Virgin from, 102, 102. See also Florence; Siena

U

Unicorn Tapestries, 18, 19, 160-68, 161-69

V

Vernière, Pierre-Yon, 58, 58

Vesperbild (Pietà), from Bohemia, 113, 113
vessels: silver ewer from Nuremberg, 154, 154; tin-glazed earthenware, from Manises, 115, 115; zoomorphic aquamaniles, 107–8, 107–9. See also beakers; chalices; cups

Virgin, from choir screen at Strasbourg Cathedral, 78, 78, 79 Virgin and Child in Majesty, fresco from

Tredós with, 40, 40

Virgin Mary and five standing saints above predella panels, from Boppard-am-Rhein, 128, 128–29, 129

W

Wars of Religion, 9, 58, 70
Weyden, Rogier van der (ca. 1399–1464), 125, 137
wild man, ewer with figure of, 154, 154
windows: double-lancet, from La Tricherie, 86, 86; grisaille lancet, from Saint-Ouen at Rouen, 93, 93. See also stained glass
Winteringham, tau cross from, 139, 139
Wood, Lewis John (1813–1901), 152
wood carvings: Austrian, 134, 134; French, 34, 34–36, 35, 62, 62, 94, 94, 170–72, 171; German, 135, 135, 136, 136, 141–44, 142–44, 144, 141; Italian, 114, 114; from North Lowlands or Lower Rhineland, 157, 157; Spanish, 39, 39, 130, 130, 173, 173

Würzburg, seated bishop from, 141-42, 142

PHOTOGRAPH CREDITS

New color photography of The Cloisters and of art works in the Metropolitan Museum's collection by Oi-Cheong Lee, The Photograph Studio, The Metropolitan Museum of Art. Additional photograph and reproduction credits are listed below.

The Cloisters Library and Archives, The Metropolitan Museum of Art: p. 12 (photograph by L. H. Dreyer); p. 14 (photograph by Irving Underhill); pp. 15, 18, 31, 36, 38, 43 (bottom, left), 50, 58, 68, 70. Joseph Coscia Jr., The Photograph Studio, The Metropolitan Museum of Art: pp. 161–63, 165–67, 169. From *Spanish Romanesque Sculpture*, by A. K. Porter (New York: Pantheon, ca. 1928): p. 41 (top), copyprint by Mark Morosse, The Photograph Studio, The Metropolitan Museum of Art; p. 48 (top, left).